# My Life in Sculpture

# THE DOCUMENTS OF 20TH-CENTURY ART

ROBERT MOTHERWELL,
GENERAL EDITOR

BERNARD KARPEL,
DOCUMENTARY EDITOR

ARTHUR A. COHEN,
MANAGING EDITOR

# My Life in Sculpture

## by Jacques Lipchitz
## with H. H. Arnason

NEW YORK   THE VIKING PRESS

The Chronology beginning on page 229 is based on
a shorter version that appeared in *Jacques Lipchitz*
by H. H. Arnason.© 1969 Praeger Publishers, Inc.,
New York. Published by Praeger Publishers and
The Pall Mall Press. Reprinted by permission.

With the following exceptions, all photographs in
this book were taken by Alfred Studley:
H. H. Arnason, figures 201, 202; The Art Institute
of Chicago, figure 21; F. K. Lloyd, figure 197;
Robert E. Mates, figure 81; The Museum of
Modern Art, New York, figures 5, 9, 28, 83, 134;
O. E. Nelson, figures 110, 114a, 149; Walter
Rosenblum, figure 139; William Vandivert,
page xxx; Marc Vaux, figures 2, 12, 14, 20, 32, 35,
38, 39, 47, 48, 70, 76, 77, 78, 79, 93, 108, 115,
130; The Walker Art Center, figure 151; Yale
University Art Gallery, figure 29.

# Acknowledgments

The research for this book, Jacques Lipchitz's informal autobiography *My Life in Sculpture*, is based on a series of taped interviews. Research was carried out under the auspices of the Jacques Lipchitz Art Foundation, a nonprofit educational foundation provisionally chartered by the Regents of the University of the State of New York, which was established in 1968 by a group of friends and admirers of the artist; its principal purpose is to find a permanent home for the original plasters of the artist's work and for his personal collection, as well as to establish complete documentation of his career. The Foundation sent art historian Miss Deborah Stott to Pietrasanta, Italy, to record on audiotape a living history of Lipchitz, the annotation of his acquired art collection, and his personal description of the creation of his own works. Miss Stott interviewed Mr. Lipchitz for a period of five months in 1968 and an additional five months in late 1969 and early 1970. In one hundred and eightfive sessions with him she recorded approximately two hundred hours. The work was funded by grants from the Ford Foundation, the Lester Avnet Foundation, the Seymour Askin Art Foundation, the Edgar J. Kaufmann Charitable Foundation, and by other individual contributions.

During a period of six weeks in the summer of 1971, producer Bruce Bassett filmed in color more than seventy-seven thousand feet of Lipchitz in conversation and at work—more than thirty-five hours of film. A portion of this film is part of an exhibition sponsored by the Metropolitan Museum of Art in New York. The film, *Jacques*

*Lipchitz: His Life in Sculpture,* was produced and directed by Bruce Bassett. The director of photography is Bruce G. Sparks, the editor Paul L. Evans, the Production Associate, Georgie Austin, with myself as Consultant.

Thus, in a period of a little more than three years, the Jacques Lipchitz Art Foundation has accomplished the most extensive documentation ever made of any artist. I have prepared the text for *My Life in Sculpture* in the closest collaboration with Jacques Lipchitz. I have also provided an introductory essay and other documentary material with the exception of the bibliography. This was compiled by Bernard Karpel, Chief Librarian of the Museum of Modern Art, New York.

The text, which has been read and approved in every detail by the artist, is based on his exact words as recorded in the above-mentioned interviews, as well as in other conversations and interviews carried on by me during the production of the film and on previous occasions during the last several years.

Thanks are due first of all to the splendid cooperation of Jacques Lipchitz, who continually and patiently interrupted his overwhelming work schedule to be interviewed. Needless to say, without the untiring efforts of Deborah Stott, this book could not have been realized. Thanks are further due to the Marlborough Gallery, to The Viking Press, particularly to my editor, Barbara Burn, and above all, to my research assistant, Anna Golfinopoulos.

The book was produced on the occasion of the major exhibition of Jacques Lipchitz's sculpture at the Metropolitan Museum, New York, celebrating the artist's eightieth birthday. The exhibition opened in May 1972 at the Metropolitan, and subsequently toured the United States. Particular thanks for the realization of the exhibition are owing to the generosity of Roy Neuberger and to the cooperation of Harry Parker, Vice Director for Education, the Metropolitan Museum, to Brett Waller, Associate in Charge of Public Education, and to their staff.

H. H. A.

# Contents

# List of Illustrations

Unless otherwise indicated, works illustrated are in the possession of the artist or the Marlborough Gallery, New York. Bronzes, with the exception of the transparents and one or two other works, exist usually in an edition of seven, although not all of these may have been cast. Thus, of the works illustrated, other casts may be owned by the artist or by other museums or collectors.

# Introduction

*by H. H. Arnason*

Jacques Lipchitz at the age of eighty, together with Picasso (aged ninety) and Marc Chagall (aged eighty-two), are the final survivors of the first heroic age of twentieth-century painting and sculpture, those artists who were in Paris by 1910 and who in different ways created the revolutions in ideas and perceptions of modern art. Although Picasso is a notable sculptor, he has always been primarily a painter. Thus Lipchitz, as a pure sculptor, is the last of the first modern sculptors as well as being, unquestionably, one of the greatest sculptors of this century.

As he recounts here in his informal autobiography, he was trained in Paris in the academic tradition, which had persisted for centuries and still persists in academies of sculpture throughout the world. His *Woman and Gazelles* (fig. 2), his first Salon success, is symptomatic of this phase and is remarkable for its elegance and repose, and for another unusual feature, the expressive elongation of the arms, which is undoubtedly motivated by an instinctive need to emphasize the relationship between the woman and the flanking gazelles. Early portraits (fig. 3) are generally characterized by qualities of classic restraint and sometimes by an archaic Greek abstraction and a strong sense of simplified structure within the representational means.

Lipchitz has lived a long and amazingly prolific life, producing a tremendous oeuvre of widely varying sculptures that range in forms from pristine clarity seen in his early cubist works to wild expressionism or fantasy, as in his use of found objects in improvisations. If we

compare his total work with that of the other major pioneer sculptors of the twentieth century—notably Maillol, Archipenko, Duchamp-Villon, Henri Laurens, Gonzalez, Giacometti, Henry Moore, and, somewhat later, Jean Arp, Brancusi, and the constructivists Gabo and Pevsner—we find that in most instances these pioneers were what might be called one-image sculptors; that is to say, they played continual variations on a single or limited number of forms, refining them and revealing their variety. Thus, for Maillol it was always the nude—standing, seated, or reclining; for Henry Moore during most of his career with the exception of some of the more recent "bone" figures it has been again the reclining nude; for Giacometti, the infinitely emaciated figure; for Brancusi, the egg and its variants.

This is an oversimplification, of course, and in the case of any one of these and other sculptors variations can be found, as in Giacometti's early surrealist sculptures. But the sense of a dominant image does nevertheless exist. It is only in the sculptures of Lipchitz that, looking back to the nineteenth-century prototype of Rodin, we are aware of an infinite variety of forms, images, and concepts. Many of these are achieved almost simultaneously; at a moment during the mid-1920s when he was creating some of his last great cubist sculptures he was improvising with a diametrically opposed form of free, open, wirelike sculpture in which the voids were the dominant shapes and to which he gave the name *transparents*. At the present time, in the 1970s, when he is engrossed in two of his most monumental commissions, the *Bellerophon Taming Pegasus* for Columbia University and the *Government of the People* for the city of Philadelphia, as well as in designing *Our Tree of Life* for Mount Scopus in Israel, all three monuments radically different from one another, he is also busily engaged in a series of small, immensely imaginative improvisations created in wax to which he has given the tentative name of *Columbine* or *The Invisible Hand*. The seeming changes in Lipchitz's styles and approaches to sculpture are so remarkable and achieved at such a dizzying pace that it is sometimes difficult to follow the progress from one point to the next. In this respect he has been linked with Picasso, whose progress through some seventy years has been marked by a similar restless and at times confusing transition from one style to another.

Yet in an even greater degree than is the case with Picasso, it is possible through careful study to find in the sculptures of Lipchitz

certain unifying elements demonstrating a persistent logic that continues from his earliest works to his most recent. The logic is sometimes apparent in the forms; a sense of classic or of cubist discipline recurs in some of the most violently expressionist works; and above all, an analysis of the subjects that have obsessed him throughout his career illustrates certain basic ideas that are deeply imbedded in the philosophy, the personality, and even the religious beliefs of the man and the sculptor.

If we examine the more than two hundred separate subjects that may be listed among his works, subjects each of which may have a dozen different variants, we find curiously enough that these subjects, so different in themselves and so different in the styles in which they are rendered, tend to group themselves in a small number of larger, limited themes. Thus, as an experiment we might classify Lipchitz's basic themes in the following manner:

1. Student work
2. Cubism
3. Personal Themes (those having a specifically personal association to the artist)
   A. The Embrace, or the Encounter
   B. The Mother and Child
   C. Flight and Liberation
   D. Head and Hands
   E. The Harp
   F. Blossoming
   G. The Portraits
4. A. Old and New Testaments
   B. Classical themes
5. Improvisations
   A. Maquettes (clay sketches)
   B. Transparents
   C. Variations on a Chisel
   D. To the Limit of the Possible
   E. Images of Italy
   F. Columbine (the Invisible Hand)
6. Monuments—recent projects

These are not fixed or inevitable categories, since they frequently overlap and return to one another. Also the grouping is not consist-

ent; it is partially formal and partially thematic. Thus, a work that is essentially a study in cubist forms may also include subjects of a personally inspired association. The only point to be emphasized is that in the immense variety of Lipchitz's sculpture there is a continual return to certain ideas and forms that have haunted him throughout his life, presented in entirely new images but nevertheless indicative of beliefs and associations that have persisted since his childhood and that continue to recur in his sculpture.

We may point particularly to the mother and child. This elemental subject has profound implications for Lipchitz in terms of his own mother and father, his own childhood. It appears again and again at different periods with different associations. The child is sometimes himself, sometimes his sculpture threatened with destruction, sometimes a symbol of hope and liberation in a new-found world. The embrace, or the encounter, is also one of the artist's most elemental images, appearing first in the *Encounter* of 1913 (fig. 7) and recurring constantly in versions of the embrace involving maternal love, erotic or sexual violence, or even a struggle, such as that of *Jacob and the Angel* (fig. 105), which becomes in the process a sort of physical embrace. The first conception of Europa and the Bull is filled with sensual love (fig. 128), but in the second, Europa, symbolizing desecrated Europe, is savagely stabbing the bull, a symbol of the barbarian hordes of the Nazis (fig. 137). This contrast between sensual love and violent antagonism, even brutality, emerges in a number of other variants on similar themes and unquestionably indicates a dichotomy between tenderness and anger in the artist's own personality. The mother-and-child idea may be said to have emerged first in the standing figure of *Pregnant Woman* (fig. 6), a tender evocation of approaching motherhood done in 1912. This was a free sketch executed outside of class, a somewhat unusual idea for the time, that simply came to the artist perhaps in a moment of nostalgia and loneliness when he was almost destitute in Paris, feeling like an unborn child, far from the warmth and comfort of his own mother and home. The first *Encounter* (*The Meeting*) was executed in lead in 1913 and represents what Lipchitz calls his proto-cubist phase, the standing embracing figures simplified and geometrized but not as yet achieving the full integration of properly conceived analytic cubism. Even more significant in this group than the tentative approaches to cubism is the intensity of the relationship between the figures, some-

thing that recurs again and again in the variants on the embrace that
follow. These explorations belong within the personal iconography of
the artist, subjects—whether they are rendered in a tentatively ab-
stract or in a freely expressionist broken contoured manner—having
some significance relating to immediate associations. Another subject
that appears early and that recurs frequently is that of the dancer (in
its first manifestation a 1913 *Woman with Serpent* (fig. 8), which
initially might be considered a stylistic experiment in relations be-
tween Renaissance and proto-cubist volumes and space. The dancer
recurs many times, for the obvious reason that a dancing, whirling
figure lends itself to sculptural ideas of movement or dimensions of
solids within surrounding space.

## Cubism

Lipchitz is, of course, one of the greatest, if not the greatest, of all
sculptors who explored the many paths of cubism between 1913 and
1930. During this period and even in works of the 1930s and later,
the cubist forms predominated or recurred to the point that it might
be said that no other sculptor has examined all the implications of
cubism for sculpture as thoroughly and as imaginatively as has he.
The 1913 *Dancer* (fig. 11) and the 1914 *Sailor with Guitar* (fig. 12)
reiterate the dancing motif of the figure but—particularly in the *Sailor
with Guitar*—the figure ceases to be simply a representational inter-
pretation of a human being abstracted through the translation of
organic volumes (arms, legs, etc.) into cubic masses, and approxi-
mates to a genuine cubist construction in which the figure, always
retaining the sense of human personality and organic movement, is
consciously built architecturally from abstract elements.

The artist was in complete control of the cubist vocabulary as
applied to sculpture with the detachable figures of 1915, figures also
of larger significance in that, made originally of wood and other
elements, they were among the first pure examples of sculpture as
construction. They also introduced suggestions of machine forms, with
which many of the cubist painters began to be intrigued about this
time. These works led inevitably to an application of all the cubist
elements, multiple views, tilted facets, inversions of solids and
voids.

One of the classic examples of this first stage of Lipchitz's cubist sculpture is the *Head*, 1915 (fig. 25), in which interlocking, opposing planes create the mass of the head with the eyebrows curving up in what becomes a flower form. This is a work of the utmost simplicity and power, which led to the standing figures of 1915 and 1916, in their austere, vertical, rectangular purity suggestive of Gothic or modern skyscraper architecture. Although these architectural cubist structures are among the most perfectly realized of Lipchitz's cubist sculptures, he was nevertheless concerned lest he carry cubism too far in the direction of absolute abstraction. To him sculpture must always be rooted in humanity. The cubist figure must always retain within its abstract shapes the sense of an actual human figure. It is for this reason that he felt forced to introduce a circular eye in the head and from 1916 on to revert to a complication of movement in which the subjects of arms and legs in motion continually recur. The cubist sculptures from 1916 to 1921, with a few exceptions such as the highly abstract stone *Head* of 1916 (fig. 32), reflect several different trends, a complication of rotating forms somewhat parallel to Picasso's and Braque's rococo cubism in painting, occasional experiments in austere frontality, precursors of the emphasis on frontality of Picasso's *Three Musicians* (1921) and Lipchitz's own massive *Figure* of 1926–1930 (fig. 75). There were as well in these years (1916–1920) some explorations of cubist reliefs with experiments in color, soon abandoned, and then some successful (1921–1922), deeply undercut reliefs, a direction with great potential for architectural sculpture; but the artist, increasingly obsessed with the need to discover a new subject matter, to humanize his figures even further, did not pursue this abstract, architectural direction.

Elements of cubism persisted in major works of the 1920s and 1930s (as Lipchitz himself says continually, he has never ceased to be a cubist). The monumental *Bather* (1923–1925, fig. 59) and *Joy of Life* (fig. 81), each about seven feet high, are in a sense summations of the cubist phase and farewells on a grand scale to this period of his career. In the *Joy of Life*, intended as a garden sculpture, a joyful theme of dancing figures, Lipchitz introduced an element of actual motion by having the figure rotate on its base at four-minute intervals.

But the 1920s are marked specifically by the emphasis on the recognizable element of humanity, by the figure, no matter how ab-

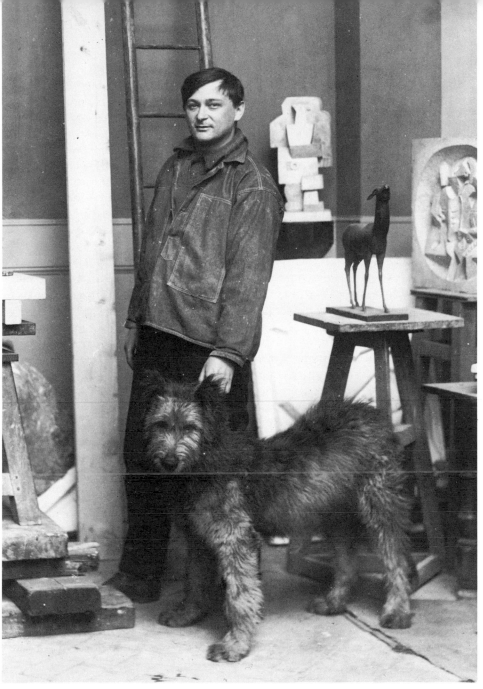

Lipchitz in his studio at Montparnasse, 1925. (*Marc Vaux*)

stracted, which takes on a specific mood, of repose, weariness, gaiety, or mystery. The element of frontality is increasingly emphasized in the series of what might be called abstract landscapes done at Plou-manach in Brittany and climaxed in the impressive, primitive presence of the 1926–1930 *Figure*. From the beginning of his career Lipchitz had explored in clay sketches, or maquettes, initially only a few inches high and very rough and free in treatment, original ideas that he frequently developed into finished works. These he began in his student days and continued during the cubist period. Most of the early ones which he regarded of no significance have disappeared, and in 1915, during an emotional crisis, he destroyed many others. From 1920 forward the artist, realizing the importance of these initial expe-riments, attempted to save them on an organized basis with the result that, although others were lost when he was forced to flee Europe, and in his 1952 New York studio fire, he still has in his possession well over one hundred and fifty of these clay maquettes, most of which have been cast in terra cotta and bronze. They have been published and exhibited widely and represent in themselves a history in miniature of the artist's developing and changing ideas during the last fifty years.

*Personal Themes*

The search for a new and increasingly human subject during the 1920s, which has continued throughout the rest of the artist's life, manifested itself in specific characterization of seated or reclining figures. During the early 1920s he returned to portraiture, which he had largely abandoned during the cubist phase, and produced some of the most powerful and incisive portraits of his career, such as *Ger-trude Stein* and *Jean Cocteau* (figs. 45, 44).

The idea of the embrace, frequently an actual embrace of erotic love, recurred constantly in maquettes of the 1920s and early 1930s to achieve a finished, large-scale presentation in *The Couple* of 1928–1929 (fig. 82), in which the theme of sexual intercourse is so explicit, despite the abstracted volumes of the figures, that the artist was forced to change the title temporarily to *The Cry* in order to disguise his intent. It was natural that Lipchitz, a young man of strong emotions,

during the 1920s and 1930s living in a bohemian society, should have frequently explored the theme of sensual love in subjects of the embrace; but what is fascinating is the manner in which the loving embrace at times becomes a theme of conflict. Thus, a maquette for *The Strangulation* dated 1933 (fig. 116) actually involves forms closely related to versions of the embrace, as does the 1931–1932 struggle of *Jacob and the Angel* (figs. 104, 105). As the artist himself emphasizes frequently, these years were years of suffering as well as of intense and passionate work; and all these conflicting experiences and emotions were present in the subjects he was exploring. For him, sex and procreation were and have continued to be symbols of hope for the future of mankind. In the mid-1940s, now settled in the United States, Lipchitz returned to the embrace in *Song of Songs* (1945–1948, fig. 152) taken from the Old Testament songs of Solomon, in which the undulating couple is transformed into a joyful, musical hymn of lyrical and passionate love. The artist is now (1971) engaged on still another, still unfinished, version of the embrace, this time in a rich, red stone, entitled *The Last Embrace*.

A theme which has haunted Lipchitz throughout his career and continues to do so is that of the mother and child, with its obvious connections with his own mother and father and with his obsessions for humanity, procreation, birth, life, and death. Among his first independent subject sculptures are the 1912 *Pregnant Woman* (fig. 6), the 1913 *Mother and Child* (fig 15) with its suggestions of primitive sources, and the complicated, frontalized *Mother and Children* of 1914–1915 (fig. 10) in which the gesture of the mother seated on a chair holding a child in her arms above her head is to recur again and again. This is a work that in its Byzantine frontality might be rooted in a Russian-Christian icon of Madonna and Child. The mother-and-child subject began to recur again in maquettes of the late 1920s and then in a monumental form in the 1930 *Return of the Prodigal Son* in which the prodigal arches over the mother and kisses her with the passionate thirst of the traveler returned to the wells of his homeland (fig. 102). It is significant that Lipchitz in this sculpture should have replaced the father with the mother image. Another large *Mother and Child*, 1930 (fig. 93), treated in a similar system of rectangular masses, shows the child on his mother's shoulders tearing at her breasts in a brutal fashion. This reflected a moment of despair in which the artist seemed to be asking himself why he was placed on

this earth to suffer. Although the forms and techniques are entirely different, the child placed on his mother's shoulders continues the formula first seen in the 1914 *Mother and Children* and recurring in the *Mother and Child* of the early 1940s (figs. 134, 135). In this latter version, one of Lipchitz's most tragic sculptures, the child on the mother's shoulders clings to her neck while the mother raises her mutilated, handless arms in agonized supplication. There were many beautiful pen and gouache drawings for this version, some dating as early as 1939 and continuing for years thereafter. As the artist himself describes it, the 1941 *Mother and Child* emerged from a confusion of emotions stemming from the spread of Nazism with its persecution of the Jews—fears for his own mother and family in Russia, for himself, and for the possible destruction of his life work in sculpture. It is a prayer for help and survival at the moment when he and thousands of others were forced to flee from France, leaving their lives and their life works behind them. This *Mother and Child* is thus also related to a series of sculptures on the theme of *Flight* (fig. 130) and *Arrival* (fig. 131) and *Return of the Child* (fig. 132). The latter two commemorate his safe arrival in the United States; the mother joyously holds the child high in her arms above her head. In the *Return of the Child* she employs the same gesture but is passionately kissing the rescued child. A small, rough first maquette for *Rescue of the Child* dates as early as 1933, again with the mother holding the child in her arms high above her head in a gesture once more similar to the 1914 *Mother and Children* and to the 1941 triumphal *Arrival*. There is as well a 1929 maquette of *Mother and Child* (fig. 92) only four inches high in which the mother is kissing the child in a gesture comparable to that of the 1930–1931 *Return of the Prodigal Son*. The strange curvilinear *Benediction I* of 1942 (fig. 141) may be considered as still another variant on the mother-and-child or fertility theme, and more orthodox versions are involved in the 1949 *Mother and Child* (fig. 165) and the versions of Hagar, 1948 (fig. 166), and 1970–1971 (fig. 201).

Thus, we may observe how this theme has continued to haunt the artist from 1912 to the present time, how it is interlocked with the joy and suffering of his entire life, his love of his own mother, his fears of destruction and persecution, the agonies of his flight from France during the First World War, and the joys of his triumphal arrival in the promised land of the United States. One may even project the

mother-and-child motif to his many versions of the Madonna, beginning in the mid-1940s and reaching a first climax in *Notre Dame de Liesse* at Assy, France, in 1953 (fig. 156). Out of this great Madonna and Child emerged the 1958 variants *Between Heaven and Earth* (figs. 179, 180) and the 1967–1969 monument for Los Angeles entitled *Peace on Earth* (fig. 182), in which the Madonna theme continues to recur.

Another theme that haunted him during the 1930s on which he made innumerable variants is that of a woman's head and hands. The first of this series he entitled *Chimène* (fig. 96), and he returned to the subject again and again in open work, transparent constructions, and massive structures of melancholy and repose. All of these, as he tells us, had specific associations with someone to whom he was deeply attached, an attachment he could express only through these sculptural images; but the theme in all its variants is reiterated so constantly that there is no question of the depth of the emotion that inspired it.

Another personal association that developed gradually into a monumental theme is that of the harp and the harpists. Beginning modestly with a 1928 transparent sculpture (fig. 85) suggested at a concert in the Salle Pleyel in Paris where Lipchitz, an avid music lover, became intrigued with the curious, almost loving embrace of the women harpists and their instruments, he repeated the subject in more massive form in *The Harpists* (fig. 97) and then transformed it into a seven-foot monument entitled *Song of the Vowels* (figs. 106, 107). *Song of the Vowels*, whose title was taken from a recently discovered Egyptian manuscript, derives from the classic myth of Orpheus, a subject that he has explored in later sketches.

The continual search for subject and content led the artist into many strange bypaths of which a series of the early 1940s might be grouped together under the general theme of blossoming. These are highly sensuous female figures (*Yara I*, fig. 144), figures filled with erotic Oriental imagery in which flowers, plant forms, and ocean shells merge with the ecstatic sensuality of the female form.

The portraits of the 1930s, 1940s, and 1950s, such as the sketches for Géricault (fig. 115), the aging Gertrude Stein (fig. 127), Marsden Hartley sleeping (fig. 139), and Mrs. John Cowles (fig. 177) continue in directions ever more free and expressive, with the whole appearance and personality of the sitter caught up in a single gesture.

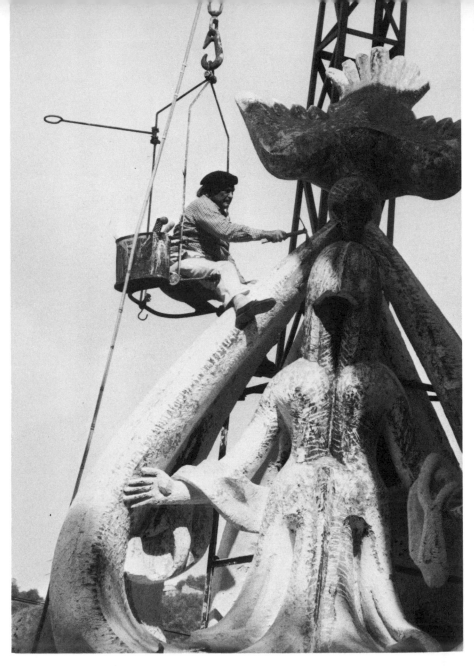

Lipchitz at work on a plaster for *Peace on Earth,* commissioned for the Music
Center, Los Angeles, California.
Photographed in Italy, September 1967. (*Frank Lloyd*)

## Old and New Testaments

It was to be expected that Lipchitz, a Jew, continually searching for an appropriate and sympathetic subject, should have been early drawn to the infinite reservoir of the Old Testament. His first approaches to Old Testament themes were nevertheless tentative and even belated. A maquette of 1925, later entitled *First Idea for Sacrifice* (fig. 68) shows the sacrificial cock held high above the head of the one about to perform the ceremony. He did not return to this sacrificial theme until many years later, in 1942, when he made bronze sculptures entitled *The Pilgrim* and *The Prayer*, among the most violently and emotionally expressive of his career (figs. 145, 147). The sacrifice recurs in a more explicit form in *Sacrifice I, II,* and *III,* dating between 1948 and 1949, strange and almost brutal interpretations in which, doing violence to the ritual, the sacrificial cock is stabbed rather than having its neck wrung.

Other Old Testament subjects made tentative and sometimes monumental appearances during the 1930s and 1940s. These included the 1930 maquette for *Return of the Prodigal Son* and the finished sculpture (1931), and the 1931 maquette for Jacob wrestling with the angel together with the sculpture of 1932. There were a number of maquettes and sketches for an unrealized monumental sculpture of David and Goliath in which there is the double imagery of David as a symbol of free Europe strangling the Goliath of impending Nazism (fig. 120). Perhaps the earliest Old Testament theme was a 1921 cubist sketch, abstract in treatment, to which the artist gave the title of *Repentant Magdalene* (fig. 50). The first improvisations of 1952, based on a chisel, took the form of Jewish figures, and the last of this series, a thanksgiving, was also a kind of Menorah with tablets of the law (fig. 172). In 1948 the artist returned to the subject of the Menorah in a series of designs dedicated to Israel (*Miracle II*, fig. 161). The Old Testament themes recur in other contexts such as a *Study for Biblical Scene*, 1949 (fig. 167), the versions of *Hagar* that have been referred to in the context of the mother and child, and most recently the in-process designs for a gigantic monument on Mount Scopus in Israel, *Our Tree of Life*.

Curiously enough, the most famous of Lipchitz's Biblical themes is

The *Virgin* and a Romanesque Madonna. (*William Vandivert*)

still perhaps the Virgin designed for the Church at Assy, France, in 1953. He has told the beautiful story of how, despite the fact that he is a Jew, he was approached by Father Couturier to design this modern interpretation of the Madonna and how its many variants obsessed him for years to come. In its finished form it is certainly one of the great examples of Christian iconography created during this or any other century. The achievement of this Christian theme has in recent years led him back to the idea of a comparable Old Testament monument extolling the traditions and achievement of his own people. It is this on which he is now working in *Our Tree of Life* for Mount Scopus.

## The Classical Theme

Aside from the Old and New Testament, the other bottomless reservoir for Lipchitz seeking subjects in terms of which he could feed his obsession for continual reference to humanity has been classical antiquity. The ancient worlds of Greece and Rome, both their history and the myths of their gods, have served painters and sculptors as an endless subject repository from classical antiquity to the present time. Even during the Christian Middle Ages the classic subject never entirely died and with the Renaissance, the Baroque, the eighteenth, nineteenth, and twentieth centuries down to our own time, artists have continually sought to find new interpretations for the stories of the ancient world.

Among Lipchitz's maquettes we find as early as 1929 a passionate sketch of *Leda and the Swan* (fig. 88) closely related to the erotic theme of the embrace that was to haunt him for the next several years. One of the classic stories that had a particular significance to the artist and on which he was to project some of his most monumental interpretations during the 1930s and 1940s was that of Prometheus. Prometheus, the Titan who brought fire to mankind and was punished by the gods for his presumption by being chained to a rock with a vulture tearing eternally at his liver, became to Lipchitz a symbol of the victory of light over darkness, of education over ignorance, of man's triumphant struggle for liberation in the face of terrible dangers and punishments. The first version of the Prometheus idea was a 1931 maquette showing simply the reclining figure of Prometheus screaming in agony (fig. 113). This does not include the

figure of the vulture. During the 1930s Lipchitz made a number of
other tentative clay sketches of different scales (some were cast in
bronze) and drawings showing variations on the theme, including a
1933 clay maquette with the standing Prometheus struggling with the
vulture and a 1936 maquette in which the reclining figure of Prome-
theus with the right arm raised above his head is in process of stran-
gling the vulture (fig. 123; see also fig. 150). From being a victim the
Titan here is transformed into a triumphant victor. A commission for
the 1937 World's Fair in Paris enabled the sculptor to develop his
ideas on a huge scale in a gigantic *Prometheus Strangling the Vulture*
placed eighty feet above the ground over an entrance portal to the
Grand Palais. This project was his most monumental commission to
date, although since it was designed for a temporary exhibition it was
only realized in plaster and destroyed at the end of the fair (fig. 126).
Nevertheless, it inspired him to carry on the Prometheus theme over
the next several years and to make it permanent in bronze on a
monumental scale. As he has recounted, he was given the commission
of a major sculpture for the new Ministry of Education and Health
Building in Rio de Janeiro designed by Corbusier and Niemeyer, a
marvelous opportunity for architectural sculpture for which he pre-
sented a model for a gigantic Prometheus strangling the vulture:
Prometheus, the symbol of light, victorious over the powers of dark-
ness. He sent a seven-foot model to Brazil which, through some tragic
misunderstanding, was not enlarged to twenty feet as intended and
was placed on the façade in the scale of the model, thus proving
completely inadequate to the sculptor's project (fig. 148, showing
model in appropriate scale). Finally, between 1944 and 1953 the
artist was able to make two magnificent casts of *Prometheus Stran-
gling the Vulture*, free-standing, eight and a half feet high, now in the
Philadelphia Museum and at the Walker Art Center, Minneapolis (fig.
151).

Another classical subject to which Lipchitz has returned again and
again is that of Pegasus, the flying horse of the gods who gave birth to
the Muses when he struck his hooves on a rock on Mount Olympus
(first designed as a transparent in 1929). This he realized as the relief
design for the *Birth of the Muses* installed in a Rockefeller guest
house, New York, in 1950, and he is now completing his most monu-
mental interpretation of Pegasus in the gigantic sculpture of *Bellero-
phon Taming Pegasus* for the Columbia University Law School (figs.

196, 197). Bellerophon here symbolizes the victory of man's reason over the wild forces of nature.

Other classical themes of the 1930s and 1940s included two versions of the *Rape of Europa*, the first of which shows Zeus in the guise of the bull swimming off to Crete, embracing the nymph Europa (fig. 128) and the second of which, entirely different from this erotic myth, has Europa symbolizing Europe killing the bull, here a symbol of fascism (figs. 136, 137). Related to them in form and concept is a bronze of Theseus stabbing the Minotaur in which there is a curious assimilation of the figures. This is a savage work interpreted almost as though Theseus, in the process of destroying the Minotaur, is destroying himself (fig. 143). A subject that is not specifically classical but which in its violence, terror, and free execution anticipates the later version of Europa, and the Theseus, is the struggle of *Bull and Condor*, of which the artist made a sketch as early as 1932 (fig. 114).

## *Improvisations*

During all of his career, while Lipchitz has worked on ideas derived from the Old and New Testaments, classical antiquity, and his personal associations, he has continued to refresh himself with a wide variety of sketches and free constructions to which the general name of improvisations might be given. We have seen how he has continually begun explorations with little clay maquettes, freely rendered and growing under his hands frequently as the first ideas to be later developed into major sculptures. These maquettes he has continued to make to the present day, and their very freedom and ingenuity of concept are carried into the final sculptures, no matter how large-scale these become. During the mid-1920s the artist experimented with a revolutionary series of linear sketches, almost drawings in bronze, to which he gave the name of "transparents." These were some of the first completely open constructions in the history of modern sculpture, pieces in which solids and voids were reversed—open space defined the forms outlined in linear bronze drawing. The transparents were a beautiful revelation to the artist, a new concept of sculpture that helped to clarify his subsequent ideas on its very nature (see fig. 78).

The next series of improvisations were the *Variations on a Chisel*

(1951–1952), most of which were created after the destruction of his studio and which in their playful experiment served as a temporary relief from the tragedy that had overcome him. The *Variations on a Chisel*, in which the form of the sculptor's chisel was translated into a series of figures, sometime serious, sometimes playful, could be described as experiments in "found objects," or readymades, in which Lipchitz, starting from the commonplace of the sculptor's tool, translates it into a series of fantastic images (figs. 169–171). From time to time he has, as he himself described the experience, continued experimenting with semi-automatics. In the series of the 1950s which he entitled *To the Limit of the Possible*, he incorporated in the bronze actual natural objects such as twigs and even leaves and flowers, fabrics, strings, and bones (figs. 174–75). In these the artist was fascinated not only by the strange naturalistic objects he could create but also by how far he could carry the techniques of bronze casting. It is for this reason he entitled the series *To the Limit of the Possible*, although more recent experiments have extended these limits even further.

During the 1960s, when he began his long sojourn in Italy, his delight at finding the perfect working conditions at the bronze factory of Tommasi in Pietrasanta led him to a group of delightful semi-automatic fantasies to which he gave the collective name *Images of Italy*, although some of them have no specific Italian reference (figs. 185, 188). In these he squeezed and molded and twisted the wax under his fingers, letting the shapes emerge in almost any form they willed. These are frequently semi-automatic evocations of the conscious from the unconscious. Most recently, while he is devoting his major efforts to the completion of great monuments such as the *Bellerophon Taming Pegasus* and the Philadelphia *Government of the People*, he continues to refresh himself with the wax sketches on the theme of Columbine in which all the imagination and experience of the earlier improvisations are incorporated.

H. H. Arnason

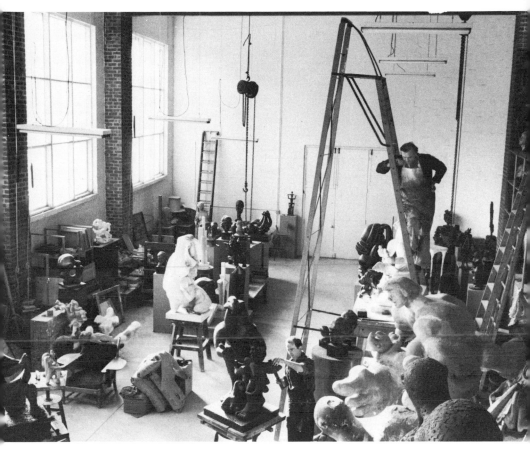

Lipchitz and an assistant in his studio at Hastings-on-Hudson, a few miles
up the Hudson River from New York City. The studio was built after his
Twenty-third Street studio was destroyed by fire on January 5, 1952.
*(George Moffett-Lensgroup)*

# My Life in Sculpture

# Chapter 1

As long as I can remember I have been interested in sculpture, although during my childhood I had no idea what sculpture was. In the town of Druskieniki, Lithuania, where I was born, there were no sculptors. Nevertheless, for some reason which I cannot analyze I modeled continually. The only thing that I knew about sculpture was that it was white. When I started to go to school in a large city nearby, I saw for the first time plaster molds that were white, so I painted my clay sketches white and felt that I had become a sculptor. My father, who was a successful building contractor, had little enthusiasm for my efforts. He wanted me to become an architect or an engineer with an academic degree, probably so that I could join him in his firm. My mother was more sympathetic. Since I want to talk principally about my sculptures, I shall not say too much about my childhood in Druskieniki, then a part of Russia, or my school years at Bialystok and Vilna. During my years at Vilna I must have learned about Paris as the center for the study of art, and I developed a passionate desire to go there. This I was able to do through the assistance of my mother, despite the resistance of my father. After I went to Paris, my father forgave me, and, as long as he was able to, he contributed to my support.

When I arrived in Paris in October 1909 at the age of eighteen, I attended classes briefly at the Ecole des Beaux-Arts, but then transferred to the Académie Julian, which was smaller and more personal, although it had many of the same professors and the curriculum was

not too different. In fact, the method of teaching art, whether painting or sculpture, had probably not changed very much since the eighteenth century. Mornings were spent at the academy drawing or modeling from the model and afternoons visiting the Louvre and other museums. On Saturdays the professor would come to judge and criticize the sculptures after nature and the sketches that had been made during the week. Themes for the exercises were written out in the administrative office of the academy, and included many subjects from the Old and New Testaments or from classical antiquity. The professors principally analyzed the composition. At the Ecole des Beaux-Arts I worked with Jean-Antoine Ingalbert and at the Académie Julian, Raoul Verlet. In the evenings I attended the Académie Calarossi to study drawing.

One thing that I learned in the academy was the process of beginning with a clay sketch. This was a traditional working pattern which sculptors had used at least since the eighteenth century and probably since the Renaissance. I have continued to use this method ever since that time because I believe strongly that it is superior to all others. With the small clay sketch it is possible to fix an idea immediately and to change it rapidly. Most of my drawings and sculpture sketches from this period have disappeared, but I remember making a "Perseus and Andromeda" with Perseus in armor and Andromeda naked. I was fascinated by the contrast between the armor and the naked woman. Another subject that I remember sketching in clay and possibly firing was that of Ruth and Boaz. Again, this has disappeared, but I still hope that at some time I may discover it again. I also made some small heads around 1911, one of which (fig. 1) I have found.

At the academy, aside from drawing or sketching from the living model, we would use the anatomical model, the same one that was designed in the eighteenth century by Jean-Antoine Houdon. There were also classes in stone carving. At the Grand Chaumière, an academy where there was also a model for sketching, you would pay by the hour to work from the model.

Paris between 1900 and 1914 was filled with foreign artists, many of whom I met and to some of whom I became very close. These included such Spaniards as Picasso and Juan Gris, and the Italian Modigliani. Chagall came to Paris from Russia in 1910. Sculptors included Brancusi, Zadkine, and Archipenko. In 1911 I began exhibiting at the Galeries Malesherbes and in 1912 at the Salon National des

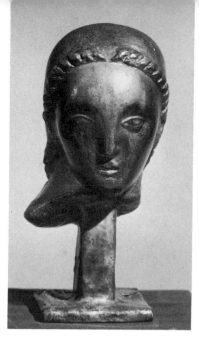

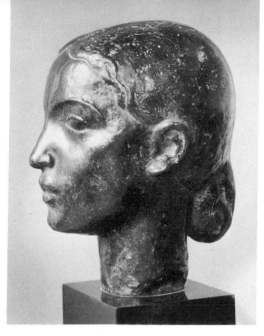

1. *Head of a Woman*, 1912.
Bronze, 5½″ h.

2. *Little Italian*, 1911. Bronze 11″ h.

3. *Woman and Gazelles*, 1912. Bronze, 46½″ l.

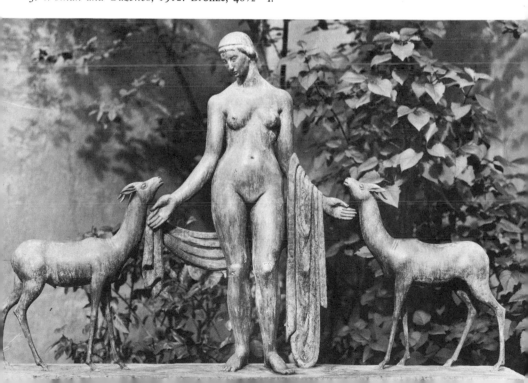

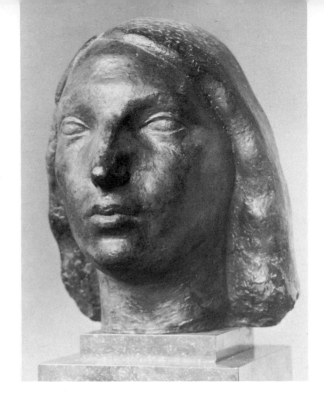

4. *Head of Mademoiselle S.*, 1911. Bronze, 11″ h. Private collection, Paris.

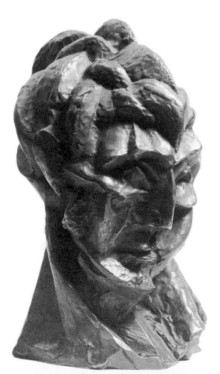

5. Pablo Picasso: *Woman's Head* (Fernande Olivier), 1909. Bronze, 16¼″ h. The Museum of Modern Art, New York.

Beaux-Arts and at the Salon d'Automne. Typical of this early period is the *Woman and Gazelles* (fig. 2), which was exhibited in the 1913 Salon d'Automne and had a considerable success. This I designed originally with one gazelle in 1911 but then decided to balance with another. At that time I was only about twenty years old, so that the success of the piece made a tremendous impression on me. The idea for the composition may have come from statements quoted by my professor, who was a pupil of a pupil of Rude, the great French sculptor who created the *Marseillaise* on the Arc de Triomphe. Rude was always saying that sculpture is "a plate and chestnuts." The professor never gave any explanation, and this seemingly stupid statement bothered me. Finally I understood that what Rude meant was that sculpture involved the contrast of planes and round volumes. This elementary idea was a revelation to me and immediately began to affect my own sculpture.

At the time that I was first exhibiting, around 1911 and 1912, Rodin was still the great figure in French sculpture. I heard that he had praised a portrait that I had exhibited at the Salon National des Beaux-Arts in 1912, but at that time I was not prepared for such praise by an artist who seemed to me to represent the older generation from which I was already attempting to escape. It was only much later that I understood the greatness of Rodin and accepted him as the master of modern sculpture. Some of the pieces I first exhibited were compared to Despiau, an artist with whom I was not familiar at that time. When I saw works by him I could see the similarity, but I felt that this resulted from a common source in Greek and medieval sculpture. Like all the young sculptors, at this period I was making portrait busts in a simplified manner with the blank eyes and the broad generalization of classical sculpture (figs. 3, 4, 1911). These were the characteristics that probably resulted in the association with Despiau, but they were really characteristics of the period.

Among my friends at school I remember an American, John Storrs, from Chicago, a good sculptor and a very nice man, who lived most of his life in France. He is one of the American pioneers of modern art and is only now beginning to be recognized in his own country. Diego Rivera, the Mexican painter, was close to me. At that time he was a cubist, and he even made a cubist portrait of me. It was Rivera who introduced me to Picasso in 1913. He took me to Picasso's studio but Picasso was not there. Rivera showed me a little

painted sculpture by Picasso and said, "And that is sculpture, by Picasso" as though that was the real thing, not what I was doing. When Picasso came back and I met him, and we came to this piece, I asked him rather naïvely whether he considered it painting or sculpture. Picasso somewhat sarcastically asked if I could tell him what is painting and what is sculpture. I answered that I could not, but that I was sure this piece was not sculpture. Picasso said, "Why? Because it is painted? Look at that Negro mask; it is painted too." And I said, "But look how it is painted; just look at the white, round shapes under the eyes; they are shadows and they are white because the sculpture is black." When we left Rivera was very angry. "Imbecile," he said, "what did you do? You made Picasso an enemy." I said that I could not help it, I had to say what I thought. But the next day Picasso came and knocked on my door, and ever since we have been good friends.

In Paris there were many Jewish artists who have since become famous. These include Chagall, Soutine, and Modigliani. Most of them were living in a strange building called "La Ruche," which belonged to a French sculptor, Boucher, a descendant of the famous Boucher. During the first war I introduced Soutine to Modigliani, who immediately recognized what a good painter Soutine was. When Modigliani was dying he told his dealer, Zborowski, a Polish poet, that he was going away but that he was leaving him a man of genius, Soutine. I think that I was responsible in some degree for the recognition of Soutine. I was acquainted with the American collector Dr. Albert Barnes, and one day, in 1922, when I was with him, we saw a Soutine. He became very excited about the painting and wanted to know who the artist was. As a result, I arranged a meeting. Since I happened to be busy that day, I asked Kisling and Pascin to take Barnes to see Soutine. As a result, Barnes not only began to buy Soutine but also Modigliani, whose painting he saw on the same occasion. He bought about twenty Soutines and twenty Modiglianis.

Soutine was a very strange man. Like so many of the painters of this period, he was extremely poor. When someone gave him some francs, he went wild. On this occasion, with the money from Barnes in his hand, he went out and stopped the first taxi and told the driver to take him to Nice. The driver pointed out that it was a long way, but Soutine pulled out the money and showed him, and off they went to Nice, a trip that cost him two thousand francs. Soutine would buy

pieces of meat to paint and let them become rotten because he liked the colors. The result was such a stink that it was unbearable. Soutine, like Modigliani, lived a very dissipated life and died young. Modigliani was an alcoholic and a drug addict, but he was a very beautiful young man, a poet and an aristocrat. I met him first in the Luxembourg Gardens through the poet Max Jacob and he immediately began to recite from the *Divine Comedy* of Dante.

Max Jacob, who was a fine poet, was also a painter who made his living doing charming, realistic gouaches. He was one of Picasso's closest friends and often helped him by selling his drawings or bringing clients to him. Jacob was a Jew but was converted to Catholicism and became an extremely religious Catholic. He even tried to convert me. Somewhere I have a letter from him, a prophetic letter in which he says, "I feel that I have to die; I don't know if I will die as a Jewish martyr or a Christian martyr. But I am afraid to die away from my confessor; but that you cannot understand." In those days there was much communion between poets and painters. Reverdy, one of the leading French poets, was a friend of mine and of Juan Gris. Apollinaire, of course, was not only a great poet but an important propagandist for the new movements in painting and sculpture. I do not think he had much understanding of modern art, but he believed in it and he was most influential in promoting it.

Two of my close friends were the Chilean poet Huidobro, and Juan Larrea, the Spanish poet. Just recently at Pietrasanta, Italy, where I am now working at the foundry, I saw a picture of them in the local newspaper, *La Nazione*. Huidobro is now dead and Larrea is a professor of philosophy at the University of Cordova in Argentina. Juan Gris, whom I met later in 1916, was particularly close to me and we talked continually about every subject under the sun—about art and about literature and philosophy and all the ideas circulating at that time. I am much indebted to Gris, who was a very intelligent man and who enlightened me on many subjects. One of the exciting things about those early days was this continual interaction between writers and artists. We had much to learn from one another.

It was in 1911, after I had been in Paris for about a year and a half, that I learned that my father had lost his money through ill-advised investments. This made me feel that I had to return to Druskieniki to see my parents. Also, I originally had left Russia without a passport. I felt that it was essential for me to return and straighten out

my affairs. In my innocence I thought this would be extremely simple, but it turned out to be much more complicated than I realized. Fortunately, as a result of the fact that I had been very sick in Paris and was still suffering from my illness, I managed largely to escape military duty. Finally, I was able to get a proper passport and return to Paris. The trip home was very sad because of the difficulties of my parents. My mother was keeping a hotel in order to help support the family.

There was one good result of the trip. I had never been to St. Petersburg because Jews were not allowed there, but, through a man who was staying in my mother's hotel and who had an influential brother in Petersburg, I was able to go there. Although the Hermitage was closed, the brother arranged for me to get into it and I went there every day. The marvelous paintings made an enormous effect on me, but I particularly remember a great collection of Scythian art, which was a revelation to me. These almost abstract, interlocked figures seemed to have some relationship to what I was trying to do, and, although this was before I had become a cubist, I think they also helped clarify my ideas.

I returned to Paris with a proper passport in 1912, knowing that this was where I must remain no matter what the difficulties. As my father could no longer contribute to my support, the next few years were extremely difficult. It was not until 1916, when I got a contract with the dealer Léonce Rosenberg, that my situation began to improve. Also, I made a number of portraits on commission. One of the earliest commission portraits—although I had always done portraits on my own—was for a Mme. Joffé. It was a bust of a relative of hers, which is now lost. She paid me three thousand francs, a very good price for a young, unknown artist. At this time I also made a little money retouching reproductions of eighteenth-century terra-cotta sculptures. I became quite good at this, and it taught me something about the traditional technique of terra cotta. I also made a portrait of Mme. Joffé as a gift to thank her for getting me the commission.

All my life, with a few intervals, I have done portraits. I love to do them, and no matter what else I am working on I find them an excellent discipline and even relaxation. I have never believed in the idea of abstract or cubist portraits. Although Picasso's 1909 cubist portrait of his mistress (fig. 5) is an important work historically, as a first essay in cubist sculpture, I do not think it is successful either as

cubism or as a portrait. To me the portrait is rooted in my observation and impression of a specific individual, and, although it is necessary to transform that individual into a work of sculpture, the subject can never be lost sight of. My early portraits of the period before the First World War are simplified and generalized both as a result of my interest in ancient Egyptian and Greek sculpture and because I was working toward a kind of simplification that emphasized and clarified the structure, the masses and planes of the head.

The *Woman and Gazelles* (see fig. 2), which was my first major exhibition piece, had, as I noted, a considerable success, something that was probably not good for me since even at the time this was done I was becoming dissatisfied with the academic tradition in which I had been working and more conscious of the new findings in painting that were all around me. I made some other pieces in this general vein during 1912, of which the most significant to me is probably a figure of a pregnant woman (fig. 6). This, which was done without a model, since I could not afford one, has to do with the mother-and-child theme, something which—perhaps because of my close attachment to my own mother—has always been of greatest importance to me.

It was in 1913, the year that Rivera took me to Picasso's studio, that I began to move seriously into what I would call my proto-cubist phase. Although these initial efforts in the direction of cubism were simplified geometric compositions rather than true cubism, I think it is of interest that I experimented both with an angular geometry, as in the *Encounter (The Meeting)*, 1913 (fig. 7) and a more curvilinear, even baroque, manner, as in the *Woman with Serpent* (fig. 8). The *Woman with Serpent* in particular was an attempt at a complicated organization involving intricate interaction of masses and linear movement. The figure is not actually in motion, but there is a tension of implied motion between the withdrawing but solidly planted forms of the nude and the writhing abstract curvilinear pattern of the snake. In making this group I was also consciously interested in the opening up of the voids; I might almost say that this is my first transparent sculpture. Although it has been compared to some figures, such as the *David*, of Bernini, I do not remember at that time being acquainted with Bernini's works. But I certainly knew the *Laocoön*, which was probably my first inspiration for the subject. These 1913 figures now seem very naïve to me, but they were a necessary phase in my development.

All this time I was continually going to exhibitions both at the salons and in the private galleries and was constantly introduced to new impressions, although we must remember that by far the greatest proportion of works exhibited was still being done in a traditional manner. The experimentalists, the fauves and then the cubists, in terms of whom we now write the history of modern art, were still a very small group.

I think I first saw cubist paintings in the 1911 exhibition of the Indépendants, but I am not sure. It was perhaps in Kahnweiler's gallery. But I remember that I was intrigued by them almost immediately. There were other sculptors at this time who were trying to make cubist works. Archipenko was perhaps the first but his versions of cubism were decorative and not too interesting. I met Henri Laurens in 1916, when I had a contract with the dealer Léonce Rosenberg. Brancusi was a neighbor of mine and I remember hearing a continual tapping from his studio. I discovered that he was a stone carver, then working on *The Kiss*. I have never liked his work. It is always better to work from a clay sketch in which the idea can be caught quickly and immediately, and which acts as a start or a support for more elaborated work.

I was with Picasso a great deal during these years, but we very rarely talked about art. Picasso was not then, and has never been, much of a talker. He would make jokes but not talk seriously, except perhaps with Braque during the years when they were together. Juan Gris, who later became a close friend of mine, loved to theorize about art.

At this period, cubism was so much in the air that everyone was borrowing from everyone else. We all saw one another's works and the results were some kind of collective art.

7. *Encounter (The Meeting)*, 1913.
Lead, 31⅛″ h.

6. *Pregnant Woman*, 1912. Bronze, 24½″ h.

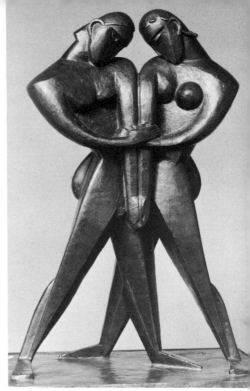

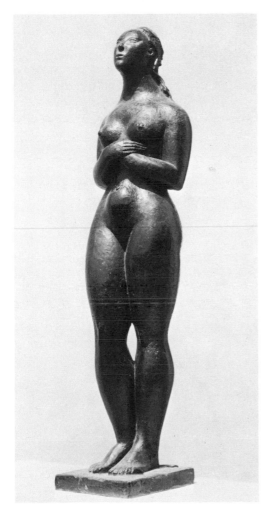

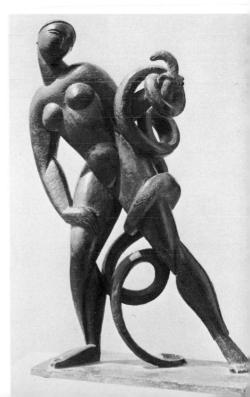

8. *Woman with Serpent*, 1913. Bronze,
25″ h.

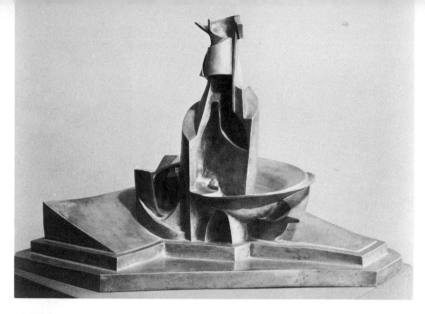

9. Umberto Boccioni: *Development of a Bottle in Space*, 1912. Bronze, 15″ h. The Museum of Modern Art, New York, Aristide Maillol Fund.

10. *Mother and Children,* 1914–1915. Bronze, 28½″ h.

11. *Dancer,* 1913. Bronze, 24″ h. Collection Mrs. Jeannette S. Hush, New York.

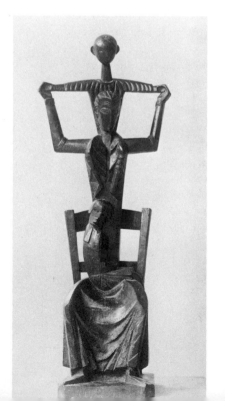

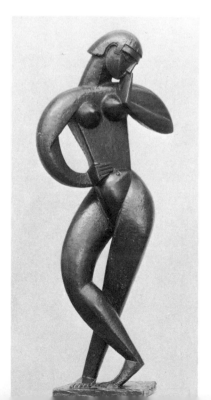

# Chapter 2

Nineteen-twelve was the year of the Italian futurist exhibition in Paris and I visited it several times. Futurism, of course, came out of cubism, although the futurists did not like to admit this. Even so, I think that they largely distorted cubism in their passion for movement and for a kind of nationalistic propaganda having to do with their ideas of progress. I was interested in the sculpture of Boccioni, particularly the *Development of a Bottle in Space* (fig. 9); here, I think, Boccioni did something original. I cared less for the *Unique Forms of Continuity in Space*, the man walking with all that fluttering drapery. Although this is a free-standing sculpture, it is really a relief concept, almost a futurist painting translated into sculpture. I do not think that the futurists' obsession with violent movement was a particularly important end in itself. Nevertheless, it may have added some new ideas to the vocabulary of cubism, just as Mondrian and the Russian abstractionists, also beginning with cubism, carried it in other directions. Although I have never been too sympathetic to the movement toward complete abstraction, I recognize the great influence it has had and I feel that it is always necessary and good that art should keep changing and moving in different directions.

As I said earlier, in my *Woman with Serpent* I was not interested in the idea of motion in itself but rather an interaction of forms. This is a sculpture that is thought out from every side. It is impossible to understand it completely from a single photograph. I was then aware of the sculpture of Archipenko. Duchamp-Villon exhibited his

relief of a couple and his portrait of Baudelaire in the same Salon of 1913 where I showed my *Woman and Gazelles*. I did not see his *Horse* until after the war, when I visited his studio with some other people. Duchamp-Villon was killed in the war. The *Horse* has always struck me as a very strange piece. I could not understand how it could have developed from the works that he was doing earlier; it did not seem to have any relation. As to Archipenko, one has to be careful about the dating of his early cubist pieces. I'd like to see them reproduced in some magazine before the war to be certain that they were actually made then.

Although I worked in all materials, including the carving of marble, during my years at the academy, when I set up my own studio in 1911 I soon began to concentrate primarily on modeling, first in wax, using the lost-wax process. It was through the help of the foundry owner Valsuani that I was first able to cast some of my works in bronze. He agreed to cast a few of my things on credit and I was able to pay him after I had sold them. This meant a great deal to me.

Other pieces that I made during 1913 and 1914 included the *Encounter*, the *Dancer* (fig. 11), *Acrobat on Horseback*, and *Acrobat with Fan*. The circus subjects resulted from the passion that all of us had for the wonderful French circus of this period. I think that the *Acrobat on Horseback* was probably inspired by Seurat, for whom I have always had a great admiration. There is no particular stylistic relationship, but the idea for the subject may have derived from Seurat's circus scenes. A piece from this proto-cubist period that has always been of particular interest to me is the *Mother and Children* (fig. 10), the mother seated frontally on a chair, holding one child on her lap and the other on her shoulders. This was begun in 1914, before I went to Spain, but not finished until 1915. Of the works of this period, it is one I particularly like. It is of interest to me for a number of different reasons, which I understood only years later in retrospect. There is first of all the mother-and-child theme, deriving from my feeling for my own mother—a theme, as I said, to which I have returned again and again. There is also the absolute frontality of the group, very different from the circular movement of the *Woman with Serpent* or the *Dancer*. There may be some reflection of my interest in African art in this frontality, but I think that the idea developed unconsciously from some recollection of a Russian Byzantine icon of the Madonna and Child. I was certainly not aware of this

at the time I made it, but as I looked at it years later, with greater knowledge, this similarity struck me. I was also very much interested in the architectural relationship of the figure with its upstretched arms to the chair on which she is seated. This work undoubtedly anticipates the strong geometric, architectural, vertical-horizontal forms of my first purely cubist sculptures of the following years. The *Dancer* of 1913 (fig. 11) comes after *Woman with Serpent* but before the *Mother and Children*. It is, I think, a step beyond the *Woman with Serpent* in the direction of pure cubism. It still pivots around an axis to emphasize its existence in surrounding space, but the forms are generally more simple, massive, and geometric. I would place it in my development as a transitional work between the *Woman with Serpent* and the *Sailor with Guitar* that I made in Spain.

There is one thing I would like to emphasize in relation to my move from the curvilinear style to a more geometric style and then to cubism. At this time, late in 1913, I had seen little sculpture that could be considered purely cubist. In fact, not very much existed, with the exception, perhaps, of one or two experiments that Picasso made in translating collage into three dimensions. I was really acquainted with cubism only in terms of the paintings of Picasso, Braque, Juan Gris, and others. Thus, I had to work toward cubism in sculpture entirely on my own; and perhaps the greatest revelation that led me in this direction was the importance of light for sculpture. I suddenly discovered that volume in sculpture is created by light and shadow. Volume is light. In a smoothly rounded or curvilinear sculpture the light washes over the surface and may even diminish or destroy the sense of volume, the sense of the third dimension. When the forms of the sculpture are angular, when the surface is broken by deep interpenetrations and contrasts, light can work to bring out the truly sculptural qualities. As I said, this was a tremendous revelation and it has affected my attitude toward sculpture ever since. At various times, I have experimented with smoothly rounded forms, but I always find myself returning to angularity, interpenetration, and contrasts of geometric shapes.

In 1914 Diego Rivera and I took a vacation trip to Spain, together with some other friends. As I have mentioned, Rivera, the Mexican painter, was a close friend of mine, and one to whom I am grateful for introducing me to Picasso and to some of the other cubist paint-

ers. Although Rivera became famous when he returned to Mexico as the leader of Mexican social realism and mural painting, at this moment he was very much involved in all the new expression in Paris.

In Spain we visited Madrid, where I was immensely excited by the revelation of the great paintings in the Prado, particularly those of El Greco and of Goya. I could see at once the relations of El Greco's powerful, expressive, angular paintings to cubism, and I was also deeply impressed by the power of his interpretation of religious subjects. In a different but equally forceful manner I reacted to Goya. These impressions have remained with me for the rest of my life. Even when I was entering upon the period of my cubist sculpture in which I was concentrating most strongly perhaps on formal problems, I realized that for me abstraction could never be a satisfactory way. I must always retain and increasingly emphasize the expressive subject, the element of humanity.

We settled in the countryside in the north of the island of Majorca, where we could live for two and a half francs a day, and there I was able to rest and recover my strength. The landscape was fantastically beautiful, like a Biblical country, and I can still even remember the special smell of flowers, cypresses, and pines. I had not gone intending to work and for a while I principally meditated, observed the rocks and flowers, and drew continually. I could see from the mountains to the ocean, and in this austere and beautiful landscape, filled with contrasts, many of my ideas about cubism were clarified. It was at this time that I made drawings for the *Sailor with Guitar* (fig. 12), inspired by the sailors and fishermen who were around us. It was the trip to Spain and all the impressions that I gathered there which made me take the final step toward cubism. In the *Sailor with Guitar*, a subject which I studied first in drawings of many angles from various aspects, of a young sailor dancing around a pretty girl, I was finally building up the figure from its abstract forms, not merely simplifying and geometrizing a realistic figure. At the same time I would like to emphasize that I never lost sight of the gay young sailor who first suggested the subject. I think that the sculpture still retains much of the human quality that I found in him. I made clay and plaster models of the sailor in Madrid and brought them back with me to Paris. In Spain I also created the *Toreador* (fig. 13), which is more decorative as a result of his elaborate costume, and the *Girl with Braid* (fig. 14), in which the anatomical form is in some ways even

more fragmented cubistically than is the case with the *Sailor*. This was suggested by a daughter of one of the fishermen who always wore her hair in a long braid with a cloth sewn over half of it, perhaps to protect her clothes from the oil she used in her hair. In the *Sailor*, what I wanted to catch was the rhythm of the graceful dancing figure. Thus, the circle of the cap, presented just as he wore it, tilted over one eye, is expanded in the larger circle of the arms which are integrated over the diagonal of the guitar. This diagonal and the curving shape of the guitar body create a flow to the dancing legs of the sailor. Although all the elements of the body derive from different cubist shapes, there remain many reflections of the actual sailor as I saw him, not only his total movement, but such details as the pants leg rolled up over his knee and his cap gaily tilted over his eye.

My friend Landau and I stayed in Majorca longer, after the others had left, and then went to Barcelona to meet Rivera; and all of us went on to Madrid. Landau was a student, not an artist, the son of an industrialist and the only one of us who had any money, so he was able to help finance our trip. In Madrid I met the great bullfighter Joselito, who was later killed, and my *Toreador* was inspired by him, although it is not in any sense a portrait. The bullfights fascinated me, once I began to understand the ritual. I always had a strange sense of the toreador as a woman and the bull as a man whom this toreador charms and fascinates in order to kill.

It was in the Prado, I think, where I went every day, and because I was now more mature than when I visited the Hermitage in St. Petersburg, that I really learned to look at paintings. Aside from El Greco and Goya, I was perhaps most moved by Tintoretto, Rubens, and Velasquez, by the grandeur and movement of the Baroque.

There were many artists, writers, musicians then in Madrid, whom we met at the cafés. Among these was the young guitarist Segovia. Although the trip had been a tremendous experience, I now wanted very much to return to Paris and to work. However, the First World War had started and we were trapped in Madrid for almost three months before I was able to get back.

Another work about whose date I am somewhat uncertain is the *Mother and Child* (fig. 15). This may have been made before I went to Spain in late 1913 or early 1914. It is interesting, despite the fact that I never found it entirely satisfactory, because of the specifically Negro quality of the figures and particularly of the heads. Although I

had been collecting African sculpture (whenever I had any money) ever since I first came to Paris, there are few of my works in which I feel a definite influence from Negro art. The large *Figure* of 1926 to 1930 (see fig. 75) has been compared to an African totem, but this is true only in a most general sense. As I shall demonstrate, the origins of this *Figure* are quite different. In this context, I have never believed that African primitive art had much real influence in the development of cubism. Certainly Picasso, Braque, and others, including myself, saw and were intrigued by examples of primitive art in the Ethnological Museum; and Picasso and Braque, particularly in their proto-cubist paintings, used some details from primitive art, as in the mask-like heads in the *Demoiselles d'Avignon*. But the greatest source for cubism was unquestionably in the late works of Cézanne; you can see immediately the relationship between these works and the first pre-cubist paintings of Braque and Picasso.

Back in Paris early in 1915 I entered upon a very exciting period in my work. It was a sad time because of the war. A lot of artists, such as Braque, were fighting, and everybody had somebody in the war. As a Russian national I did not have to go, and, although I had some guilt feelings, I was happy to be able to continue with my sculpture. In some ways, at least financially, things were easier for the artists. There was a moratorium on rents and those of us who had been accepted in the Salon received meal tickets. Despite the war, there was an active social life in Paris among the artists and writers.

I remember in 1915 when I was deeply involved in cubist sculpture but was still in many ways not certain of what I was doing, I had a visit from the writer Jules Romains, and he asked me what I was trying to do. I answered, "I would like to make an art as pure as a crystal." And he answered in a slightly mocking way, "What do you know about crystals?" At first I was upset by this remark and his attitude, but then, as I began to think about it, I realized that I knew nothing about crystals except that they were a form of inorganic life and that this was not what I wanted to make. In my cubist sculpture I always wanted to retain the sense of *organic* life, of humanity. It was as a result of this encounter that I made the *Head*, about 1915 (see fig. 25), which was my most nonrealistic work to that time but was still strongly rooted in nature. I should say it is a sculpture parallel to nature maintaining its sense of humanity within the abstract forms. From this point I was able to create cubist sculpture with a confidence

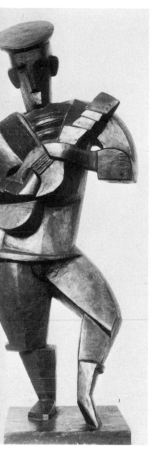

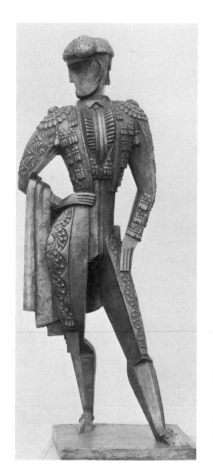

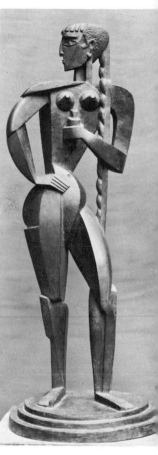

12. *Sailor with Guitar*, 1914.
Bronze, 30″ h. Collection
Mr. and Mrs. H. Singer,
New York.

13. *Toreador*, 1914. Bronze,
32″ h. Collection Mr. and
Mrs. Herman Elkon, New
York.

14. *Girl with Braid*, 1914.
Bronze, 33″ h.

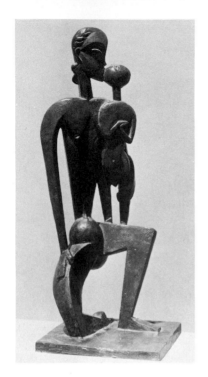

15. *Mother and Child*, 1913. Bronze, 28¾" h.

17. *Bather*, 1915. Bronze, 38½" h.

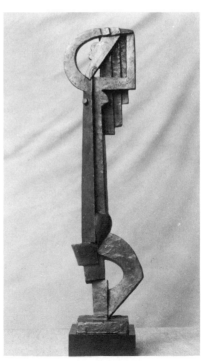

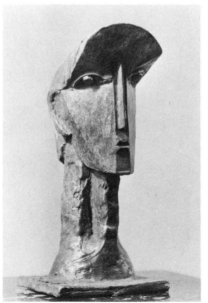

16. *Head*, 1914. Bronze, 9" h.

and understanding of what I was doing. I think that Romains wanted only to warn me as a young artist that my thinking was too simple, and his warning worked.

I think it was about this time that I met Gertrude Stein and went frequently to her receptions, where I liked not only the beautiful paintings on the walls but also the excellent food. I became quite good friends with her and found her a most interesting woman. She had absolutely no inhibitions; for instance, she said to me, "Jacques, of course you don't know too much about English literature, but besides Shakespeare and me, who do you think there is?" Although she had a great collection, unfortunately I could not interest her in sculpture. Her two brothers, Leo and Michael, were also important collectors, although Leo sold off most of his best paintings. Michael was the solid businessman in the family, the one who managed the money. He had a fine collection, largely of early Matisse paintings. Gertrude's friend Alice B. Toklas was a strange little woman. When I first saw her, I thought she looked Indian, though perhaps she was Jewish. In any event, she was an extremely good cook and managed the household for Gertrude as though she were the lady of the house. I met many interesting people at Gertrude's salon, including the novelist Sherwood Anderson, the art critic Henry McBride, and also the young Ernest Hemingway.

After the war, in 1920, I made her portrait, hoping she would buy it, but she never did. In this, I was particularly impressed by her resemblance to a fat, smooth, imperturbable Buddha, and it was this effect that I tried to get. She mentions in her autobiography that she liked to sit for me because she knew the beginnings and ends of many stories and I knew the middles. She also wrote one of her "portraits" about me and someone translated it for me, but I did not understand a word of it.

When I first came back to Paris at the beginning of 1915, I was busy for a while finishing some things like the *Toreador*, the *Sailor with Guitar*, and the earlier *Mother and Children*. During 1915 and 1916 I was working so energetically and prolifically that it is sometimes difficult for me to date the exact order of the sculpture.

Here I would like to say something further about my habit of working from small sculpture sketches. Sketches of this type, known as maquettes or in Italian as *bozzetti*, are as old as the history of sculpture, and in the traditional training of the academy I learned to

work in this manner. As I have said, I believe it is the best way for a sculptor to work, even better than making preliminary drawings, because he can fix his idea quickly in the clay and then change it easily. In effect, the idea grows under his fingers in three dimensions as the final sculpture will appear. I made many such clay sketches when I was a student, but almost all of these have disappeared or were destroyed, since I had no means of fixing them in a durable material. In fact, in those days, I thought of them only as preliminary ideas and did not realize their importance to me. More of these maquettes were broken up in 1915, when during an emotional crisis I destroyed many early works. Then, many others disappeared from my Paris studio after I left France or were destroyed in the terrible fire in my New York studio in 1952. However, I still have more than one hundred and fifty of these preliminary sketches, which I have made permanent in terra cotta and bronze, and I would like to refer to them from time to time as I am discussing the development of my sculpture.

The earliest bronze sketch that I still have is the head of a woman dated 1912, only 5½" high (see fig. 1), a work that indicates some of the simplification of my early portraits and of my proto-cubist manner. More important to me is a bronze head dated 1914, which is already a developed cubist work, quite massive and frontalized in the manner of the cubist sculptures of 1915–1916 (fig. 16). This is actually a head of a girl and the projecting part at the top is her forehead, although in the photograph it looks like a miner's cap.

In the surviving maquettes it is possible to see the first ideas for many of my completed sculptures, very quickly and roughly sketched out. There are also sketches of ideas that I made and then did not develop until years later, sometimes in a radically different form.

To return to the works of 1915 and 1916, one of the first new sculptures designed after I had completed a number of pieces begun earlier is the *Bather*, 1915 (fig. 17). Here, I would say that the transition to developed cubism is complete. My ideas were clarified; I knew exactly what I wanted to do. As can be seen, this is an elongated figure with the tilted head enclosed by the upraised arms; folds of abstracted drapery fall down behind the head. The most significant change between the 1915 and 1916 sculptures and the proto-cubist works is that the former are no longer composed around a pivoting axis. Works like the *Sailor with Guitar* (see fig. 12) or the *Dancer*

(see fig. 11) revolve and create their sense of three-dimensional space by the pivoting of the figure around its axis. This is actually the manner in which later Greek sculptors and sculptors of the High Renaissance tended to create a sense of existence in space. In the 1915 *Bather* the figure is composed in a severe vertical angularity modified by the curve of the arm and the leg. This sense of geometric structure derived from a number of different things about which I was thinking at this time. There was first, of course, the example of cubist painting, particularly the earlier analytic cubist painting of Picasso and Braque in which the emphasis was largely on figures or still-life objects broken down and faceted in a similarly severe and geometric manner. I think in the development of my first purely cubist sculptures I was more influenced by the earlier, soberer examples of analytic cubism than by the decorative or rococo cubism to which Picasso and Braque turned after 1914. Their earlier works seemed to me to have more possibilities for development in sculpture but, as a sculptor, with few immediate sculptural prototypes at hand, I was also very conscious of the examples of Egyptian and archaic Greek sculpture. In my desire to move away from the classical and Renaissance tradition in which I had been trained, it was natural that I should look to these more ancient cultures, which also had a particular relevance to the findings of the early years of the twentieth century. Egyptian and other pre-Greek or archaic sculpture had many points of relationship in its accent on simplicity and directness. The Egyptians and archaic Greeks also used the multiple points of view that the cubists had adopted. In an Egyptian relief the head, arms, and legs are normally shown in profile, with the eyes and torso frontalized. This approach was not essentially different from the multiple and simultaneous views that the cubist painters were seeking. These first cubist sculptures of mine, like the 1915 *Bather* and the somewhat similar *Detachable Figure (Dancer)* of 1915 (fig. 18), also tended to be flat and frontalized in the manner of Egyptian figures.

As I look at these first, more abstract, cubist works, I can see also how directly they evolve from certain 1914 sculptures such as the *Mother and Children* (see fig. 10) and the *Girl with Braid* (see fig. 14). In the *Girl with Braid* I even turned the head in profile and depicted the eyes in full face in the Egyptian manner. Thus, it is possible to see the many different roots of my cubism. In 1915 I was

still only twenty-four years old, but I had been studying continually since I came to Paris in 1909 and I now felt that I knew exactly what I wanted to do.

The 1915 *Bather* (fig. 17) and *Dancer* (fig. 18) are among my first attempts at constructed sculpture, an idea then extremely new and very important for the subsequent history of sculpture. They are in some degree like machinery, since I was then interested in the relationship of machine forms to cubist sculpture. When I talk about the different influences that might have gone into the making of these pieces, I must emphasize that I was not deliberately thinking about them at the time. They were part of my general experience, but when I was actually working I used these different experiences intuitively and only later, looking at them after an interval, did I realize the many different things that must have been in my subconscious. Some critics have referred to these early cubist works as my cathedral period, and I think it is true that they have a sort of Gothic architectural feeling. I know that I frequently thought of the relationship of cubist sculpture to architecture, remembering my father's insistence that architecture was really the mother of the arts. There is a great deal of truth in this idea, but I also think that the character of Gothic cathedrals is largely created by the masses of sculpture that are integrated into them. The *Detachable Figure* reminds me of certain ancient mechanical devices I have collected, such as a part of a Chinese crossbow from the Han period. This crossbow with its green patina now looks like a piece of sculpture.

Some of the demountable sculptures were originally made of different materials, wood and metal and even glass, but as these did not survive too well I have had them cast in bronze. In certain pieces I carried my findings all the way to abstraction, but most of these abstract works I have destroyed since I felt that when I had lost the sense of the subject, of its humanity, I had gone too far. I am now sorry that I destroyed these works, since I believe it is important for an artist to keep everything, even those works which he regards as failures. This was the period when I had a kind of emotional crisis, about the summer of 1915. I felt for a time as though I had lost my way and tried to resolve the problem by going completely in the opposite direction, making very realistic portraits of friends of mine. This was like going to school again, and most of these portraits I also destroyed. However, they did help me to find my path once more.

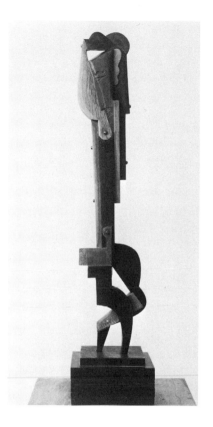

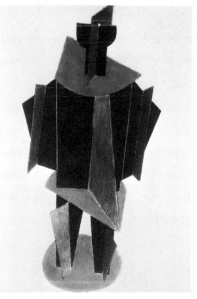

18. *Detachable Figure (Dancer)*, 1915. Ebony and oak, 39¼″ h. Collection Mrs. Leo Simon, New York.

19. *Detachable Figure (Pierrot)*, 1915. Bronze, 27¼″ h. Collection Mr. and Mrs. Robert Bollt, New York.

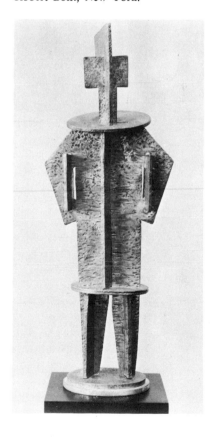

20. *Pierrot*, 1916. Drawing with color crayon, 22″ by 14¾″. Collection Mr. and Mrs. Burton Tremaine, Meriden, Conn.

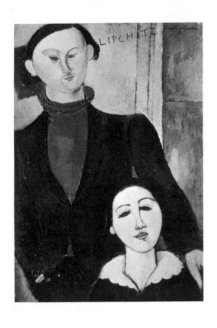

21. Amedeo Modigliani: *Portrait of Jacques Lipchitz and His Wife*, 1916. Oil on canvas, 31½″ by 21″. Art Institute of Chicago, Helen Birch Bartlett Memorial Collection.

22. Modigliani: *Jacques Lipchitz*, 1916. Drawing, 12½″ by 9″. Collection Jacques Lipchitz, Hastings-on-Hudson, N.Y.

23. Modigliani: *Berthe Lipchitz*, 1916. Drawing, 12½″ by 9″. Collection Jacques Lipchitz, Hastings-on-Hudson, N.Y.

# Chapter 3

After this moment of uncertainty, I made another demountable structure, a figure in wood that also was later worked out in bronze. Once I had made this, I felt that again I had found my path and I was able to move forward with certainty and with joy. The figure is a *Pierrot* (fig. 19), even more rigidly vertical and horizontal than the previous ones but now organized, despite its frontality, with a greater sense of three-dimensional depth. The head and body of the figure consist of flat planes placed at right angles to one another in a cruciform shape, tied together by the two horizontal, circular planes. The important new step in this work is the way in which the volume of the figure is created by the voids between the planes. This is once more a new idea in sculpture, and one that was taken up later by many of the so-called constructivists. I made a colored drawing of a *Pierrot* (fig. 20) about the same time that is closely related to this sculpture, but if the two are compared, the difference between cubist painting and cubist sculpture becomes clear. In the drawing, which is, of course, organized on a flat surface, the planes are tilted at angles to the surface to create a limited sense of depth from the plane of the picture that reinforces that plane. In the free-standing sculpture it was necessary to emphasize the three-dimensional quality; and for this reason I organized the planes at right angles to one another. This is a kind of bone structure that exists firmly in space like a skeleton.

It was about this time that I met my first wife, who was Russian and a poet. I made a portrait of her (see fig. 46) in 1922. I fell in love

with her and we lived together for a while and then were married. We stayed together for some thirty years. I have not seen her since 1946, although she is still alive, now more than eighty years old, and she still writes to me most affectionately.

Speaking of my first wife, Berthe, I am reminded of the time, in 1916, that Modigliani made drawings of me and a painting of both of us. I had managed to get five hundred francs by selling some of my drawings to a dealer. I knew that Modigliani was very short of money but also that he would not accept money as a gift. So one day I asked him to make a wedding portrait to send to my parents. Modigliani agreed, stipulating a fee of ten francs a sitting (not very much) plus a supply of alcohol. He came the next day and made perhaps twenty preparatory drawings very quickly, beginning with the eyes and then continuing without any hesitation. I had a photograph made by a well-known photographer which I intended to send to my parents, so he used the pose of this. The next day he came with an old canvas—which he liked because it already had some preparation on it—and began to paint at one o'clock. From time to time he would take a drink and stand back and look at it; then, around five o'clock, he said that it was ready. I did not actually care too much about the painted portrait, but I did want to be able to give him some more money, so I asked him to work some more on it, explaining to him, "We sculptors like a little more mud, a little more material." Modigliani said that if I wanted him to spoil the painting, he would do that, but, in any event, I was able to keep him working on it for two weeks. It is now in the Art Institute of Chicago (figs. 21, 22, 23).

Although I liked the drawings, I did not care too much for the portrait and kept it in a closet. At some point, in 1920, just after Modigliani had died, I wanted to buy back some sculptures from my dealer and since I did not have the money I exchanged the portrait for two stones. My dealer, Rosenberg, sold it almost at once to an American lady who gave it to the Art Institute, where it remains and where it is generally very much admired.

Many artists at this period, when none of them had much money, tried to help others who were in real need. Picasso, the most successful of them, helped artists a great deal by giving them drawings or paintings which they could sell. With Modigliani you could never give him anything directly, since he was too proud and would not have tolerated it; so I would invite him to have lunch with me at some

restaurant where I had a credit and this he would accept. He would also go to a café, make a drawing of someone, and take a drink as payment, but that he did not mind because it was business. He was a wonderful man, although he was pathetic. In 1917 he married Jeanne Hébuterne and after this, during the final three years, his life became perhaps somewhat more settled. His paintings also began to sell a little more, although the prices he received for them were nothing. About 1917 Zborowski organized an exhibition of the paintings at the Berthe Weill Gallery, which had large windows, on the rue Lafitte. Zborowski asked Modigliani to make some nudes for the windows in order to attract people, since the public did not then know anything about the artist. On the first day of the exhibition the police came and insisted that the nudes be taken out of the window. Zborowski was desperate that he didn't have these nudes as an advertisement and asked me to buy the four paintings for five hundred francs. I could not do this because to have those four Modigliani nudes in my small studio would have driven me crazy. However, I was able to give him the addresses of some collectors I knew who bought them.

Although I have always collected a few paintings along with sculptures and artifacts, I would buy primarily old masters or works by unknowns that had some significance for me in terms of my own work. Mainly I bought sculpture of all cultures from which I could learn something. I did acquire one very early Picasso and some others by my colleagues, but I was more interested in getting works by such artists as Géricault.

To return to my own sculpture and the period about 1915, I have always made drawings related to my sculptures both before and after the sculpture. These could be sketches preliminary to the clay maquette or drawings after the sculpture. In the latter case, they did help to clarify my ideas about sculptural themes on which I was working and to suggest possible variations. Nevertheless, all my drawings are related to my sculpture. I never make drawings as independent works of art. Compared to the cubist painters, my cubist drawings always tend to be more constructed and less pictorial, extending into space in the manner of a sculptor or an architect. When I drew I was thinking about pronounced planes and I used color to indicate the positions of the planes in space, with the white closest, the gray in the middle distance, and the black farthest back as though it were in shadow. The drawing to me was a kind of blueprint, a sculptural

indication or reminiscence. I am not interested in making beautiful or finished drawings but rather in making something from which I can build in stone or clay, or, as I said, in which I restudy a finished sculpture and develop my ideas in relation to it. I have always drawn a great deal, developing ideas for sculpture. I characteristically make many sketches, put them up on the wall, and keep studying them. In later years many of my drawings and gouaches have become more finished and collectors have acquired them as separate works of art. But I still find that if I push a drawing too far, make it too finished, I cannot make a sculpture from it because everything is solved and I do not need to make the sculpture. Although in later years I have sold drawings after the sculpture was made, for a long time I simply burned them after they had served their purpose. The earliest drawings that have survived were principally those taken by my dealer, who bought them at a price of one hundred francs for three. I did not begin to think much of the value of drawings until some time after 1925 when I wanted to have some of my master drawings matted to keep in portfolios, and I asked a framer how much it would cost. They were scattered all over the floor. The framer said that he would make all the mats in exchange for a few of my drawings. I admit that I was astonished, but when he insisted, "Mr. Lipchitz, these are master drawings," I was flattered and made the deal. Since that time, I have stopped destroying them. Even after I returned from Spain I continued to attend drawing classes in the evening, working naturalistically after the model. I have always found drawing after nature a good exercise in that it demands a certain rapidity as well as rigor and precision. Even in my most abstract phase, I was always making drawings after nature.

On a typical day in 1915 and 1916 I would work from morning to night, waking at six o'clock in the morning no matter how late I had stayed up. I have never slept long but always well. In the evenings I would work or go to the movies, the theater, or out to a café with some friends. I was always visiting museums and art galleries and, needless to say, dealers in antiquities.

After the demountable pieces of 1915 I began making a series of sculptures that were perhaps my most abstract and architectural in feeling (fig. 24). These I normally entitled simply *Sculpture* as a result of my preliminary emphasis on the sculptural forms rather than on the subject. Some of them have the feeling of architectural sky-

scrapers, even though they were made at a time when the skyscraper was scarcely known. Some are related to an Egyptian obelisk. These abstract cubist sculptures, even though they represented an important new direction in my development, seem, as I look at them now, still a little young (I was still a very young man when I made them). I am convinced that an artist who dies young, no matter how brilliant he is, can never really fulfill himself, because he will not have had the necessary breadth of human experience. Even such a great painter as Raphael in my estimation did not achieve all his potential. This idea is not really opposed to my conviction that a great artist, even if he dies young, has always fulfilled some kind of a cycle. So Seurat, a brilliant painter, accomplished his cycle, but, if he had lived, he would have moved on to greater and widening cycles resulting from an ever-enriched experience. At the time of my first cubist sculptures I was passing through my first cycle as an artist and this had a sort of unity and maturity in itself, but, as a sculptor, I was still like a child learning to walk. I was gaining mastery over the techniques and ideas about the forms but I still had much to learn. A subject or an idea was nevertheless always implicit in even the most abstract works. For instance, in the obelisks there is a subject of a figure set within an architectural frame. In many of my abstract cubist sculptures, such as figure 24 and others, the figure or group of figures is suggested by such details as a circular eye-shape.

Many of these abstract architectural sculptures are made in both stone and bronze. Although I have never cared about working directly in stone and, even if I had, was largely prevented from doing so by a recurring bursitis, these works so clearly needed the architectural mass of stone that I began to make them in this way. In the stone sculptures of this period and later I normally worked with a stone-cutter, although I always finished them myself. This, incidentally, is a tradition of virtually all the master carvers, from Michelangelo to Rodin, since most of the preliminary work for a stone carving is simply time-consuming detail that can just as easily be carried out by an assistant.

Of the greatest importance in clarifying my ideas about subject and form in 1915 was the *Head* (fig. 25). This was made after the moment of my emotional crisis, when I felt that in my exploration of abstract shapes I had lost sight of the human element, the relation to nature that has always been so necessary to me. In fact, this work was

probably more than any other the means of bringing me out of this moment of despair. It is really a very simple structure, obviously in the same vein as the abstract architectural works that preceded and followed it. There is a large, vertical-rectangular mass that rises up the back of the head and then comes down in front as the forehead and nose. This rectangular plane is bisected almost at right angles by another plane that suggests the face diminishing at the bottom to form the neck and rising in a frontal curve to suggest the protruding line of the eyebrows. There is even an implication of the eyes in the shadows created under this protruding ridge. This is, then, clearly, a human head with even a feeling of monumental dignity. Yet the entire effect is achieved essentially by two interlocking sculptural planes. The work is, thus, rooted in the demountable figures that had preceded it, such as the *Pierrot* (see fig. 19), but it has progressed greatly as a totally integrated and realized sculptural organization. With this work I entered into a period almost of euphoria. I knew that I had discovered something, that I was on the right road to the realization of a kind of sculpture in which I had complete control of the vocabulary of cubist forms in the creation of works where the human subject or idea was uppermost.

The next several pieces, from 1915 and 1916, illustrate what I mean. The first of these is a half-standing figure which rises from a circular base that is like the top of a table at which he is sitting. This and the others that followed it were made in clay, then in stone, and later in bronze. All of these, in the construction of interlocking planes, are developments from the earlier demountable figures. In them I was definitely building up and composing the idea of a human figure from abstract sculptural elements of line, plane, and volume; of mass contrasted with void completely realized in three dimensions. These works, beginning with the *Head*, were the resolutions of my problems after I had first gone too far in the direction of abstraction and then had reacted too far back in the direction of representation. Now I had the balance between the nonfigurative form and figuration for which I was unconsciously seeking. I must emphasize again that when I analyze these works now and point out the gradual progress from one phase to another I am doing so in retrospect. Years after the event I can see the logic of what was happening, but at the time these different steps were arrived at intuitively in a groping after some half-realized ideal which I could comprehend only when it had been

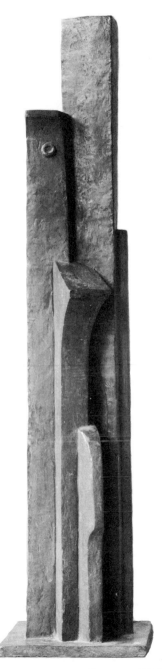

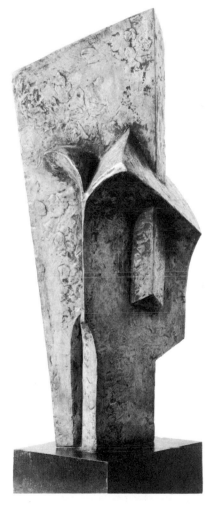

24. *Sculpture*, 1915. Bronze, 48½″ h.

25. *Head*, 1915. Bronze, 24½″ h.
Collection the Reis Family, New York.

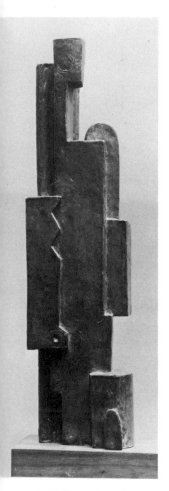

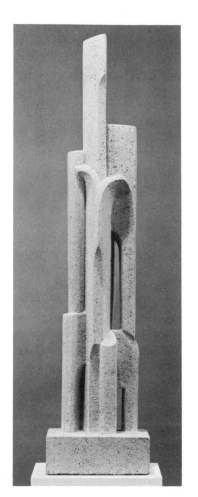

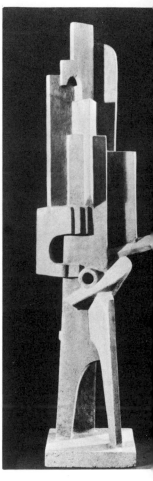

26. *Half-standing Figure*,
1915. Bronze, 19⅞″ h.
Collection Mr. Sig
Edelstone, Chicago.

27. *Standing Personage*, 1916.
Stone, 42½″ h. The Solomon
R. Guggenheim Museum,
New York.

28. *Man with a Guitar*,
1916. Stone, 38¼″ h.
The Museum of Modern
Art, New York, Mrs.
Simon Guggenheim Fund.

formed under my hands. There were some other things made between these particular sculptures, some sketches and drawings, even some little constructions in cardboard, but most of these were false starts that I recognized as such and destroyed. There is one that has survived, a small sketch (fig. 26) that still has much of the machine world of my demountables.

The *Standing Personage* (fig. 27) embodies many of the ideas with which I was then involved. This, like all these works, was completely realized in the round as a three-dimensional object existing in three-dimensional space. Thus, when it is seen in a photograph, it is impossible to understand the work fully. The vertical architectural basis of the structure is apparent. It looms up like a cluster of skyscraper towers, something like those in Rockefeller Center, New York. The pointed and curving arches and indentations give it somewhat the feeling of a Gothic tower. In this context, I am reminded that many of the early skyscrapers, including Rockefeller Center (which these sculptures antedated by some twenty years), also frequently used Gothic elements of pointed arches to emphasize the verticality. While this sculpture is in one sense an architectural construction, it is also clearly a figure or figures. The V-shaped curves rising from the sharp vertical in the upper central area reiterate the eyebrows and nose of the slightly earlier head, and the angled elements at the bottom can be either the buttresses supporting a Gothic vault or the legs of a seated figure. In this work it can easily be seen how the term "cathedral style" arose.

The figurative image is more immediately apparent in *Man with a Guitar* (fig. 28). One can see at once the top element that suggests the head with an arched nose: the vertical cut-out plane of the right arm and the tilted diagonal plane of the mandolin and the legs on which the figure is standing firmly. A peculiar and important departure is the hole in the center of the figure; it is no longer a circle indented in the surface but a hole cut right through the sculpture from front to back. The purpose of the hole is simple: I wanted it as an element that would make the spectator conscious that this was a three-dimensional object, that would force him to move around to the other side and realize it from every angle. This was an innovation that took courage to make. In a way it was a testament, the assertion that this object is finally a work of sculpture not actually a human figure, even though it embodies important elements of humanity. For some reason, critics

and others who looked at it at the time were shocked at the idea of a hole in the stomach of the figure, but this, of course, was because they were thinking of it as a human being and not as a sculpture. Over and over again I must repeat how difficult it is to see a true sculpture in a photograph. The photograph not only shows it from a single point of view and frequently tends to flatten it out, but the light and shadow in the photograph depend on how the picture was taken and may not reflect accurately the manner in which light moves and changes over the plastic shapes. As I have said, I am always tremendously conscious of the importance of light and shadow in the creation of a sculpture. As I organize the different planes, the solids and voids, I am continually thinking of the way different lights will work in and around the forms. As the light moves and changes so do these forms, and the figure seems itself to move and change as though it were filled with an inner life. *Man with a Guitar*, which is now in the Museum of Modern Art, New York, is a piece on which I worked a great deal. I cut it myself directly in the stone, composing it from clay maquettes and drawings. It was never cast in bronze.

In all of my works up to 1916 and for some years thereafter, it seems to me now that I was still looking for a personal vocabulary. I was still engaged in finding the grammar, the syntax of sculpture most congenial to me. Beginning in an academic tradition, my emphasis was obviously on subject matter composed traditionally. With my explorations of cubism I was, like the cubist painters before me, first attempting, by a concentration on the formal elements, to subordinate the subject to the plastic forms and then gradually to bring the center back together again. But, whereas the cubist painters had many precedents and prototypes in the paintings of Cézanne, Seurat, and the other postimpressionists, I had virtually no sculptural models on which to build. I had to find my vocabulary by myself, and thus the process was long and painful.

# Chapter 4

This period during the First World War was a very exciting time in Paris, with artists, philosophers, and poets continually discussing and arguing about the work with which they were involved. I remember many sessions at Juan Gris's studio participated in by such people as the mathematician Princet, the poets Reverdy, Jacob, and Huidobro, in which the arguments raged continually; more perhaps among the writers, who were more articulate and who were continually concerned as to who did what first and whether it was of any value. Their conversations tended to be on a more abstract, conceptual, philosophical level than those participated in by the artists; although I remember that Picasso once told me that when he and Braque were working together at the beginning of cubism, they had continual conversations. These conversations are now, unfortunately, lost, although they do survive in the paintings that emerged.

I began attending this sort of gathering before the war at Rivera's place, where I remember meeting with Russian writers and Mexican, Spanish, and French artists. I met Juan Gris in 1916, probably through my gallery, and we very quickly became close friends. At Gris's home there were not only the writers I have mentioned but occasionally the poets Larrea and Apollinaire. Princet was a clerk in an insurance company, but he was primarily a mathematician interested in ideas. It was probably for this reason that he was intrigued by cubism, which seemed to be adding a new dimension, like time, to painting and sculpture. Among the artists, Metzinger and Gleizes,

who were intelligent, educated men and theoretically minded, tended to take these mathematical analogies more seriously. Although I myself am little concerned with abstract theory, I certainly do think of cubism as a form of emancipation essentially different from artistic movements that had preceded it. Thus, impressionism, while it was a revolutionary technique, was still an essentially naturalistic movement concerned with a precise examination of the nature of light and the effects of changing lights on representational scenes and objects. Cubism did add a new dimension to painting and sculpture, whatever you want to call it, a dimension that changed our way of looking at nature and the work of art. This fact, which is now, in the 1970s, accepted as a commonplace, was then, in 1916, a tremendous revelation to me and to the others who participated in cubism. I remember a dream that I had; I had bitten into a ripe apple, and I woke up feeling extremely happy. The dream had some relationship to this moment of understanding that cubism was a triumph for the artist and for mankind, a new beginning, an emancipation from Mother Nature. My reaction was as acute as the one I felt recently when man first stepped on the moon. When this happened, somebody called me from New York to Italy to ask my impressions of it and this is exactly what I said, that I felt it to be a moment when humanity had come out of the womb of nature to the beginning of a new independence.

I am frequently asked about the relationship of my cubist sculpture to the cubist paintings of Picasso, Braque, Gris, and others. Certainly I was influenced in my ideas by cubist painting which had preceded me, particularly by that of Picasso. When artists are living and working as closely together as we were in those years, they are all obviously influenced in some degree by one another; they all derive motifs from one another. I remember one day when Juan Gris told me about a bunch of grapes he had seen in a painting by Picasso. The next day these grapes appeared in a painting by Gris, this time in a bowl; and the day after, the bowl appeared in a painting by Picasso. This was not simply imitation; we were all working with a common language and exploring the vocabulary of that language together. But I must reiterate that the ideas of cubist sculpture were essentially different from those of cubist paintings, in some ways simpler and more direct, since cubism lent itself so naturally to sculptural construction.

It is natural that we should have been interested in machines, not only because we were seeking in our painting and sculpture some-

thing of the clarity and precision of machine forms but because this was a moment in history when the machine loomed very large in our consciousness. It was the beginning of modern technology and much of modern industrial expansion. As I have said, I was never interested, like the futurists, in machine forms as symbols of speed and power, but rather as models for a kind of clarity and order. This was also the approach of Léger in his machine paintings. We tended to angularity of design not only as a consequence of the machine aesthetic but as a reaction against the soft, curvilinear emphases of *art nouveau*.

*Man with a Mandolin* (fig. 29), which was made late in 1916, has a quality of massiveness and is organized in a rectangular manner. It is close to some of the figures that Picasso was making about this time, and, in my search for effects of light and shadow, it may have become a little too pictorial. In seeking my language, I was always conscious when I had gone too far in the direction of abstraction on the one hand or, on the other, too close to literal representation. This piece was bought by the American collector Katherine S. Dreier, who was brought to my studio by my friend John Storrs. Miss Dreier was then forming one of the first important collections of modern art in the United States.* The collection is now at Yale University under the name of the Société Anonyme.

At this time I was, like the other cubists, very much interested in theories of abstract mathematical proportions and tried to apply them to my sculpture. We were all intrigued by the idea of the golden rule or section, a system that was supposed to have been the basis in the design of Greek classical art and architecture. The golden rule is simply a division of a line or proportion of a geometrical figure such as a triangle or a rectangle in which the smaller dimension is to the greater as the greater is to the whole. Since I was at the moment working extensively in stone, I would have before me a rectangular block of stone and I would try to divide the block into proportions

---

* It should be noted that in the dating of many of Lipchitz sculptures, particularly the early cubist works, there may be a discrepancy between the dates of the plaster, the stone, and the bronze. Thus, *Man with a Mandolin* seems to have been made in clay and plaster, in 1916. The limestone in the Société Anonyme is dated 1917. Frequently, since Lipchitz has in recent years wherever possible been casting these early unique pieces in bronze, the actual date of the bronze casts may be much later. Wherever possible in the text we attempt to use the date of the original clay, wax, or plaster.—H.H.A.

that seemed the most harmonious. Soon this method of working became irksome to me because it was too mechanical, it was taking away my freedom, so I abandoned it.

In the winter of 1916, when I finally got a contract with the dealer Léonce Rosenberg, he was then collecting all the cubist artists: Picasso, Braque, Gris, and Rivera. He was able to do this because Kahnweiler, who was Picasso's first dealer and the first dealer to be interested in cubism, had to leave Paris during the war because he was a German, and his entire stock of paintings was taken by the government. Rosenberg, who up to this time had been principally a dealer in ancient art, stepped into the gap and made contracts with all the cubists, not only those I have mentioned but also Léger and Henri Laurens. This contract was a tremendous thing for me since for the first time in my career I no longer had to worry about money. Rosenberg paid me three hundred francs a month and all expenses, and I gave him everything I made. Despite the contract, I continued to be in debt, but at least I had a little security and was able to continue working quietly and productively.

The contract with Rosenberg enabled me to employ a stone carver, since, as I have said, my bursitis prevented me from doing the work myself. I would still make my figure first in clay and then translate it into stone. The *Seated Bather* (fig. 30, 1916) represents again an important change and development in my cubism. In a sense, it marked a new phase symptomatic of the free-standing cubist sculptures I did between 1916 and the early 1920s. It was finished first in stone and later cast in bronze, as was the case with most of the works of this period. The figure here is treated even more massively than the two earlier works. Although it is extremely compact, there is a greater use of twisting diagonals and curvilinear forms suggesting a three-dimensional spiraling of the figure on an axis. Here I began to abandon that rigid vertical-horizontal aspect that marked the works of the preceding years. In a sense what I was doing was combining the geometric clarity of those works with the circular movement of some of the proto-cubist works such as the *Dancer* or the *Sailor with Guitar* of 1913. I was thus combining my findings of the last several years in an enlargement of my vocabulary that resulted in a greater spatial realization and complexity. It is also true, I think, that the *Seated Bather* as a figure takes on a greater human presence. While it is still in every way an organization of plastic masses and volumes, the sense

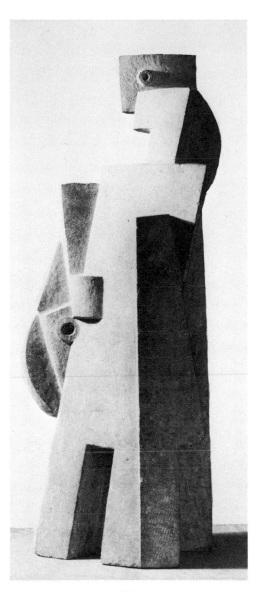

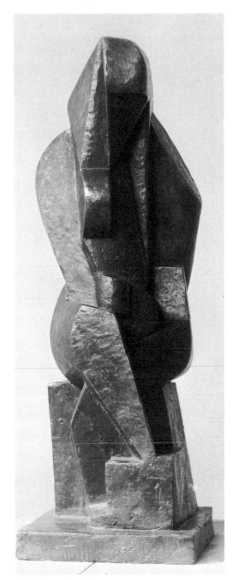

29. *Man with a Mandolin*, 1917.
Limestone, 29¾″ h. Yale University
Art Gallery, New Haven, Conn.

30. *Seated Bather*, 1916. Bronze,
28½″ h. Collection Mr. Irving Moskovitz,
New York.

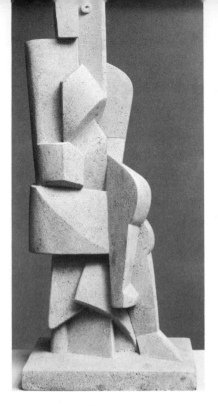

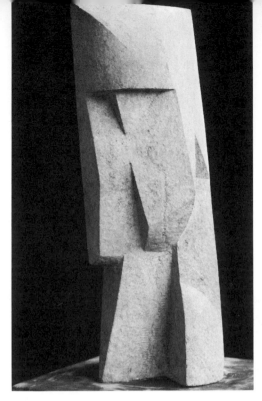

31. *Seated Bather*, 1917. Stone,
41½" h. Collection Mr. Alan
Tishman, New York.

32. *Head* (profile view), 1916. Stone.
Private collection, France.

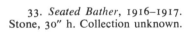

33. *Seated Bather*, 1916–1917.
Stone, 30" h. Collection unknown.

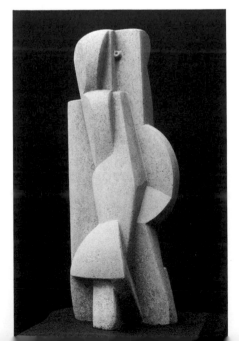

of humanity gives it a specific personality, a brooding quality emphasized by the shadowed face framed in the heavy, hanging locks of the hair. In this work I think I clearly achieved the kind of poetry which I felt to be essential in the total impact.

Incidentally, I began translating these stone sculptures into bronze for a variety of reasons. The number of stone sculptures I actually made was limited, and many people who had begun by buying my later works wanted to have one or more of the earlier examples. Also, since I have always worked primarily in clay and bronze, I was intrigued to find out how the stone figures would translate into bronze. In the bronze versions I frequently made certain variations, particularly in the handling of the surface in order to bring out the qualities of the bronze material. It was probably about this period, early 1917, that I finally began to realize the importance of Rodin as a great master of sculpture. Rodin characteristically made the same subjects in both stone and bronze and I could see how he varied his technique in terms of the different materials. When I cast my bronzes, frequently many years after the stone, I have always been most careful to limit myself to my traditional seven casts and to identify them by putting my fingerprint into the actual wax model, which was then made permanent in a bronze. It is sad that Rodin, and many other modern sculptors who have worked in bronze, neglected to take these precautions, with the result that their sculptures continue to be copied indefinitely in posthumous casts that completely lack those all important final touches which only the sculptor himself can give to the original.

My awakening awareness of Rodin did not then manifest itself in any particular stylistic influences. The *Seated Bather* probably still owes more to my continuing passion for Egyptian sculpture in its massive organization. Even the treatment of the inclined head with the hair framing it has some suggestion of an Egyptian Pharaoh. The strong assertion of the original clay modeling evident in the bronzes may owe something to Rodin's technique, but, as I have said, these bronzes were normally made years later.

When I finished the *Seated Bather* (fig. 30), I realized and was excited by the significance of the new departure, the new syntax of forms. In the next work, *Seated Bather* (fig. 31), I attempted a more ambitious, and an even more complex, statement of the figure, in this case perhaps moving somewhat too close to representation. Although

this sculpture introduces curvilinear elements in the arm, the leg, the breast, and the drapery, it is in toto somewhat more vertical and rectangular than the preceding piece. The progress of my ideas has never been in a straight line. There was a continual search backward and forward, new findings combined with ideas which I may have explored years before but which I had dropped and then taken up again.

Like the other artists and writers of the time, I was immensely excited by the appearance of Diaghilev's Russian ballet in Paris during the war. Although he developed out of the traditional Russian ballet which had been supported for generations by the Tzars of Russia, Diaghilev's importance lay in his making ballet a focal point for all the new experiments in music and the visual arts. He sponsored the great new talents in music such as Stravinsky and Eric Satie and he used the leading artists such as Picasso to design his sets. I was present at the famous, or infamous, première of Stravinsky's *Rites of Spring*, when the audience actually rioted in reaction to the new ideas. I remember that, in my enthusiasm, which was both chauvinistic and a recognition of this ballet's importance, I was applauding wildly when suddenly an old gentleman behind me hit me on the head with his umbrella. Diaghilev's ballets were exceptional, but they were still symptomatic of the tremendous richness and excitement of the artistic life in Paris even during the darkest years of the First World War. We were all going about our work in the midst of this chaos, perhaps conscious that what we were doing represented some of the few marks of sanity in an insane world.

Late in 1916 I made another cubist head comparable to that of 1915 (fig. 32), but now in stone. Between the two I had tried other ways with a simple head as a subject, but in general these became too complicated in their details. This one is more satisfactory in its elemental statement of the basic mass of the stone. A work that is related to this head, although slightly later in date, is the stone *Seated Bather*, 1916–1917 (fig. 33). In this, as in the head, I was seeking an extreme simplification of solid, massive forms. Although I think it is a successful piece, I may have felt at that time that it was carried too far in the direction of austere abstraction.

In the next three pieces, two bathers and a singer with guitar, all made in 1917, I am consolidating some of the ideas involved in this new phase. In all three there is the sense of twisting movement, of the

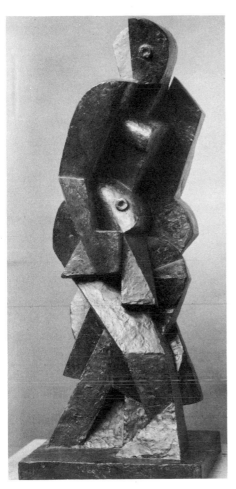

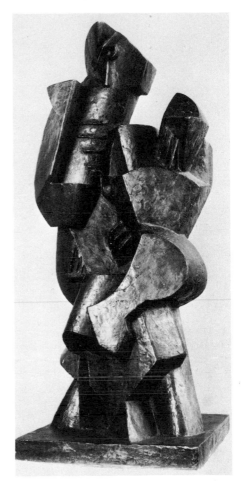

34. *Bather*, 1917. Bronze, 35″ h. Nelson
Art Gallery, Kansas City, Missouri.

35. *Sailor with Guitar*, 1917–1918.
Bronze, 36″ h. Collection Mr. and Mrs.
Jack Meyerhoff, Miami Beach, Fla.

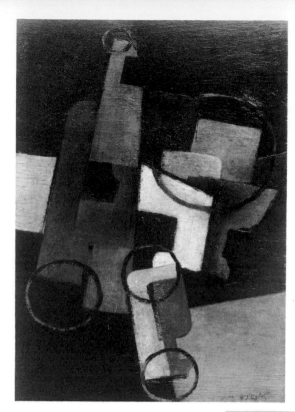

36. *Still Life with Compotier*,
1917. Oil on canvas,
21¼″ by 14½″.

37. *Seated Man with Guitar*, 1918.
Bronze, 30″ h.

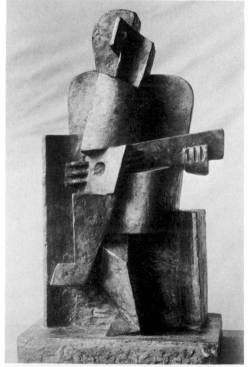

figure spiraling around its axis. There is the massive monumentality I was now seeking. Although these sculptures are still generally small in scale, thirty-six or forty inches high, they have a monumental feeling and could easily have been translated into far larger sculptures. They represent some of my first findings in this direction, the moment at which I began to sense the possibilities of sculpture as a truly monumental form of expression. All three are intricate works, highly complex in the manner in which the figures are built up of many different interacting elements, but all still maintaining the rigid control of the block of stone. I was seeking effects that were both rich in their complexity and controlled in their simplicity. Once again I believe that these figures evoke the living human figure into which the forms were translated, while maintaining the purity of those forms. The bathers, observed from different angles, are even reminiscent of traditional portraits of bathers as seen in the history of sculpture from ancient times through the eighteenth or nineteenth centuries. *Bather* (fig. 34) is conceived as a bather stepping down to a pool or a river, holding her drapery as her head turns back over her shoulder. This is a pose suggestive of certain eighteenth-century bathers by Falconet and other sculptors of the time.

Although normally I like to finish one sculpture before commencing another, I was then working so well, with so many ideas turning in my mind, that I had several pieces going at one time. While working on one piece with the stone carver, who was constantly in my studio, I was making maquettes of others. It usually took me a month to finish a piece, but it is hard to estimate how much time went into preliminary sketches and rethinking of ideas. My greater sense of spatial existence made me naturally more aware of how the piece must look in the round, so that I would make drawings of views from every side. The *Sailor with Guitar* (fig. 35) was actually a reminiscence of the 1914 *Sailor with Guitar* (see fig. 12). As I began to compose this subject, I was inevitably reminded of that young Spanish sailor joyously dancing around the girls as he played his guitar. The horizontal stripes suggest those of his sweater while the more vertical ones are, of course, the strings of the guitar. The knee is pulled up as though he were leaping in space. At the same time it reiterates the shape of the guitar body. This is a piece I particularly like. Le Corbusier bought the stone and I do not know where it is now, perhaps in his estate. I wish that I had it again or at least that I could see it. It is

a dynamic work, pyramidal in form, but slightly tilted off balance to emphasize the quality of the motion.

In 1917 I made what is my only finished oil painting (fig. 36, *Still Life with Compotier*), although as I have indicated I have always made drawings and gouaches related to my sculpture. This was different in that it was a deliberate effort at cubist painting, attempted as an experiment to see what I could do in this medium. It is not quite finished, as I intended to put some grapes in the compotier. It was certainly inspired by the works of my friend Gris, although it is a simple and somewhat elementary work when compared with his sophistication. I have never been a painter, and, while this single effort was amusing, I had no inclination to repeat it. The colors are subdued, brown, green, ochre, black, and white, colors that would appeal to a sculptor.

Early in 1918 there was another addition to my vocabulary when I became conscious of negative space and began to use its effects. This was simply a matter of wrapping the solid forms around a void to frame it, in effect using the void rather than the volume of the stone to suggest the form of the head or part of the torso (*Seated Man with Guitar*, fig. 37). In this work there is an opposition between the positive volume on the right and the negative volume on the left, a delicate transition from light to shadow in the contrasting curves. Although I had used comparable effects earlier, these now became a significant part of my total vocabulary, one that was to lead to my most open and transparent sculpture of the twenties. In subjects such as this, the *Seated Man with Guitar* or the *Sailor with Guitar*, the guitar is used as a point of reference, a stabilizing influence around which the figure is organized and into which it is integrated. The guitar, which is a man-made object, normally remains relatively recognizable, while the figure may be largely disintegrated. The existence of the guitar assists in the visual recomposition of the figure into a new and different kind of reality.

Looking at the *Seated Man with Guitar* again, after many years, I am struck by something that certainly did not occur to me at the time, since, as I have said, I was always (and still am) working out my new ways intuitively as I went along, without a deliberate, planned program. But as I see this figure now, I realize that it is significant not only in its clear use of curving planes to create effects of interior or negative space, but also, when compared with other figures of the

period, it demonstrates a new or revived interest in frontality. The figure is rather wide and squat, firmly and frontally placed on his chair, with the guitar and the legs at severe right angles, emphasizing the frontal design. Whereas most of the cubist figures of 1916 and 1917 and others that were created during the 1920s emphasize the classical or Renaissance spiral, in this work I was again doing something comparable to the frontalized Greek archaic and Egyptian statues which were among my first loves. Or perhaps I was beginning to be affected by the examples of African art that I had been studying and collecting for a number of years. As you will see, this move toward totemistic frontality is a characteristic of some of the major pieces of the 1920s, and I have subsequently returned to it from time to time.

*Seated Man with Guitar* was a sculpture which I was happy with. I felt it to be new and successful, without completely understanding why. I now remember that I was only dissatisfied with the back, which then seemed to me to be too simple. But this was unquestionably a result of the fact that I was unconsciously concentrating on the major view from the front.

The war came closer to us when the Germans actually began to bomb Paris with their famous "Big Bertha" cannon. One day, when I was not there, a piece of shrapnel came through the window on the exact spot where I had been working. We were alarmed and felt that it was necessary to get away. Gris rented a house at Beaulieu, and my wife and I stayed for a time on the first floor of this house. Since it was too damp, we left shortly and rented a room in the village. In Beaulieu, in the spring and summer of 1918, I was not equipped to continue with my free-standing sculpture, so I made drawings and gouaches, preparatory sketches for a series of bas reliefs. In these, perhaps because I was thinking them out so completely with colored drawings, I began to experiment with polychrome. The Egyptians and Greeks had always used color on their sculptures and this was continued in many medieval and even in some Renaissance and Baroque works. Baroque sculptors such as Bernini did not actually paint their statues, but achieved coloristic effects by using varicolored marbles. Previously I was antagonistic to the use of color on sculpture, realistic color in particular, and I have continued to dislike it, feeling that it is a contradiction in terms. The color can distort and even destroy the volumes of the sculpture. However, I felt that color could be better

controlled in reliefs than in free-standing works since reliefs are obviously more closely related to painting. When used judiciously and sculpturally it can even enhance the sculptural effects one is seeking. In a relief (fig. 38) that I did at Beaulieu, the colors are relatively subdued, mainly black to white, graded to brown; the darkest areas are those in highest relief and the lights most distant. These reliefs were interesting experiments, perhaps inspired by my close contact with Juan Gris at this time, but I did not persist in them for very long. They did nevertheless teach me something. Later I learned that the Greeks used color on their temple statues, which were seen at a distance in brilliant sunlight, in order to increase and accentuate the visibility of the forms. Although I continued to make reliefs for the next three or four years, I soon abandoned the use of color as something that tended too much to mechanical rule-of-thumb effects. Also, I was much more interested in all the ideas of free-standing sculpture now opening up before me.

When I speak of possible influences from a painter like Juan Gris on my sculpture, I am not talking about a one-way street. We were all working so intimately together that we could not help taking motifs from one another. I know as a fact that Gris, to whom I was pretty close, used images that he saw first in my sculptures, so my conscience is clear. I remember one time that in trying to help him resolve an idea, I almost ruined his painting. I used some stone powder mixed with water and rubbed it over the painting with disastrous effects. Fortunately, he was able to rescue it, and he did not blame me since he knew that I was attempting to be helpful. The trouble was that I was thinking as a sculptor, not as a painter.

As I said, I have never used color on sculpture except in those few brief experiments and I have been generally opposed to it. It is not inconceivable that I might use it again, particularly for a sculpture exposed to brilliant sunlight as was the case with the ancient Greeks. This question occurred to me recently in relation to Israel, where I have been asked to design a monument for Mount Scopus. The light there is extremely intense. I remember a strange experience when I was in Israel six or seven years ago. Before lunch I saw a sculpture in a garden and when I came out after lunch it had disappeared. It was still there, but the rounded forms and the somewhat pink material had simply vanished visually as the sun intensified. It was then that I could understand why the Greeks and the medieval sculptors painted

their works. It was not to make them naturalistic like the Egyptians, but to control them in the light. This is an interesting problem, about which I have been thinking a great deal. The sculptor must use light to achieve his effects. However, whereas the painter is using a substitute, the color spectrum, the sculptor is using actual light and shadow, which can be more difficult to control.

Of the two or three other color reliefs that I made after returning to Paris, perhaps the most interesting is *Still Life* (fig. 39). This is an intricate arrangement of flat elements principally at two distant projections from the white ground. The relief motifs closest to the eye are the darkest; those behind them are a middle tone, and those farthest from the eye, white. Since a strong white tends to advance visually, the background comes forward and helps to pull all the different parts together. For this work I even carved a sort of broken rope motif as a frame. Although it is well composed, I feel it to be somewhat too careful and even mechanical. This kind of color relief did not seem to have been too congenial to me, and in subsequent reliefs made in stone or bronze I abandoned color, undercutting the material more deeply to achieve greater projection and stronger contrasts of natural light and shadow.

Henri Laurens, who was a talented sculptor, perhaps the only one aside from myself who worked consistently in cubist sculpture for many years, made a great number of color reliefs during 1919 and the early 1920s. I believe these were somewhat later in date than my own polychromes and, in any event, I did not see them till later. Laurens in his sculpture was much closer to cubist painting. He, like Braque, was trained originally as a decorator, and he continued to make cubist paintings, collages, and graphics throughout much of his career. In his early free-standing sculptures, which were often intricate constructions of wood and iron or steel, he characteristically used polychrome. These are interesting works, although to my eye they are too pictorial, reflecting a strong bias as a painter. Laurens continued to work as a cubist in a narrow sense throughout the 1920s and only began to develop a curvilinear, naturalistic approach in his later career, after 1930.

# Chapter 5

My wife and I returned from Beaulieu in the fall of 1918, and for a while we were both very ill with Spanish influenza. Berthe was most courageous during this period toward the end of the war, a period of particular hardship and even hunger for most of us. Things seemed to get worse before they improved, and I still recall the frenzy of joy with which we greeted the hope and liberation of the armistice. For me it was a particular occasion of happiness since I was then able to find out what had happened to my parents, with whom I had lost all contact not only because of the war but also because of the Russian revolution.

*Still Life with Musical Instruments* (fig. 40) illustrates my later approach to relief sculpture. In this I have organized the objects within a rather deeply cut oval which gives them a strong sense of projection from the ground. I am using here, within the oval frame, many clearly curvilinear shapes, curving lines reiterating the oval, spheres and a funnel shape contrasting with rectangles and diagonal projections. The increased use of curvilinear shapes anticipates the direction of my sculpture during the next few years. The high relief emphasizes the contrasts of light and shadow and thus the three-dimensional sculptural effect.

The musical instruments that I used in this and other reliefs were part of my basic vocabulary. Like cubist painters, I collected musical instruments and decorated my studio with them. We used these objects, which were familiar parts of our everyday lives, as a kind of

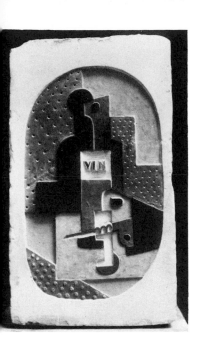

38. *Bas Relief*, 1918. Stone polychrome, 22″ by 14″.

39. *Still Life*, 1918. Stone relief, 14″ by 18″.

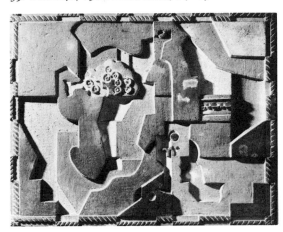

40. *Still Life with Musical Instruments*, 1918. Stone relief, 23⅝″ by 29½″.

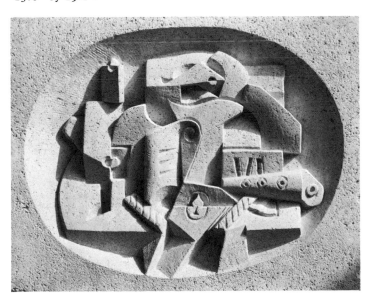

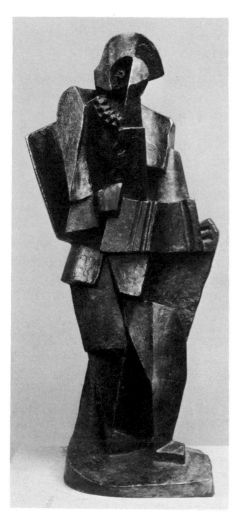

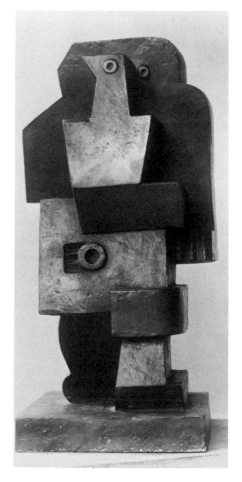

42. *Man with Guitar*, 1920.
Bronze, 20⅝" h.

41. *Harlequin with Accordion*, 1919.
Bronze, 30" h. Collection unknown.

reaction against the noble and exalted subjects of the academicians. They were, in effect, truly neutral subjects that we could control and in terms of which we could study abstract relations. They also appealed to us because they were always interesting and unusual in their shapes and thus served as the basis for intricate compositions.

If this relief (fig. 40) is compared with the earlier *Still Life* (fig. 39), it can be seen how much more complex and even sophisticated it is. Instead of the limited arrangement of three distinct levels of flat planes, there are now many different degrees of projection, flat and angled and cylindrical.

In my use of musical instruments, there may have been a particular feeling of guilt; I remember that when I was a child and my parents wanted me to learn to play the violin, I became angry with my teacher and broke the fiddle over his head. That was the end of my musical career, and I may have been trying to make amends. I think I was also affected by the eighteenth-century *boiserie* decorations that were so common in old French houses. I know that I was strongly attracted to the still-life painting of Chardin. This particular relief (fig. 40) was bought by the American collector Barnes, and in 1922 he commissioned me to make some large-scale reliefs for his museum in Pennsylvania. Also, I remember that when Le Corbusier built my house after the war, I wanted to insert a relief into a large bare wall. Corbusier was aghast that I should want to spoil his beautiful wall and he would not permit it.

The end of the First World War was, as is well known, a period of great change for modern art and for all the artists involved. On the part of some cubists, even of Picasso, there was a reaction toward naturalism; and then, of course, the dadaists who had met in Switzerland during the war converged on Paris. With the decline of dadaism, surrealism, the new movement, emerged in the early 1920s. During 1919 I was anxious to try different ideas, but my dealer, Rosenberg, was reluctant to have me change. My reputation was beginning to enlarge, and, as is frequently the case, my dealer was afraid that if I changed my direction the works might be less salable. As a result, we agreed to part in 1920. After a final exhibition at Rosenberg's I was able, through the help of friends, to buy back all my sculptures from him and make casts myself from the plasters. After the exhibition, Maurice Raynal wrote a book about my sculpture which helped my reputation. Nevertheless, times were still difficult until 1922, when I

met Dr. Barnes and he began to buy and commission works from me. From this point forward everything was much easier. During the period of difficulties, I even had to sell many items from the collection I had built up so painfully over the years. My problems were compounded by the fact that after the war I had to use any extra money to help my family in Druskieniki, who had been right in the middle of the fighting between the Germans and the Russians.

When I re-established contact with Russia, I became aware of some of the Russian experiments in constructivism and suprematism that had developed during the war, and I began to be known in Russia as a pioneer of modern sculpture. Even Trotsky wrote an article about my work in *Pravda*, although with little understanding of it. I was, myself, not too sympathetic to Russian abstraction, any more than I had been to that of Mondrian and the De Stijl movement which had developed in Holland out of cubism. The Russian abstractionists, of course, were suppressed soon after the war as the Soviet insisted on a return to a popular narrative art.

Lithuania, when I was born, had been a part of Tzarist Russia, but after the First World War it became Polish. When I returned to visit my parents I had to secure a Polish passport, and thus was a Polish citizen until I was naturalized as a French citizen, about 1924.

One of the first sculptures made in 1919 was the *Harlequin with Accordion* (fig. 41). It reflects my interest in eighteenth-century painting, particularly that of Watteau. It is certainly more pictorial in feeling than the 1918 *Seated Man with Guitar* and the sculptures of 1920 and 1921. The Pierrots and harlequins were part of our general vocabulary, characters taken from the *commedia dell'arte*, particularly popular in the eighteenth century. We may have been attracted to them originally because of their gay traditional costumes, involving many different varicolored areas. During 1919 and 1920 I continued to make a number of these standing figures in stone and bronze, the traditional subjects of bathers, Pierrots, and harlequins and one or two studies of a man or woman reading a book. Generally, this was a transitional period in which I was playing variations on a number of familiar themes, more or less conscious that I needed to find a new direction, a new stimulus. Of these transitional works, the most satisfactory to me in terms of my new ideas is the *Man with Guitar*, 1920 (fig. 42). This should be compared with the *Seated Man with Guitar* of 1918 (fig. 37) which I referred to earlier, the work that prophesied

a movement toward a kind of massive frontality. The later *Man with Guitar* is now completely frontalized, composed of massive, integrated blocks. I even eliminated the shaft of the guitar, squaring off the body and integrating it completely with the torso of the figure. The asymmetrical staring eyes give to the figure a peculiar sense of almost hypnotic power which emphasizes its specific human personality. This is a work that is important to me as an anticipation of the monumental totemistic *Figure* of 1926 to 1930 (see fig. 75). Although it is still quite small in dimensions, only about twenty inches, it has a monumental feeling about it that indicates a subconscious desire to work on a much larger scale.

Most of the pieces I created during my early career were of a scale suitable to fit into a room, like easel paintings in contrast with mural paintings. Larger works could only be achieved through specific commissions and these I did not begin to receive (with the exception of those from Barnes) until later in the 1920s and 1930s. Now, in my late years, I am working on great monuments. I think, however, that the wish to create on the grand scale was always present and that this may account for the illusion that the small works are much larger than they are. In any work of sculpture of any period this feeling for scale is a question of the sensibility and the creative urge of the artist. I know huge pieces which in a photograph might be miniatures, and I have in my own collection tiny works by primitive, Egyptian, or classical artists which might be many times life-size.

After the war I made a few more portraits. There was, after the war, a movement toward realism on the part of many artists in Paris and elsewhere. Picasso had again begun making beautiful, realistic drawings when he was associated with the Russian ballet during the war, and this led him to his second period of classical realism. Juan Gris and others became somewhat more representational for a while, and Derain and Vlaminck, among others, continued to paint in a new, realistic style throughout the rest of their careers. For most of the major artists this was a time for them to re-examine themselves and what they were doing, a natural thing after the long and difficult period of the First World War when new vistas of peace were opening out before them. In most cases, any extreme forms of naturalism lasted only briefly, and some artists, such as Picasso, Braque, and Gris, were moving on to important new achievements.

As far as I was concerned, my excursions into realism were very

brief and only took the form of a revival of my continuing interest in portraiture, although there were certain very important developments in my sculpture around 1921 and 1922 which did lead to major advances in my point of view. I must admit that I took some portrait commissions because money was scarce after I had bought back all my works from Rosenberg. As it turned out, however, there were not many commissions. Most of the portraits I made were of friends or writers who interested me, and I was not paid anything for them. One of the first is the portrait of Raymond Radiguet, 1920 (fig. 43). Radiguet was a young poet at that time, no more than twenty years old, a talented man and extraordinarily mature for his age. I think it was Jean Cocteau who introduced him to me and suggested that I do a portrait of him. The young man had an extremely beautiful skull structure, very crisp and clear-cut features, all of which I accentuated. In order to do so, I subordinated the mass of the hair in the plaster and even eliminated it in the bronze. This may be termed more realistic than the earlier portraits done before the war in its precision and in the fact that I sketched in the pupils of the eyes. To me, however, it is still an extremely classical work, one that has some of the qualities of idealism and repose that you find in ancient Greek sculpture.

About the same time, I also did a portrait of Cocteau (fig. 44) which is nervous and dynamic in its reflection of Cocteau's personality. He had a great shock of curly hair, which I only sketched in as a relatively unfinished mass to frame and not to distract from the intensity of the face. Cocteau was an enormously talented man who could do almost anything. He was first of all a poet and essayist, but he was also a painter who made brilliant sketches, and he even tried his hand at sculpture. He found his métier in the ballets of Diaghilev, which embodied dance, music, and spectacle. This versatility manifested itself later in such experimental films as *Blood of a Poet* and *Beauty and the Beast*, which were some of his most successful works. He was enormously quick, alive, and intelligent, and he created some masterpieces in different media, but I always felt that he lacked something of profundity and true creativity.

It was about this time, also, that I made my first portrait of Gertrude Stein, to which I referred earlier, showing her as a massive, inscrutable Buddha (fig. 45). In this case, I hollowed out the eyes deeply but did not indicate the pupils, so that they give an impression

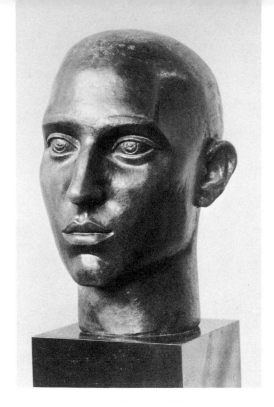

43. *Portrait of Raymond Radiguet,*
1920. Bronze, 12″ h.

44. *Portrait of Jean Cocteau,* 1920.
Bronze, c. 14″ h.

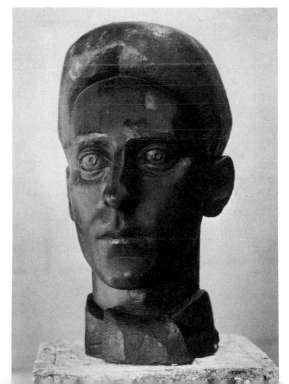

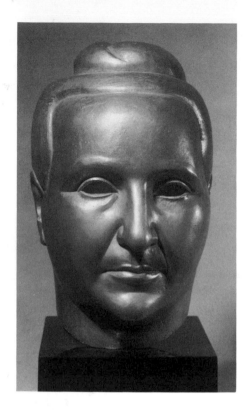

45. *Gertrude Stein*, 1920. Bronze, 13½" h. The Museum of Modern Art, New York.

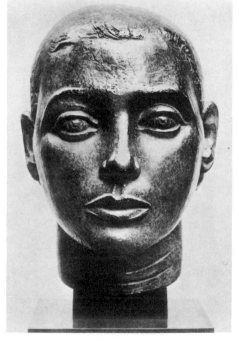

46. *Berthe Lipchitz*, 1922. Bronze, 19¾" h.

of shadowed introspection which emphasized the characterization I was making. In my first model, I rendered the eyes, and there still exists a version with the eyes in the Musée National de l'Art Moderne in Paris. But I was not satisfied with this and found my solution by hollowing them out.

A number of years later, in 1938, I met Gertrude after a long interval and found that she had lost a great deal of weight. She looked now like a shriveled old rabbi, with a little rabbi's cap on her head. I was so struck by the contrast that I asked if I could make another portrait of her. I made two different sketches, one with the cap (see fig. 127) and one without. She preferred the one without the cap, perhaps because it looked more feminine, but I liked the other one better. I did not carry the second portrait beyond the sketch stage because of the interruption of the Second World War, although I made a variant of it for a university in Houston, Texas, I think after that war. I liked these later sketches very much, particularly that with the cap. They have a strongly lifelike appeal. The massive, self-confident Buddha has become a tired and rather tragic old woman.

The portrait of my first wife, Berthe, was made in 1922, perhaps the last of the series of that period (fig. 46). Like Raymond Radiguet, she has a very strong face with a dynamic expression and clear-cut classical features. All of this I attempted to capture. Again, I subordinated the hair in order to concentrate on the structure of the head.

One of the few real portrait commissions I received was a head of Mademoiselle Chanel, "Coco" Chanel, the famous *couturière* (fig. 47). I am not sure how I first met Coco Chanel, perhaps through a friend of hers, an interesting woman who became the wife of the Spanish painter José Maria Sert, who was very successful at that time doing frescoes. Sert was the uncle of the distinguished architect José-Luis Sert. Coco Chanel was extremely successful in her field, very beautiful, elegant, and intelligent. She must have been about thirty-five years old at the time of the portrait. The portait itself is not one of my favorites, although I think it caught her appearance, her strange beauty and something of her strong personality. It was perhaps a little too much of an official or commissioned portrait. Since making it, I have been reluctant to portray women, perhaps because I tend to be too brutal in my analysis and because of my lack of flattery. I did make a portrait a few years ago of Mrs. John Cowles,

which I think is successful as a portrait, although I am not sure that she cared for it.

My meeting with Coco Chanel was important to me and to my sculpture in other ways, since I received from her some commissions that started me off on an entirely new train of thought. Relevant to these there is a somewhat amusing story. Once when she was visiting my studio, which was very shabby and reflected my own poverty, she commented on the fact that artists seem satisfied to live in mediocre surroundings, going on to say that they probably could not do otherwise. I was somewhat nettled by her remark and made a bet with her that if I wanted to I had the ability to make some money without working. Since my portrait commission was to be five thousand francs, we agreed that this was the amount I should try to make. So she advanced me one thousand francs to invest, and immediately after our sitting I went out, and, by pure coincidence, on the street of her palatial home, I passed a large store of eighteenth-century antiquities. There in the window my eye was caught by a little ivory. Immediately I ran into the store, and, although I knew what it was, I asked the owner about it. He said it was a late Spanish ivory from the collection of Princess Radziwill and that it cost twelve hundred francs. Since the owner would not come down in his price, I looked around and noticed a pair of ceramic candelabra identical with a pair I had once bought for three francs. So I offered to let him have my candelabra along with the thousand francs for the ivory. The next day, since I wanted her to see every step of the transaction, I went with Coco in her Rolls-Royce to the dealer and exchanged the thousand francs and the candelabra for the ivory. I then called a dealer and expert, Paul Guillaume, whom I knew, and told him I had something to show him. After looking at the ivory and consulting some catalogues, he said it was worth eighteen thousand francs, but that he could only give me three thousand francs for it. Since I said it was not for sale, he kept raising his price, but we left, of course, without selling the piece. I was thus able to demonstrate to Coco that even an improvident artist could make money if he wished and this, for some reason, impressed her very much. She said I could keep the ivory as a souvenir. It is a Benin ivory cup which the original dealer did not recognize and today is worth perhaps fifty thousand dollars.

As a result of this incident, Coco was impressed by my knowledge of antiquities and one day asked me to go with her to an antique

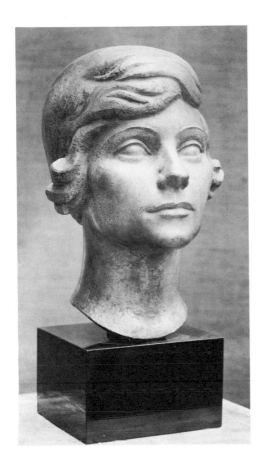

47. *Portrait of Mlle Coco Chanel*, 1921. Bronze, 14″ h. Estate Mlle Chanel, Paris.

48. *Reclining Woman* (firedog), 1921. Bronze, 14″ h. Estate Mlle Chanel, Paris.

50. *Repentant Magdalene*, 1921.
Bronze, 3¼″ h.

49. *Seated Woman in Armchair*, 1921.
Bronze, 5⅜″ h.

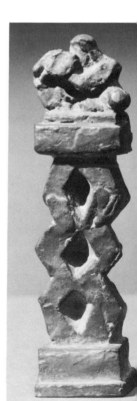

52. *Study for Garden Sculpture*, 1921.
Bronze, 5⅜″ h. Collection the Reis Family,
New York.

51. *Reclining Woman*, 1921. Bronze, 2¾″ h. and 3¼″ h.

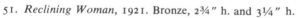

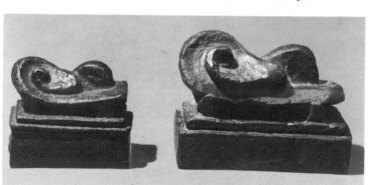

dealer to see some andirons which were attributed to the French Renaissance sculptor Jean Goujon. I asked her what they were worth and she told me three hundred thousand francs, a sum that I thought was so ridiculously extravagant for a pair of andirons that I refused to see them. So she said, "All right, then, you make me a pair of andirons," and I agreed. The chimney for which she wanted them was in the rococo Louis XV style, all decorative curves, completely opposed to the geometric cubist sculpture I had been making. I realized that I must change my entire approach for this commission, and the experiment in curvilinear forms was to have a most profound effect on my sculpture of the next decades (fig. 48). The andirons took the form of a reclining woman with her skirt flounced up, lying on a couch with a curving back, something like a Victorian sofa. I made the two pieces slightly different, but both of them were deliberately decorative, light-hearted, and gay, even satirical as befitted their decorative purpose. I made another pair of firedogs for a different fireplace of Coco's house in the forms of animals. These were more severe, since the decoration of the fireplace was itself in a formal Chinese mode. On some other occasions, during the later twenties and thirties, I have been commissioned to do other firedogs and screens.

Coco Chanel also requested that I make some designs for garden sculpture, and, although these were not actually carried out in final form, the small clay sketches that I made started a whole chain of events in my career. These, which are only a few inches high, included a sketch for a *Seated Woman in Armchair*, 1921 (fig. 49), highly simplified, with the abstract blocks of the woman integrated into the curving back of the chair. There was also another, most abstract, piece that I called *Repentant Magdalene*, the reclining Magdalene reading a book (fig. 50). This is simplified to an asymmetrical pyramid intersected by a curving mass. I gave it the title *Repentant Magdalene* later, although there is to me the suggestion of a reclining figure reading a book. This is perhaps significant as one of my very first uses of a Christian subject, although in making it I was not thinking particularly about the Christian theme. There was in my mind some idea of a repentance that I myself felt, conceivably a repentance for my excursion into realistic portraiture.

Then, for Coco Chanel's garden, I made sketches of a reclining woman (fig. 51) and a vertical study for a garden sculpture (fig. 52). The latter is a column of intersecting diamond shapes surmounted by

a figure group. These were intended to be seen in a vista of forest at the end of an alley of grass. The reclining woman was, of course, suggested by the reclining figures on the andirons and marked the beginning of this theme in my sculpture as well, perhaps, as in the sculpture of many others during the next decades. The study for the garden statue was actually the first example of a theme that was to appear in a number of intermediary projects, culminating in the monumental *Figure* of 1926 to 1930 (see fig. 75). Although I continued to be friendly with Coco Chanel, I did not carry out these commissions for her, perhaps because in 1922 I met Dr. Barnes, my first major patron.

# Chapter 6

My works were becoming more widely known. Maurice Raynal's book on me appeared in 1920 and I met the critic Waldemar George, who wrote a number of pieces. Others also began to write, and my sculptures started to sell on a regular basis. It was perhaps because of this, seeing my works leave the studio, that I started to have a photographic record made of all my sculptures, and also to preserve the original maquettes.

Nineteen twenty-one and 1922 did not produce very many sculptures, aside from the few portraits and the commissions for Chanel. These were most difficult years financially. I was deeply in debt as a result of buying back my sculptures from Rosenberg and being forced to acquire a second studio in which to store them. This period was also disturbed because once more my family was in trouble, my father and sister were sick, and I had to support them.

Juan Gris, whom I loved dearly and whom I still love, became very angry at me as a result of a ridiculous misunderstanding. He had designed a ballet for Diaghilev to be presented in the Palace of Versailles for some charity. When Diaghilev showed me the model stage as it had been set up, he asked my opinion and I made a few little suggestions. These must have been represented in a distorted form to Gris because he became furious with me, accusing me of attempting to destroy him. I, in turn, became angry and for almost a year we did not speak to each other. We were both living in the same suburb of Paris, Boulogne-sur-Seine, and we would see each

other at the bus stop, but each would completely ignore the other until finally one day Gris came over to me and said, "This is really stupid, when friends like us cannot *pisser ensemble*." So we became friends again. It was only after this that I realized Gris was becoming extremely sick, with a sickness which was never clearly diagnosed until it was too late and he died in 1927.

During 1922, despite the personal difficulties that continued much of the year, some of my new sculptural ideas began to come clearly into focus. *The Seated Man* (fig. 53) is a major departure for me, composed as it is from simplified rectangular masses. In its effect it does have a relationship to the frontalized *Seated Man with Guitar* of 1918 (see fig. 37) and, even more, with the 1920 *Man with Guitar* (see fig. 42). But now the entire form is solidly cubic in a literal sense rather than traditionally cubist, with the figure frontalized diagonally on the square base, the veritical masses pulled together by the curving, enclosing arms. The figure is squat, compressed, with a great sense of sheer weight. It shows a deliberate restriction of means, which adds to the total tension. This was the time when the mad fantasy of the surrealists was beginning to sweep Paris, and it is conceivable that in my own way I was reacting by carrying my sculpture to an opposite extreme of clarity and compression. The idea for this work first appeared in the small sketches of the *Seated Woman in Armchair* and the *Repentant Magdalene* (see figs. 49, 50). I made a number of variations on this seated figure during 1922 of which *Seated Man with Guitar* (fig. 54) is perhaps the most interesting in its total integration of the man, the guitar, and the chair. All become part of one another. The guitar is also the torso of the man and the man's legs are those of the chair. This is another step forward in curvilinear organization, building on the pattern of Coco Chanel's andirons.

During 1923 I was principally engaged in designing a number of reliefs for Dr. Barnes's museum near Philadelphia. I met Dr. Barnes late in 1922 when he was in Paris buying works by old masters of modern art and also looking for young talent. Someone must have given him my name and recommended me as a promising young artist. He asked the dealer Paul Guillaume to take him to my studio. This Guillaume did rather reluctantly, as we had had a falling out over an object he had for sale about which my opinion had been asked. I had advised against the object and Guillaume resented this. Nevertheless, he had to bring Barnes to me and Barnes bought a

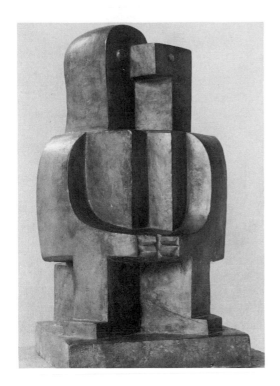

53. *Seated Man*, 1922.
Bronze, 20½" h.

54. *Seated Man with Guitar*, 1922.
Bronze, 15¾" h.

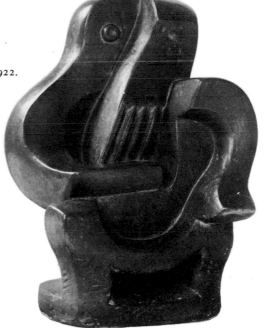

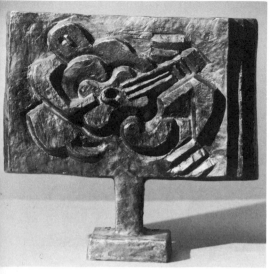

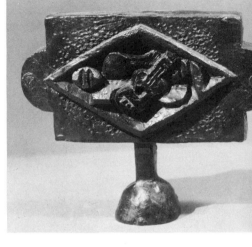

55. *Figure with Guitar*, 1922.
Bronze, 8½″ h.

56. *Reclining Figure with Guitar*, 1923.
Bronze, 7¾″ h.

57. *Figure with Musical Instruments*, 1923.
Bronze, 8″ h.

58. *Study for Garden Vase*,
1923. Bronze, 12″ h.

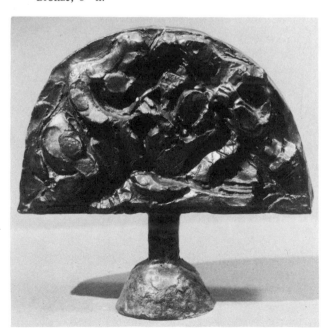

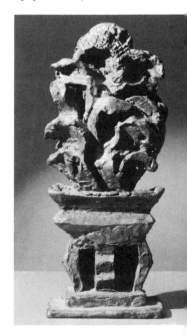

number of pieces. He then asked me to meet him at Guillaume's shop and go out to dinner with him. When I came, I must say that I was treated with great respect as a result of Barnes's interest. The first thing Barnes did on this occasion was to ask me to design some reliefs for his museum. Initially, I refused, since the building was classical in style and I did not think my sculpture would fit with it. After some discussion, I agreed to the commission on the condition that I would have complete freedom to do anything I wanted. There were five locations for the reliefs and the serious problem was the architectural shapes of these places. The wall spaces to be filled were an awkward and rather ugly shape, a rectangle with protruding curves at each end. I finally resolved the problem by creating a powerful inner lozenge-shaped frame within which I set the sculptural figures. These reliefs, on which I worked throughout 1923, again represent a breakthrough for me, the consolidation of a number of ideas that had been fermenting during the previous years. I made a number of small clay maquettes for them, studying variations on the problem. In these the theme is principally that of a reclining figure with guitar, figures with musical instruments, or simply still lifes of musical instruments. What I was searching for essentially was that total integration of the objects, the guitar or other musical instruments, with the figure so that the result would be a figure-guitar rather than simply a figure holding a guitar. I wanted to synthesize the curving contours of the figure with the more rigid geometry of the guitar shaft and the strongly angular frame within which the theme is set; in other words, a completely integrated design involving a wide range of curving volumes contrasted with straight lines and rectangular masses. These reliefs also represent a departure from the earlier reliefs in the unusually deep undercutting. Since I was not using any color and since I wanted them to be completely visible on the building from a distance, to stand out from the architectural frame, I achieved my result by making them in high relief with the strongest possible contrasts of light and shadow. Thus, they approximated almost to free-standing sculpture. It was perhaps for this reason that I began placing the maquettes on pedestals which became part of the total sculpture. This use of a pedestal, combined with the essential frontality of the high relief sculpture, suggested to me further possibilities for frontalized organization in major sculptures of the next few years (figs. 55, 56, 57). I also made two lunettes for Barnes's building, works in which I inte-

grated the figures and musical instruments with the semi-circular frame in a free and flowing manner, though still with deep undercutting. This approach was also a prophecy, an anticipation of ideas that I was to work out at a later date.

Aside from the reliefs, I was working during 1923 and later on two designs for niches in Barnes's building. For one of these I planned a monumental figure of a standing bather, a work that was in a sense looking backward to my cubist figures of the previous several years. It was in essence a large-scale summary of these previous findings at the moment when I was beginning to move away from them in a new direction. Perhaps because I was somewhat torn between this effort at recapitulation and the new ideas with which I was anxious to proceed, this proved to be an extremely difficult project. I made several different versions of it between 1923 and 1925 before I finally found a solution satisfactory to me. I also designed for another niche in this same building a large-scale sculptured vase designed to hold flowers. In the clay sketch (fig. 58), I indicated the way the flowers or plants would look growing out of the vase. The freedom with which these were rendered once more suggests the direction in which I was moving, away from literal cubism toward more organic forms. The completed stone vase in the Barnes collection is now used as a pedestal for one of my sculptures.

In the standing *Bather* (1923–1925, fig. 59), which is 80 inches high, the largest sculpture I had made to this date, I was returning to the problem of creating a cubist figure, free-standing in surrounding space, creating that space by its axial pivot. The legs are placed firmly at right angles to each other, and the circular movement is suggested by the curvilinear forms of the drapery enclosing the arm, actually enclosing space. In its final form, I think it is a successful work, despite and perhaps because of the long period of struggle that went into its making; but, at the same time, it was in a sense my farewell to literal cubism, the record of the moment when it was no longer necessary for me to concentrate on the vocabulary of forms, when I could move on to a sculpture of themes and ideas. This does not mean in any sense that I ever completely abandoned cubism. When I am asked, as I frequently have been, when I ceased to be a cubist, my answer is invariably, "Never!" It will be seen in my later works how I have continued to use the cubist point of view, continued to refresh myself at the springs of this fundamental grammar.

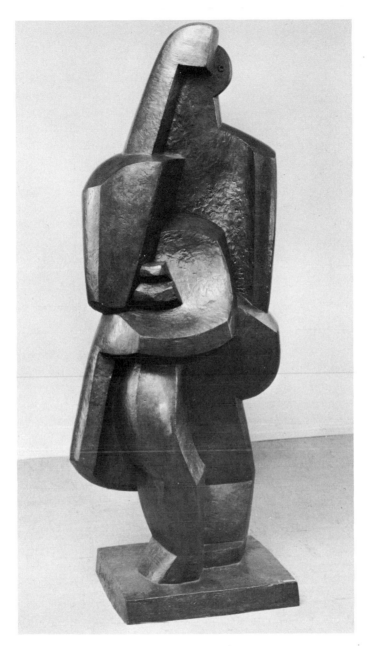

59. *Bather*, 1923–1925. Bronze, 80″ h.

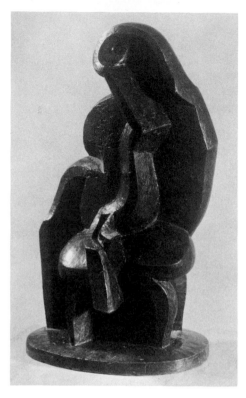

60. *Seated Bather*, 1923. Bronze, 15½″ h.
Collection unknown.

61. *Man with Guitar*, 1925. Stone,
23¼″ h. Collection Mr. I. M. Pei,
New York.

62. *Seated Man* (*Meditation*), 1925.
Onyx, 14½″ h. Collection Mr. and
Mrs. William Mazer, New York.

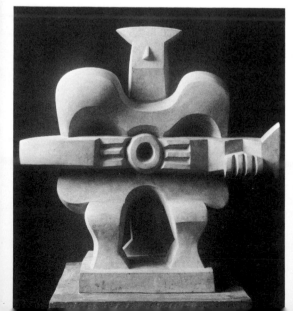

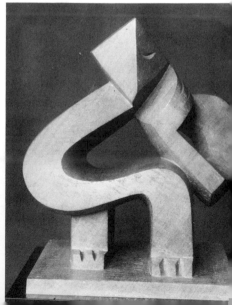

Cubism was for me the great liberating force. I realized early in my career that it had a significant role to play for sculpture as it did for painting. It was a means of re-examining the nature of sculpture as an art of three-dimensional space, mass, plane, and directions. It was a means of stating the nature of sculptural form in its simple essence and asserting the work of sculpture as an identity in itself rather than as an imitation of anything else. I feel today that cubist sculpture, by the very three-dimensional nature of the sculpture medium, contributed importantly to cubist painting. The cubist sense of form has remained with me throughout my life, even though my style may have departed radically from that of cubism in its narrower sense. During the 1920s some of my most monumental works, such as the *Bather*, 1923–1925, and *Joy of Life* (*La Joie de Vivre*), 1927, were still specifically cubist; and most of the major works of the 1930s maintain the flattened planes and the sense of rectangular masses deriving from cubism. However, by the early 1920s I knew that I needed to move beyond the simple cubist vocabulary I had learned and to find a new content, a new personal expression. Abstraction was never enough for me.

Again, this was not a conscious program of changing from one thing to another. I did not deliberately set out to develop a new subject matter. I was, in fact, strongly against what I consider the excesses of fantastic subject that the surrealists were beginning to explore. To me, fantasy has a particular and somewhat disagreeable connotation, that of uncontrolled Freudian experience. I oppose to it what I think of as imagination or content, which I was seeking and have continued to seek, but imagination with a human base and the control of my hard-earned formal vocabulary. I recognize that there is an element of surrealist expression in the art of many different cultures. Even so traditional a work as the Venus de Milo is, in fact, greatly distorted in terms of human proportions, and could be called surreal. This is even truer of the highly elongated Romanesque sculptures; we could argue that a table, which is made out of a wood tree trunk but changed out of all recognition, is a surrealist object. I have even experimented with a kind of semi-automatism. I remember an assistant of mine, Isadore Grossman, who was also attending school and who reported that a professor of his had dropped a lump of clay on the floor and then, picking it up, said, "That's a Lipchitz." This intrigued me to the point where I started taking melting pieces of wax,

cooling them in a basin of cold water, and then molding them blindly with my hands to see what happened. Sometimes some extremely interesting images emerged, but the crucial point was that I then had to take these first suggestions and, with the knowledge and control I possessed, transform them into a work of sculpture. The artist must be free to do whatever he wants, but his freedom is, in fact, limited by an enormous number of different factors—how he feels on a particular day, whether he is tired or ill or emotionally exhausted. Sometimes the inspiration will come from some chance observation at a time when nothing seems to be going right. In 1930 I was making a mother and child and could not find any satisfactory solution in my sketches. Then I suddenly saw a strange cloud form in the sky which came like a moment of revelation to me. I immediately incorporated it into my sketch and my problem was solved. But I still go back to this question of a personal vocabulary which the artist must learn, which must become an innate part of him, whether he realizes it or not, and which then controls or directs everything that he does. I never deserted the subject, even in my most abstract, cubist sculptures, because I have always believed that there must be communication between the artist and the spectator. The spectator must in the last analysis be able to see the human image in the sculpture, to be able—even though it requires a long and painful process of education such as the artist had to go through in making the piece—to come to an understanding, a meeting of the minds.

To return to the maquettes or reliefs that I made in relation to the Barnes commission and which I continued to make after this time, my incorporation of a pedestal for them arose from the fact that I now wanted to think of the relief as a complete piece of sculpture, a totality in itself. When I actually attached it to the wall, it seemed to become an anomaly, a part of something else, something foreign to it and thus not totally satisfactory.

The commissions from Barnes were not only useful in themselves. Barnes's reputation as a connoisseur of art helped to promote my sculpture and I was soon selling to other collectors from Philadelphia, New York, and Paris. I thus entered into a period of relative affluence that continued until the Depression of the 1930s. In 1926, I joined the gallery of Madame Bucher, although I maintained my independence and reserved the right also to deal with other galleries. During 1924 I was still working on the Barnes commission and was producing a

number of other sculptures. Despite continuing financial problems and illnesses of different members of my family about which I worried a great deal, I was working well, still making sculptures primarily of a massive and frontalized character. I must continually repeat what I have said many times, that at the moment of working I could not visualize all the implications of what I was doing. I always worked intuitively from step to step, continually dissatisfied and seeking a direction or a goal which I could not always see. When I have expressed my belief in the superiority of the modeling approach in sculpture over that of direct carving in stone (at least for me), I have never intended to say that I thought it was any easier. Although working with the soft clay enables the sculptor to catch an idea or an image immediately, the final image that emerges is the result of countless false starts, of countless clay maquettes that are destroyed before there suddenly appears one which magically reflects the unformed idea in his mind.

As I look back now, after almost fifty years, at the sculptures I was making in the early 1920s, I am able to see things happening that I did not consciously realize at the time. Many of these are particularly apparent in the little maquettes, those first ideas for sculptures, some of which were not fully realized or developed until years later. Although, as I have pointed out, in the period after the First World War many of my major free-standing sculptures were becoming more solid, massive, and frontalized, emerging like Egyptian Pharaohs or primitive totems, I can now see the genesis of a number of other experiments which were to result in my work taking two separate directions. There was first the tendency toward a new kind of curvilinear movement initially apparent in the sketches for a reclining woman, related to the rococo firedogs I made for Mademoiselle Chanel. This free, curvilinear tendency is also very apparent in the reliefs I did for Barnes and particularly in the preliminary maquettes for these reliefs. In most of these I was intrigued by a contrast of opposites, the highly organic, freely flowing figure-form set within a rigidly geometric architectural frame. In other reliefs, as I have noted, such as the lunette for Barnes, the entire figure composition is so free that it can be described as baroque in its movement. This organic, free-form tendency is also apparent in the treatment of the flowers I sketched in the maquette when designing a garden vase for Barnes. My explorations of a more open sculpture with interpenetrations be-

came more explicit in the 1921 maquette for a garden statue in which I cut a series of diamond-shaped holes and also in the original maquettes for a number of the sculptures I made during 1924 and 1925. Thus, although I probably did not realize it at the time, there were many different sculptural ideas fermenting: in general, the two different directions of static, frontalized mass and open, curvilinear movement. While I was more obviously studying and expressing the heavy material of sculpture, in a word, its fundamental, physical aspect, I was at the same time tentatively exploring the intangible spirit, if you will, the soul, that underlay the physical reality. Out of this exploration emerged my transparents, those extremely free, open sculptures with their total inversion of space and solid, and out of all these different ideas emerged my concepts of subject, of sculptural content.

There is a small *Seated Bather* (fig. 60, 1923) which, I think, indicates some of the ideas I have been discussing. This is a figure seated in an armchair. It reflects some of those ideas I was concerned with involving the complete integration of a human figure with an object, whether it was the harlequin or Pierrot with guitar or the woman in a chair. The sculpture emerges from the very abstract maquette of *Seated Woman in Armchair* I made in 1921, but now the figure, or the woman-chair, takes on a specific personality, a spirit of humanity. To me, as I look at it now, it has a kind of tenderness, not unrelated to late medieval conceptions of the Madonna and Child, although I know that at the time I made it I was thinking of nothing like this. This is, as I said, a small sculpture but it is quite complete, a total assimilation of the figure to the object, easily and completely realized in the round. When I made it on this small scale, I knew it was complete; there was nothing further I could do; there was no point in attempting to enlarge it, to make it monumental, so I simply left it as it was.

Totally different and indicating the dichotomy I have been discussing is the *Man with Guitar* (fig. 61), one of the first pieces I made after the Barnes commission. This is an aggressively frontal conception in which the guitar is so completely a part of the man that he becomes a man-guitar. The body of the guitar is the body of the man. This is also a man seated in a chair which is part of the man. His legs are like the legs of a chair or stool, even to the point where I give him three—two at the front and a central one at the back. The next stage

in terms of abstract simplification is the *Seated Man* (*Meditation*) (fig. 62), which grows out of the 1922 versions of a *Seated Man*, but now, perhaps because of intervening reflections on the question of personality and mood, of specific subject or identifiable attitude or individual, is much stronger. As a form, we have simply the block of the head with suggestion of a half-closed eye, the S curve that is the reclining torso and one leg, the contrasting curve and diagonals of the arm, and the vertical mass of the other leg. All of this translates into a weary man, slumped in a chair, his arm supporting his nodding, drowsy head. The personification involves a deliberate element of humor. I recall a businessman I knew who, when he saw this piece, exclaimed, "My God, that's exactly how I feel at the end of the day." In terms of form there is, finally, a most significant departure, the opening up of the spaces to the point where not only are the intervals between the legs and the arm completely interpenetrated, but the torso is actually a void encompassed by the S curve of the solid stone or bronze. Here we can see the first stage in the concept of the transparents, of sculpture as space, as air or spirit rather than as solid mass. The maquette for this piece illustrates the spirit of open freedom even more than does the finished sculpture. There is another maquette, which I think was made before either of these, a man leaning on his elbows, 1925 (fig. 63), in which the concept of transparency is even more evident. This is simply a skeleton figure, a framework of elongated torso, inclined legs and arms folded up over the head, in which every tradition of solid and void in sculpture is reversed. It was one of a whole series of maquettes that I made about this time, a series in which there was no deliberate theme, but in which I was groping for an idea, something that I felt I needed to explore in sculpture even though its exact nature was not yet clear to me.

The idea of openness was further explored in a different manner in *Musical Instruments* (fig. 64), a free-standing sculpture that emerged from some of the reliefs of musical instruments created in 1923. It is also related to some free-standing maquettes of 1925, two versions of *Woman with Guitar* and, even more, with *Woman with Mandolin* (fig. 65). The *Woman with Mandolin* embodies an element, the suggestion of a hooded figure, which in the bronze of the *Musical Instruments* is translated into a kind of architecture. The subject of a hooded figure, as I see it now, was probably one of the earliest anticipations of that hooded figure I was to use years later in such

works as *The Prayer*, 1943 (see fig. 147), and the versions of *Sacrifice* (see figs. 162, 163, 164). In a sense, I can now see even earlier relations in the 1921 maquette of *Seated Woman in Armchair* and, going a long way back, in a 1916 *Figure* in which the figure is enclosed within an obelisk form. There is another *Man with Mandolin*, 1925 (fig. 66), perhaps not too important in itself, but interesting in this context in that the man is again shrouded in a pointed hood. The *Musical Instruments*, like the reliefs, is more specifically cubist in feeling than the *Meditation* or other works of this year, but it is cubism with a difference, extremely free, open, interpenetrated, and dynamic. The guitar or mandolin becomes a dancing figure and both figure and guitar become a kind of architecture. This is a work, despite the memories it invites, that is probably unique. I cannot think of anything quite like it, although it does have relations, in its free and open use of cubist forms, with the *Joy of Life* I made two years later.

There are many maquettes of this period that, I now realize, were looking forward to both forms and themes I only developed years later, in the 1930s and even the 1940s. For instance, there is another version of the *Meditation*, a small maquette dated 1926 (fig. 67), which is again the man leaning on his elbow, his other arm stretched over his knees. The difference, however, between this and the 1925 *Meditation* as well as the maquette for that work is that the later one is a much more organic, naturalistic bone structure, in a way closer to actual humanity and definitely anticipating many of the large organic sculptures I created during the next decade. I love these little original maquettes. They are so fresh and warm in feeling, not worked out and cooled off. Here I can see my natural capacities. I can sense the periods of struggle and uncertainty and those marvelous moments of lyrical expansion when nothing could go wrong. When I think back on these subjects, such as the man leaning on his elbows that I entitled *Meditation*, I cannot be certain of their origins. I know, however, that such themes always emerged from some visual impression of an actual individual whose state of almost helpless exhaustion was caught and remained in my mind until it finally appeared in the sculptures. There is another maquette, dated 1925 (fig. 68), that is quite explicitly the first germ of an idea for the *Sacrifice* and *Prayer* series I executed during the 1940s. In this, the man holds the cock of expiation over his head, prepared for the sacrifice. I know that the later, completed sculptures had a particular significance for me, re-

63. *Man Leaning on Elbows*, 1925.
Bronze, 4½″ h.

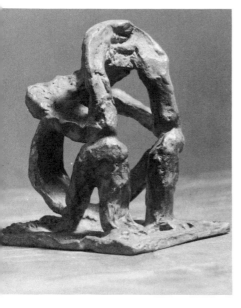

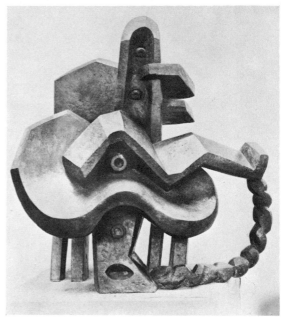

64. *Musical Instruments*, 1925. Bronze,
29″ h. Collection Mr. Charles Benenson,
New York.

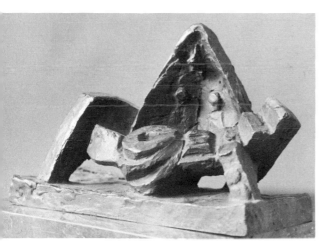

65. *Woman with Mandolin*, 1925.
Bronze, 5½″ h.

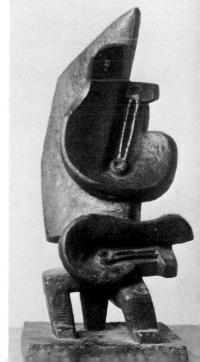

66. *Man with Mandolin*, 1925.
Bronze, 18″ h. Collection Mr. Kern,
Caracas, Venezuela.

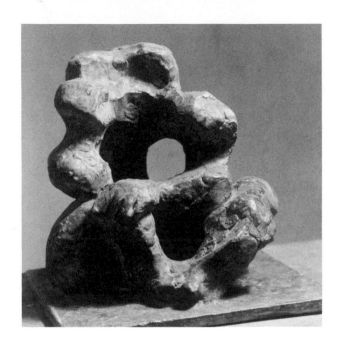

67. *Meditation*, 1926.
Bronze, 7″ h.

68. *First Idea for Sacrifice*, 1925.
Bronze, 7¼″ h.

69. *Pierrot*, 1925. Bronze, 5″ h.

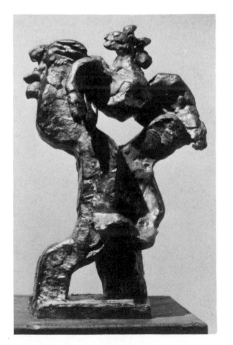

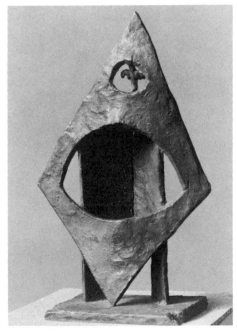

lated to the Second World War, but I cannot recall what motivated this first cursory statement of the theme. It must have had something to do with suffering, perhaps the difficulties and illnesses of my family which were preying on my mind. In any event, although it was an idea that was not carried out until years later, it was a work of great importance to me, both because it was one of the earliest complete narrative subject themes and because it was the first attempt I can recall at a specifically Jewish theme. Although during much of my life I have not been a practicing religious Jew, I have always considered myself a religious man. I was educated in a religious family and the teachings of my youth have remained with me, affecting me more profoundly as I have grown older and come to understand them more deeply.

Right after the *Man with Mandolin* (see fig. 66) came the first transparent, the *Pierrot* (fig. 69). This was a surprise to me. One day I was at the Sorbonne at a lecture given by a German art critic. He had such a terrible accent that I could not listen to it, so I absorbed myself in my thoughts and suddenly I saw how to make something that I had apparently been longing to make for a long time. So I left the lecture and went home. There I built it from cardboard the same evening. I went to bed, impatient to go the next day to the foundry and speak with the technician there, the brother-in-law of Valsuani, who had died. His name was Spor and he was a very good technician. I asked him if he could make it in bronze, and he said that it would not come out. But I said let's try it. So I built it up in wax, a small thing, and we discussed how to cast it and it came out. This gave me courage and I made more complicated things. The problem was the extreme thinness of the elements and the fact that this kind of casting had not been done before. Little by little we started to be more courageous, and everything came out; it was marvelous. Later, I made things in America, much more difficult, of different materials. I wanted to introduce space and light into sculpture itself and make it quickly, as quickly as my inspiration came and my imagination dictated. These works have the quality of a sketch, except that they are the final work. When this concept came to me, I was in a state of euphoria; I did not feel the earth under me: it was a wonderful time.

The 1925 *Pierrot* has relations with some of the preceding figures, such as the 1925 *Man with Mandolin*, in terms of the hood that surrounds the head or features. The hood is obviously related to the

Pierrot concept, but, as I said, I was to use it later in some of the hooded *Sacrifice* figures.

The *Harlequin with Guitar* (fig. 70) was the first transparent I made in 1926. We were still struggling with certain technical problems in terms of casting; the fingers, which are also the guitar strings, did not come out originally, but these we could repair with wires and weldings. This figure has some relationship to some of the figures of 1915 in the construction of right-angle planes. I think it was followed by the small *Harlequin with Banjo*, an extremely simple composition of two overlapping planes, made directly in wax after I had learned more about the process of preparing the wax. I bought a small stove to warm the tools and worked in my studio. *Seated Figure with Book*, 1925, is an adaptation of the 1925 *Man with Mandolin*, in which the figure composed of interlocking planes becomes the mandolin in a total sense. The planar legs of the figure are like details of musical instruments. All of these pieces were extremely quick in execution. I normally made them in a day or two, continually excited by the feeling that I had embarked on a whole new pattern of expression.

Probably the next is the *Pierrot with Clarinet*, 1926 (fig. 71), a frontalized figure in which the space penetrates deeply and is clearly defined by the sculptural planes surrounding it. In this work, I feel that the first tentative experiments have now begun to be realized in an effective manner. The idea of sculptural volume as controlled space is clearly apparent. Another related work is the *Woman with Guitar*, 1926, which develops out of the previous one. I feel that this is still somewhat raw. The treatment of the head is good but the breasts are perhaps too linear, too silhouetted. *Seated Man with Accordian*, 1926, is more successful, although still, perhaps, too silhouetted. For instance, the accordian is apparent as such but does not give the volume of the instrument. It is more like a drawing.

These transparents, which came upon me with no warning, were a fantastic experience. I had been working for the past several years toward a form of expression continually more solid and monumental. Suddenly, I found myself playing with space, with a kind of open, lyrical construction that was a revelation to me. I have no idea how I came to this. It simply happened; but it was an ecstatic experience. I felt as though I were discovering an entirely new concept of sculpture as space, of the ethereal soul of the sculpture rather than its physical corporeality.

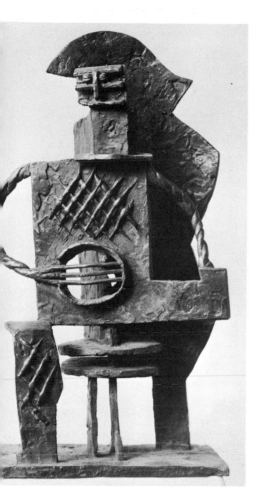

70. *Harlequin with Guitar*, 1926.
Bronze, 13¼″ h.

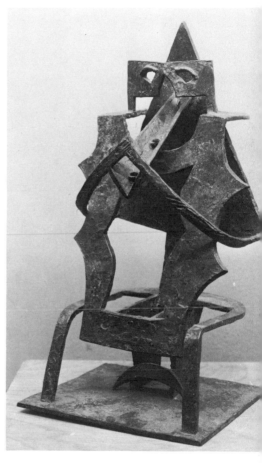

71. *Pierrot with Clarinet*, 1926.
Bronze, 14¾″ h. Collection unknown.

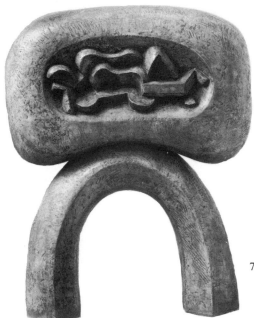

73. *Ploumanach*, 1926. Bronze, 30¾″ h.

74. *Sketch for Figure*, 1926.
Bronze, 9¾″ h. Collection
the Reis Family, New York.

72. *Ploumanach*, 1926. Bronze, 7″ h.

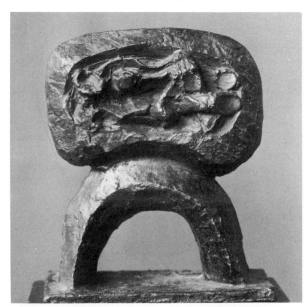

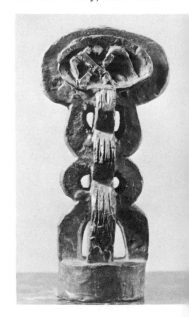

# Chapter 7

During the summer of 1926 I was at Ploumanach, a resort on the Brittany coast. There I was intrigued by some natural formations of rocks in the water off the shore. A series of tremendous stones was suspended on other stones which had been largely washed away by the waves. The large stones were thus held in a delicate equilibrium. When a wind was blowing, they moved and swayed. The feeling of these great, suspended rocks was captured in a sketch I entitled *Ploumanach* (fig. 72). The sketch does not really look like the rocks but it gives the feeling of them. Since there were people lying on the beach, I included a reclining figure on the rock. This has to do not only with the particular association but with the reliefs I had made earlier for Dr. Barnes. The first completed sculpture of the *Ploumanach* was made in ebony and the enclosed reclining figure includes explicitly a mandolin. It was soon translated into bronze (fig. 73). Here we have once more a frontalized totem, a concept toward which I had been working for a number of years. It is obviously related to some of those reliefs out of which I made free-standing sculptures on a pedestal as well as the small sketch for a garden figure designed for Mademoiselle Chanel. The fact that this concept was preying on my mind is made evident in the two small sketches for a *Figure* (1926, fig. 74). In these I was, half unconsciously, working out the various ideas that had been coming together during the previous several years. In the sketch there is still a reclining figure in the top part, but I must have begun to see this as a primitive totem, for in the next sketch I

transformed the upper part into a head with an indication of staring eyes. This was the genesis of the great *Figure*, 1926–1930 (fig. 75), a work that summarized many of my ideas dating back to 1915. Specifically, it pulled together those different directions of massive, material frontality and of aerial openness in which I had been working during the 1920s. It is also very clearly a subject sculpture, an image with a specific and rather frightening personality. Although the *Figure* has been associated with African sculpture and the resemblance is apparent, it is now evident to me that it emerged, step by step, from findings I made in my cubist and postcubist sculpture over the previous fifteen years.

The realization of the large *Figure* was the result of the fact that a lady, a Madame Tachard, who wanted a statue for the entrance to her house, saw the terra-cotta sketch and asked me if I could enlarge it for her. Otherwise I might not have done so since the sketch seemed to me to be complete as it was. It is always fascinating to take a small maquette and to conceive from it a monumental sculpture. The large *Figure* is important to me as one of the first major realizations of ideas I had previously developed on a small scale. From this point forward, I think I began to be concerned more explicitly with this question of monumentality in my sculpture and to look at my maquettes with new eyes. Incidentally, there is a rather amusing incident about the *Figure*. A critic wrote some fifty pages proving that in this image I was thinking about my mother. This was an obviously Freudian interpretation resulting, perhaps, from the fact that the domineering figure involved familiar sexual symbols. All I can say is that the interpretation is absolutely wrong and anyone who traces the genesis of the *Figure* from my previous images can see this. I must admit that I thought the interpretation was very funny. Even though I do not necessarily agree with them, I am always most interested in the interpretations of my sculptures by others. Sometimes I learn from them. For example, when I made the *Return of the Prodigal Son* in 1930, my friend Juan Larrea saw in it a child drinking. This I had not intended but I could understand what he meant. Strangely enough, I remember that when I was making the sculpture, I frequently felt a kind of thirst.

In 1926, after the sketches for *Figure* and *Ploumanach*, I continued with my transparents. *Harlequin with Banjo* (fig. 76 a, b) is a true transparent and the first one I sold, to a distinguished connoisseur,

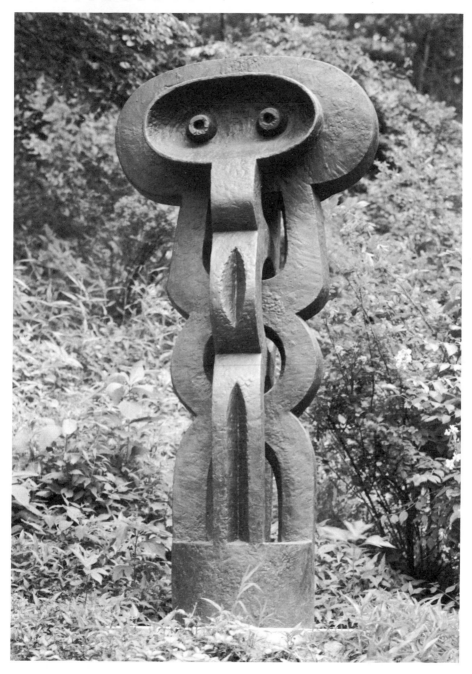

75. *Figure*, 1926–1930. Bronze, 85¼″ h. The Museum of Modern Art,
New York, Van Gogh Purchase Fund.

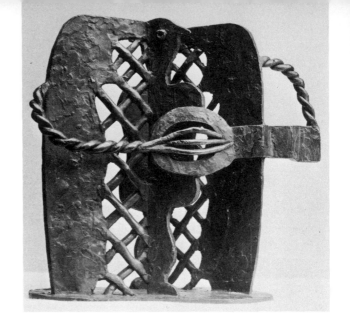

76. *Harlequin with Banjo*, 1926. Bronze. Private collection, France.

77. *Pierrot Escapes*, 1927. Bronze, 18¼" h. Kunsthaus, Zurich.

78. *Acrobat on a Ball*, 1926. Bronze, 17¼" h. Collection Baroness Gourgaud, Yerres, France.

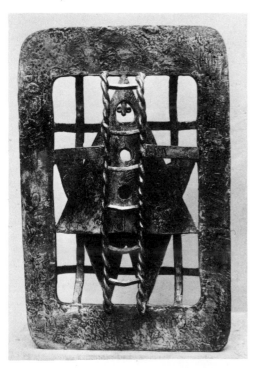

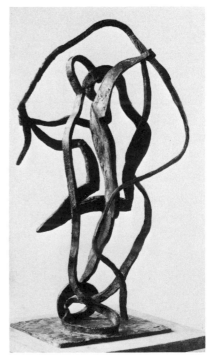

Alfonse Kahn, with a great collection. When he saw it, he fell in love with it and immediately took it away with him. I could not even have it photographed until later. I remember he wrote me a charming letter: "Dear Mr. Lipchitz, I put your sculpture in my vitrines one after another, beside the masterpieces of ancient art, and it holds up; I congratulate you." This gave me great pleasure. It always gives an artist the warmest feeling to have a response from those who own his works or even have seen them. The *Harlequin with Banjo* is made in two separate parts, with many different views of the interior space encompassed by the sculptural planes and grids. This is not only a figure, but an environment with the suggestion of the room that encloses the figure, all of this conceived lightly and poetically.

*Mardi Gras*, which follows the *Harlequin*, involves similar principles of interlocked, open planes moving in depth. These transparents immediately caught the imagination of a number of critics. Waldemar George, publisher of the magazine *L'Amour de l'Art*, wrote a major article with many photographs in 1925.

Among artists, these pieces were extremely successful; Picasso liked them very much and one day spent half an hour studying a piece at Madame Bucher's gallery. About 1929 he began to make free-form iron constructions, first employing Julio Gonzalez as a technician. Gonzalez then began to make constructions of his own, influenced by Picasso, and soon others were making them. During the late 1920s, surrealism was in the air in Paris, and Picasso was painting in a manner, or rather a series of manners, associated with it. These were the so-called bone, or metamorphic, paintings, and he made a number of sculptures related to them during the early 1930s. Most of them were large heads modeled in clay and plaster; there were only a small number of metal constructions at this time, although later in his career he returned to construction. The surrealists quickly claimed Picasso for their own, although he never officially joined the movement and his fantastic paintings had his individual stamp on them. Some of my small transparent figures were also claimed by the surrealists as embodying their kind of fantasy, but this was nonsense. Certainly, in a number of the harlequins and other figures, there is at times a deliberate suggestion of playful humor, and there is in many an increasing quality of specific personality. But, as I think I have demonstrated clearly, these were elements growing slowly and logically out of my previous work as I became increasingly desirous of

emphasizing the quality of imagination, the human or spiritual aspect of the figure. The transparents also involved continual exploration into free, light, spatial values and in many of them, as can be seen (for instance *Acrobat on a Ball*, 1926, and *Acrobat on a Horse*, 1927), these qualities of open space were explored in a freely nonfigurative manner.

For a period I sold very few of these transparents except to one or two individuals like Mr. Kahn and a friend of mine, an architect, Chareau, who saw the *Woman and Guitar* (now in the Joseph H. Hirshhorn Collection) and fell in love with it. I remember I had lunch with Picasso on the first of January, 1927, and afterward we went to my studio. He looked around and said, "I wonder you still have all these things." But, although there were a number of critical comments on these transparents, both good and bad, they did involve such a new concept that even collectors who were patrons of my other works found it difficult to comprehend them at first. I exhibited some of them at the gallery of Madame Bucher, who was a good friend and believed in my work. She handled a number of the surrealists, so it was sometimes difficult for me not to be associated with them even though I disliked most of the things they were doing, except for Max Ernst. I was instrumental in placing the sculptor Giacometti with Pierre Loeb, then one of the leading dealers in surrealism. At that time, Giacometti was a talented young sculptor who as yet had received no recognition. Although his works were very different from my own, I recognized his talent and did what I could to help him. At Loeb's gallery he met the surrealists and soon joined the movement. After this, I am sorry to say that he turned against me, something I regretted from a personal point of view, although there was no bad feeling on my part. The attitude of the surrealists was that everyone who was not for them was against them.

I had parted with Dr. Barnes in 1925 on bad terms and he was no longer a patron of mine. He saw some of the transparents in my studio but he certainly did not buy any. Barnes was a marvelous man, extraordinary, but extremely difficult. He was a self-made man and had a tremendous desire for power. Nevertheless, he deserved what he got because he had an excellent eye and was extremely courageous in his gambles on young and unrecognized talent. Although he respected my opinions and bought the works of artists I recommended to him, he always made up his own mind. He had no official advisers in his

purchases. He became extremely bitter about ignorant attacks on his collection when it was opened to the public. The collection, incidentally, contains over fifty Cézannes and 175 Renoirs and some of the best Seurats, but the American public was then not ready even for these great masters. So he closed his museum for everyone except students and it is only after his death that the general public can see the works, although this still must be done by written request.

The atmosphere of Paris during the 1920s was very different than it had been during the war. At that time we were all working together and sharing ideas. But after the war even artists who had earlier been very close began to drift apart, each pursuing his own way. I, as I have said, was concerned with liberating myself from the more rigid aspects of cubism and developing a new freedom in my expression. I remember that in 1927 I made a sculpture entitled *Pierrot Escapes* (fig. 77). This is a flat construction, almost like a relief in effect, although it is a free-standing work. Pierrot is shown within a wide metal frame behind bars but with a ladder in front of him with which he is escaping from his prison. The whole idea is extremely personal, a reflection of my excitement in the discovery of the transparents. Pierrot is myself escaping from the iron rule of syntactical cubist discipline, from all the taboos, regulations, and restrictions we had set up for ourselves, to become a free man. I must always repeat that cubism was originally for me a blessing, a marvelous enlightenment, and the discipline that I learned through it gave me real support in my later life. It gave me the necessary confidence so that ultimately I could be free. This was not a freedom at any price, but a slow and painful process that reached something of a climax in the period of lyrical expansion first apparent in the transparents. I think the *Pierrot Escapes* is now at the Zürich Museum. It was bought by Madame de Maudrot, who commissioned the *Song of the Vowels* and who bequeathed her collection to Zürich.

The *Harlequin with Clarinet*, 1926, which came after the *Pierrot with Clarinet* (see fig. 71), was made in much the same style, in a sort of linear pattern. I think this is still a little simple. The next is the *Acrobat on a Ball*, 1926 (fig. 78), which is quite different. This is the sculpture of which Klee made a painting. It is a drawing in space, a fascinating work, but I like some others much more, for example the *Mardi Gras* or *Woman and Guitar*, 1927 (see fig. 80). Why I like this better I do not know. After the *Acrobat on a Ball*, I made a relief,

*Reclining Woman*, 1926, an interesting work but somewhat decorative. There are other reliefs which are better. The next is an *Acrobat on a Horse*, 1927 (fig. 79), and another of a similar subject, *Circus Scene*. I think I was visiting the circus a great deal at this moment. *Circus Scene* is a plaque rather than a relief. Another *Circus Scene*, 1928, a free-standing sculpture, again illustrates this fascination with the circus. There may be in these transparents an echo of those Scythian sculptures I saw many years before in the Hermitage. I was not aware of this at the time, but as I look at them now, I realize there may be a relationship. I have sometimes thought that there might be Asiatic blood in me. My eyes are somewhat Mongolic, slightly raised at the outside corners. My family lived on a frontier, invaded many times; perhaps a Cossack soldier raped a great-grandmother of mine. The next pieces are the *Harlequin with Accordian*, 1927, and *Seated Harlequin with Banjo*, 1927. These two were made as presents for the son of the foundryman, Valsuani, and his technician, Spor. They still own the works. Of the pieces that I made at this time, the *Woman and Guitar*, 1927 (fig. 80), is one of my favorites. I cannot explain this, but I like it. Look at how the head is treated. It is an exciting and adventurous piece that embodies all the ideas I had about space and subject at this moment.

In 1927 I had one of the great commissions of my life, the *Joy of Life* (fig. 81 a, b). The Viscomte Charles de Noailles visited me one day and said that he was building his house in the south of France and that he would like to have a sculpture by me. The house was at the end of a garden at his estate at Hyères, like the prow of a boat on the top of a mountain. Because of the location and the problem of seeing the sculpture in the round, I suggested installing a machine so that it could rotate. Thus, it became a mobile. At this time my sister was very sick in a hospital and, in order to cheer her up, I decided to make something gay. It was for this reason I called it *Joy of Life*. The motor ran perfectly and made a complete turn every four minutes as I had intended. When I saw it turning, however, I saw certain things that were not to my liking, so I made little corrections in the plaster. *Joy of Life* is a dancing figure with a large guitar, related to and, I think, a result of many things I had done before. It is a culmination of all my findings in cubism but at the same time an escape from cubism. Although this is a monumental work, over seven feet high, it is open like the transparents. The figure itself pivots on an axis like

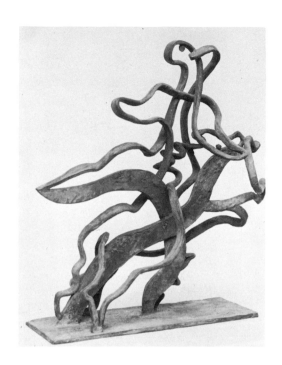

79. *Acrobat on a Horse*, 1927.
Bronze. Collection unknown.

80. *Woman and Guitar*, 1927.
Bronze doré, 10¼" h. Collection
unknown.

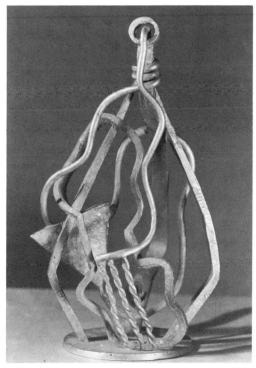

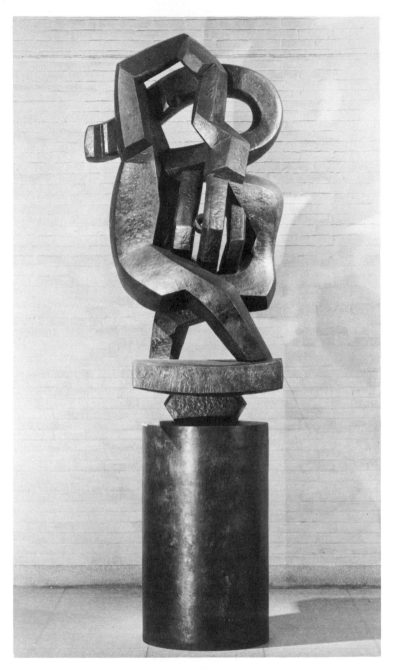

81. *Joy of Life (La Joie de Vivre)*, 1927. Bronze, 89¼″ h. Albert
Einstein College of Medicine, New York.

some of the earlier cubist works to create its own sense of three-dimensional space by the large masses which are interpenetrated from every point of view so that space flows around and through the sculpture. Although the volumes are very free in their curving movement, disciplined by sharp forms, they embody a sense of sheer simplified mass that characterizes the large works of the next years. The quality thus arises from a combination of lightness, mass, and motion.

This was one of the most tragic periods of my life. Both my father and my sister, whom I loved very much, died, and, while my sister was in a sanitarium outside of Paris, I received word that her husband was also dying. Their daughter later also perished in the Warsaw ghetto during the Second World War. Despite the fact that I was now a successful artist, selling well, and I received a number of other important commissions during the late 1920s, I had severe money problems as a result of my efforts to help my family. I had not even finished paying for my house. Fortunately, I was saved on one or two occasions by being able to sell a large Picasso I owned and by discovering an important painting by Goya. Many pieces from my collection also had to be disposed of in order to enable me to survive.

Immediately after the *Joy of Life*, in 1928 I made another large sculpture, *The Couple*, or *The Cry* (fig. 82). This is clearly a sexual work of two lovers embracing. The idea for it actually arose from my despondency at the deaths of my sister and father. I was filled with a terrible sorrow and depression, but, since I am not a pessimist by nature, I made this sculpture as a kind of release, a defiance to show that in the midst of tragedy life must continue, that we must live and multiply. In the midst of death there is love and procreation and birth. This is how the sculpture came about, as a hopeful and optimistic reaction to tragedy. Although it seems ridiculous today, with all the permissiveness apparent in painting and sculpture, in the motion pictures, in our entire society, at the time this was produced it was thought to be extremely shocking. Under the title of *The Couple* the subject was immediately apparent, and I could not even send it for exhibition outside of France. Since this was a nuisance, I changed the name to *The Cry*, since the heads of the two figures combine in the effect of a single screaming head. Under the new title, no one even recognized it for what it was until it was shown in Amsterdam at the time of the three hundredth anniversary of Rembrandt. At that time, as I said earlier, a journalist realized what it represents and wrote a

sensational story about it, creating such a scandal that it had to be removed from the exhibition. The mayor of Amsterdam wrote me a letter of apology saying that there was nothing he could do about it. Under the title of *The Couple*, I showed it at the Gallery Bernheim Jeune in Paris in the 1930s without any difficulty. However, I continued to have problems with it. Someone told me that I could not send it to the United States for fear that it might be seized as pornography by American customs. I had a large exhibition scheduled in New York in 1935 at the Brummer Gallery but Brummer was afraid to show it for the same reasons. All of this now seems a great fuss over nothing, but I did resent the scandal, since my motives in making the work were so deeply imbedded in my personal tragedy and in my attempt to overcome this by a positive and joyful statement of hope. It is possible that the problems I had with this sculpture, *The Couple*, affected a number of other works that I made during the next several years. In any event, I became intrigued with the idea of a loving embrace which was also a kind of conflict, a sort of love-hate relationship. This will be apparent in such works of the 1930s as *Return of the Prodigal Son*, 1931, *Jacob and the Angel*, 1931 (sketch), *The Embrace*, 1933–1934, and *Song of Songs*, 1945–1948 (see figs. 102, 104, 117, 118, 152).

During 1928 I had a commission from M. Doucet for a chimney piece for his house on the other side of the Bois de Boulogne in Neuilly. This consists of a mantelpiece and andirons. The mantelpiece is of a single piece of stone; the andirons, in bronze, are two doves which repeat the central motif of the mantelpiece above in which two symmetrical dogs are barking at the doves. The space behind the mantelpiece is open and slanted. M. Doucet wanted to put gold behind, but I was against this idea, so I made the inclined plane to reflect the fire behind it. The fire creates a kind of movement behind the relief, and gives it the illusion of being gilded. This is a decorative work with no particular idea behind it. It is merely a composition. There was another pair of andirons which I made in the early 1930s for Pierre David-Weill, the banker (the son of the great collector), who is the president of the trustees of the Louvre. They represent two mermaids, each with double breasts and a tail, the hair flowing out behind. Another chimney piece was designed for the Comte André de Fels about 1932, which includes two firedogs and a piece over the mantel, all involving battling beasts. These decorative works were

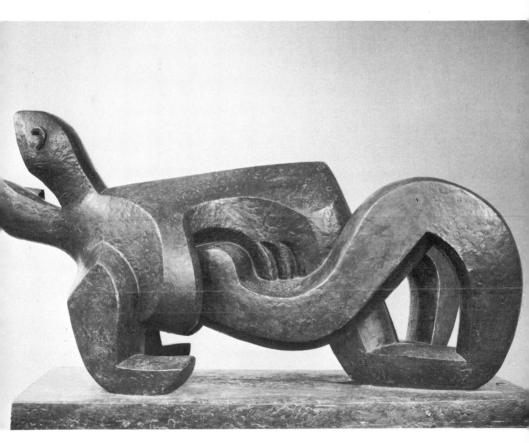

82. *The Cry* (*The Couple*), 1928–1929. Bronze, 28″ by 58″.

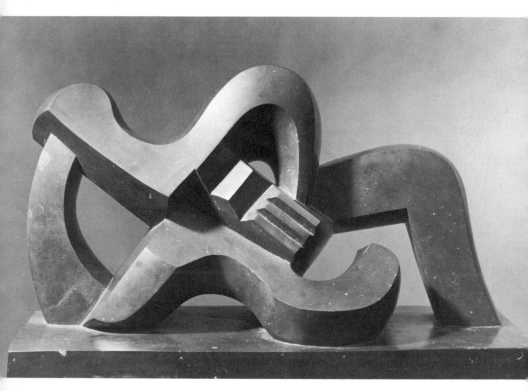

83. *Reclining Nude with Guitar*, 1928. Basalt, 27″ l. The Museum of
Modern Art, New York, extended loan from Mrs. John D. Rockefeller III.

done, frankly, as commissions to make a little money, but in every case I tried to realize them as completely as possible and in them, I think, one can see the development of certain ideas in my sculpture from cubism to a pattern of greater anthropomorphic freedom.

To return to 1928, a more important piece is the *Reclining Nude with Guitar* (fig. 83), made first out of black basalt, a piece of stone which I already had. Since this was not large enough for Madame de Moudrot, who wished it for her garden, I made it again of a white stone, with the pedestal in a rough stone. Madame de Moudrot purchased this work along with the *Song of the Vowels*, which I executed in 1931 and 1932. The basalt version of the *Reclining Nude* was purchased by Mrs. Rockefeller from the Curt Valentin Gallery and is now in the Museum of Modern Art, New York. The subject is a reclining figure with a guitar; the curved shape of the right leg is also the shape of the guitar. This is again a total assimilation of the figure to the guitar-object; even the left arm reiterates the shape of the guitar. The work is massively conceived in curvilinear volumes, with a strong sense of frontality, but involving a movement in and out of depth. Thus, the lower, or right, leg is composed at a diagonal directing the eye through the space below the left leg. Similar planar diagonals under the head and the left arm emphasize the opening void. This sculpture is a development of the 1925 *Seated Man* (*Meditation*) (see fig. 62), and is a transitional figure in the entire sequence of reclining, embracing groups of the next decade.

A number of maquettes of 1928 and 1929, although much more free in their organization, are closely related to the *Reclining Woman*. These include *Reclining Figure*, 1928; *Reclining Woman*, 1929; a relief, *Reclining Woman with Drapery*, 1928; a drawing, *Reclining Woman*, 1928; *Couple in Hammock*, 1929; and *Reclining Figure*, 1929 (fig. 84). Since I was busy during 1927 with the *Joy of Life*, I made few small transparents at that time. Perhaps the most important transparent of 1928 was that entitled *The Harpist* (fig. 85). During that year my wife and I had a subscription to the Paris Symphony Orchestra at the Salle Pleyel, where we always had the same seats. In these seats we were close to the corner of the harpists, and I became fascinated with them. It was not only the music but the glittering of the harps that intrigued me, to the point that I made a sketch of them. Then I designed the transparent of *The Harpist* in which I attempted to suggest the sensuality of the total musical experience involving the

woman playing and embracing the harp. This led to an entire series of sculptures involving the harp, climaxed in the monumental *Song of the Vowels*, 1931–1932 (see fig. 107).

During 1928 and 1929 I made a number of other clay maquettes. These included the sketch for a monument to my sister, who had died, *Study for Matzeva* (fig. 86). This is a traditional Jewish piece, including the two lions of Judah and an inscription having to do with my sister. In the final version, I simplified this and left out the lions. A *Dancer with Veil*, 1928, a relief on a pedestal, was the preliminary idea for a series involving this theme. I am not sure what motivated this except, perhaps, a general desire to explore subjects of greater freedom and movement. It is certainly related to the *Reclining Woman with Drapery* and the *Couple in Hammock* (fig. 87). All of these works illustrate the manner in which the maquettes served as preliminary ideas or experiments for themes which I was later able to develop. These maquettes were in terra cotta and about this time I began signing them with my initials, J. L., for the simple reason that they were very small and the full name would have been too long. Sometimes, in the case of reliefs, I put the initials on the back in order not to interfere with the sculptural design. Now I always include my fingerprint in the bronze casts as my signature. In stone, the signature is engraved. The maquette of *Couple in Hammock*, a free relief on a pedestal, includes perforations and, although it is a very rough, preliminary sketch, involves ideas that grew out of the transparents and that were to be developed into the different versions of the embracing couples. This is a little sketch that I like very much. Although it is conceived as a relief, it is yet deeply undercut and interpenetrated like a free-standing sculpture.

A maquette of *Leda and the Swan* made in 1929 (fig. 88) is specifically related to the large sculpture of *The Couple* (*The Cry*). The legs of the reclining Leda curve up in the same manner and the beak of the swan opens in a cry of passion. I think I was also interested in the fluttering movement of the wings, which is probably related to a number of studies such as the *Dancer with Veil* of 1928 and another one of 1929, two of a series of maquettes in which I was exploring an extremely free kind of expression in terms of the floating movement of draperies. All of these maquettes reveal an interest at this point in the development of a kind of free spatial movement that did not begin to manifest itself in the larger sculptures until some time

85. *The Harpist*, 1928. Bronze,
10½″ h. Collection Mr. and Mrs.
J. B. Brooks, New York.

84. *Reclining Figure*, 1929.
Bronze, 6″.

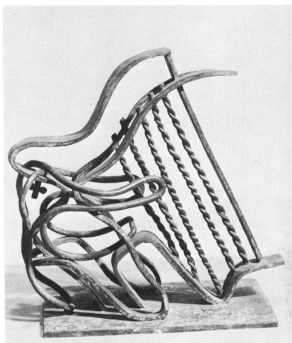

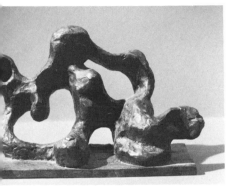

86. *Study for Matzeva*, 1928. Bronze, 8″ h.

87. *Couple in Hammock*, 1929. Bronze, 9½″ h.

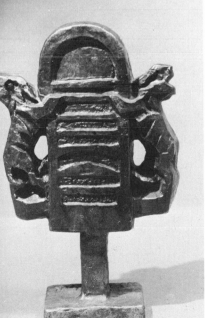

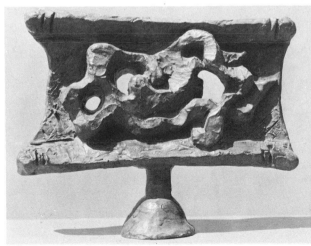

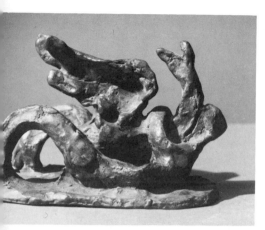

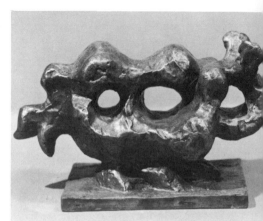

88. *Leda and the Swan*, 1929. Bronze, 4″ h.

89. *The Couple*, 1929. Bronze, 4¾″ h.

90. *Woman Leaning on a Column*, 1929. Bronze, 11¾″ h.

91. *Encounter*, 1929. Bronze, 9¾″ h.

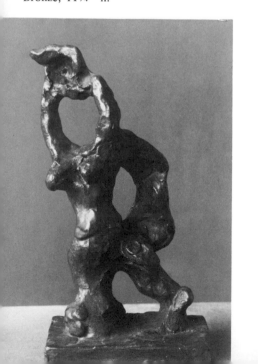

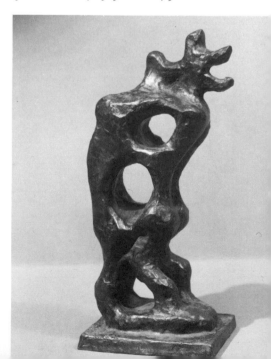

later. *Leda and the Swan* was one of the first, if not the first, specifically classical subject I attempted. Obviously, it indicated an interest in erotic themes which I believe are valid and important subjects for the artist; and the theme undoubtedly suggested the traditional loves of the gods that have been part of the artist's vocabulary since antiquity. I think it is only natural that my ever-increasing interest in sculptural subject and idea should have led me to the great reservoirs of classical myth as well as to the Old and New Testaments.

Many maquettes remain from the period after 1920 both because I was increasingly using the clay model to explore a thousand different ideas that were occurring to me and also because I was taking better care of the original models. I had a technician bake the clay for me as a means of preserving it. When I came to the United States and was established, I asked my brother, who was in Paris, to send all the works that remained there and to try to find as many of the sketches as he could. In recent years I made a bronze edition of seven casts for each of these maquettes.

*The Couple* (fig. 89) is another maquette of an embracing couple closely related to the large work, although it also embodies some explorations of a bony structure interpenetrated by the large voids. The figures cling together almost as though they were glued and transformed into a strange beast. Other 1929 maquettes of a *Standing Figure, Woman Leaning on a Column* (fig. 90), and *Reclining Woman on a Puff* illustrate further explorations of this kind of structure. I was obviously giving my imagination full rein at this moment, but a number of these free ideas were developed sometimes unconsciously into major sculptures many years later. Thus, the striding pose of the *Woman Leaning on a Column* is perhaps the original for the 1953 sculpture of *Enterprise*. Another maquette entitled *Encounter*, 1929 (fig. 91), shows two standing, embracing figures that may go back ultimately to the 1913 proto-cubist sculpture entitled *Encounter* or *The Meeting* (see fig. 7). This theme of the encounter has always had a special significance for me and at this moment in the late 1920s and early 1930s emerged in a number of different contexts. In my sculpture I think continually of the idea of encounter. This means to me not only the meeting of two individuals as in such sculptural themes as the embrace, but others I was to develop in the 1930s, on some of which I was already working. These included *Return of the Prodigal Son*, the *Song of Songs, Jacob and the Angel,*

and later such different mythological subjects as *Theseus and the Minotaur, Prometheus,* and many others. I sometimes think that the idea of encounter is central to a vast proportion of my sculpture. Whatever the specific subject, I continually think of the sculpture itself as an encounter between the artist, the material, and the forms he is using.

During 1929 I was finishing the large sculpture of *The Couple* (*The Cry*) and through the many maquettes was working my way toward the mother-and-child theme of which the *Return of the Prodigal Son* is a variant. Much of the time I was isolated in my house at Boulogne, rarely going out except to visit the Paris flea markets on Saturdays. This was a period when you could still find marvelous things.

# Chapter 8

One of the first ideas for the *Mother and Child* is the maquette (fig. 92) made toward the end of 1929. As I have pointed out, this was a very difficult time for me, with the death of my father and my sister, and I was questioning many things. "For what am I born? For what did I come on this earth?" Closely associated with it is a maquette of 1930, and out of these emerged the large sculpture of the *Mother and Child*, 1930 (fig. 93), and its many other versions. In the first maquette, the mother is seated holding the child and in the second she is kneeling. Both of them involve a cry of anguish that resulted from the tragedy that had befallen me. In the sketches, the mother is wailing for her child, and in the first version of the large sculpture the child on his mother's shoulders is tearing at her breasts. These reflected a moment of pessimism, but a fighting pessimism, because I am not essentially a pessimist. It was rather a period of angry questioning. As I look back again, I can see now many relations in the ideas of the moment that were not apparent to me at the time. In the maquettes, the mother clutching the child certainly is connected with the series of the embrace. The relationship of the heads in *The Couple*, which enabled me to call it *The Cry*, is now made specific in the anguished scream of the mother. As I mentioned earlier, there was another curious experience that went into the creation of the first large sculpture. One day in 1929 I saw a strange cloud formation that took the form of a bird. Of this I made a sketch, *Form Seen in a Cloud* (fig. 94), and the wings of this bird became the arms of the mother in the

large *Mother and Child* of 1930. None of these ideas were conscious at the moment. They were all the tangible and intangible influences that go into the creation of a work of art. The *Mother and Child* is treated in somewhat simple volumes, extremely different from the sketches that led up to it. This was true of a number of the major works produced in the next two or three years. It is as though, having worked with the greatest freedom in the sketches, I felt a need to discipline myself in their final realization. This is also a strangely brutal piece in the manner in which the child digs his fingers into his mother's breasts. I know that I identified myself with the child, but I cannot explain the brutality except as something arising from this time of extreme misery, something in which I felt a passionate need for support. I know that my own mother was the one who always supported and encouraged me and that for her I felt the deepest love. It may be that there was some kind of guilt involved in this image, some feeling that I had not sufficiently repaid her love. In any event, the mother-and-child theme had haunted me from the time of my 1914–1915 *Mother and Children*, and after 1930 it appeared continuously in many different variants.

It is strange to me that at the time I was so concerned with these ideas about the erotic embrace and the mother and child, I should also have been working on the large *Figure* which was begun in 1926 and finished in 1930 (see fig. 75). This is in many ways a unique sculpture. As I mentioned earlier, it was commissioned by a Madame Tachard, but she returned it to me because she could not stand it. The sources of this I have also mentioned as coming perhaps originally from the sketch for a garden statue of 1921 and then developing through a series of those standing bas reliefs of the early 1920s and specifically the sketches for *Ploumanach* of 1926. One maquette for *Ploumanach* begins to combine some of the elements of the earlier study for a garden statue and the final *Figure*. The basic design for the *Figure* was established in the maquette *Figure* of 1926 (see fig. 74), which was then developed into the large finished work. The only significant change from the maquette is in the female sexual symbol and the staring eyes in the head that replace the reclining figures of the original *Ploumanach*. Although this is commonly referred to as a primitive totem with a magical presence, and although I am personally willing to accept this interpretation, I must admit that I had no such conscious idea in creating it. A work of art is created not only

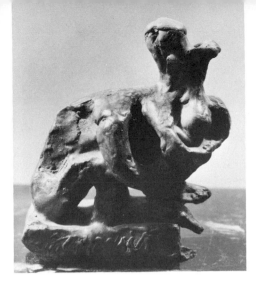

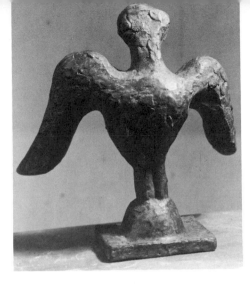

92. *Mother and Child*, 1929.
Bronze, 4″ h.

94. *Form Seen in a Cloud*, 1929.
Bronze, 9½″ h.

96. *Chimène*, 1930. Bronze, 18″ h.

95. *Man with a Clarinet*, 1929.
Bronze, 6⅜″ h.

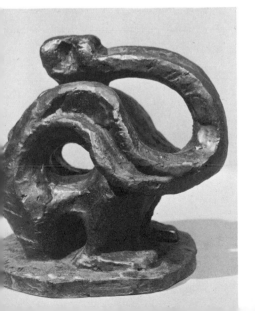

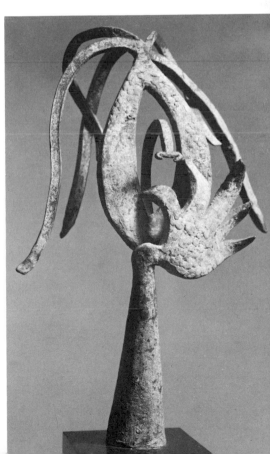

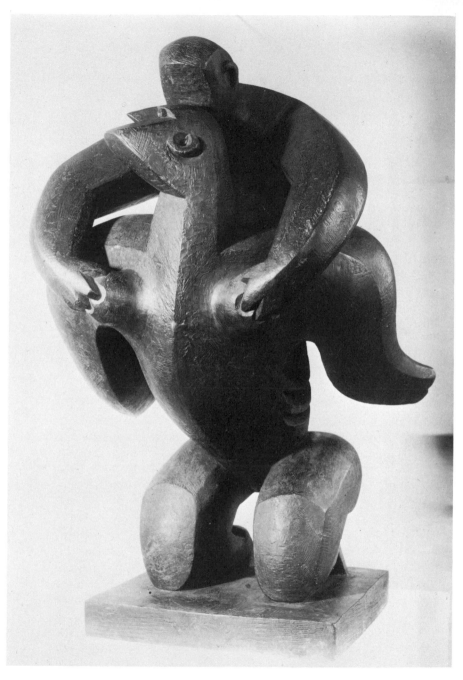

93. *Mother and Child*, 1930. Bronze, 56″ h. Cleveland Museum of Art, Stone Memorial Fund and Bernard J. Reis.

by the artist but also by its impact and associations on the spectator. And sometimes these latter contribute importantly to the ultimate existence of the sculpture or painting. To me there is always something magical in the work of creation. I feel that something has been wrung out of me when I finish a sculpture. I know that when I do a portrait I have a sense of squeezing something of spirit or personality out of the sitter; for this reason, I am now very reluctant to have my own portrait done. Although, as I have said, *Figure* is a unique and separate work in my oeuvre, I can see now that it is in actuality the culmination of all those findings in frontalized sculpture that began with some of the cubist works during the First World War.

During 1929 I made a little maquette of a *Man with a Clarinet* (fig. 95) in which the man and the clarinet are composed in a single S-curve. There is another version dated 1931. This was simply a slight diversion that at the time did not have any particular significance to me, but, again, I realized later that it involved the first idea for a number of major themes such as the return of the prodigal son.

During the 1920s I continued to exhibit from time to time in the large salons. As I became better known, I was always invited to show but had less interest in doing so except that I recognized it was sometimes useful. Madame Bucher had regular exhibitions of my work, and in 1930 she organized a large show of some hundred pieces at the Galerie de la Renaissance. This was a beautifully presented exhibition, held during May and June of that year, the tourist period in Paris, with the result that a great number of people saw it and there was a lot of press comment, mostly favorable. There was a vitrine of the transparents of which, unfortunately, a few pieces have since disappeared: a man on crutches, a poet made in iron, and also a very playful little transparent entitled *Chinoiserie*. I did not even have photographs of these, since they were among the last things I had made before the show and I had not had time to have them photographed. There were a few sales, not very many, since this was the beginning of the depression, but it was, nevertheless, an important exhibition for me, enabling me to see all these pieces together and to get a new perspective. An artist can always discover things about himself and his development and ideas from such a display. It is perhaps more difficult in France than in America for an artist to get large-scale exhibitions, particularly for a foreign artist. In 1930 I was a French citizen, having become one in 1924, but to the French I was

still a foreigner. It is the same thing here in the United States. Although I am an American citizen and a member of the American Academy, to some of my colleagues I am still not a full-blooded American. In this context I like to emphasize the fact that when I was very ill a few years ago, I lost seventy per cent of my blood. I was actually dying until they started to pour twenty-two pints of American blood into me and I was saved, so now I defy anyone to say that I am not a full-blooded American. In France I could, of course, always show at Madame Bucher's gallery and at other galleries that bought works from me as well, and I was continually invited to the different salons, not only the Salon des Beaux-Arts, the Salon D'Automne, but the Salon de Tuileries and the Salon des Indépendants, as well as others; but these usually involved only one or two pieces.

The 1930 exhibition did interrupt my work schedule, since there are always a great number of details in connection with such shows, arrangements, and people to see, but no matter how I am interrupted I always have gone and I still go to work every morning without waiting for inspiration, and begin doing something, whether it is only playing with a small piece of clay. There are many false starts in this procedure, but always at some moment, since, after all, I have many, many years of experience, something emerges, everything begins to become clear and to fall into place; and when this happens it is still a revelation, I have a marvelous feeling of lightness and euphoria. I feel like those Moslem dervishes who turn and turn and turn until suddenly at the most unexpected moment they achieve ecstasy. It is a feeling that is exhausting but wonderful and for me it comes only by continual work; I have never needed alcohol or drugs to achieve it. In my studio I even have places where I feel that I can work better. This has nothing to do with the light or other conveniences but is quite simply a superstition. There are spots where I have worked well and I gravitate to them in the conviction that I can do so again. And it really happens. I admit frankly that I am a very superstitious man, even about the clothes that I wear when I am working.

I remember that when I first arrived in New York I was invited to the home of a very important dealer and collector. I only had the clothes I was wearing, which were dirty and disreputable, and at first I refused the invitation, explaining the reason. The collector said not to worry, to come anyway, so I went. When I arrived, my host studied me so intensely, back and front, that I became self-conscious. He then

took me into a bedroom and threw open a closet door, explaining that since we were the same size I should select anything I wanted from his wardrobe. I was embarrassed, since never before in my life had I done such a thing, but my host insisted, saying that it would be fun for him; so he dressed me from top to toe and said I must keep this new outfit. Since I was then a penniless refugee newly arrived in New York, I finally and reluctantly agreed to do so, and I must admit that those new clothes became for me a symbol of hope and good fortune. For years, until they wore out, I would wear exactly that outfit whenever I had something important to do because I was convinced that the clothes would bring me luck. And I think they did.

One of the last transparents was the piece called *Chimène*, 1930 (fig. 96), a work that involved a good number of new ideas, even different from the previous transparents. Sometimes one does things that have no relationship to anything before or after except a poetical evocation, a very personal association. I am reminded in relation to this that later I found an Etruscan tool, a ritualistic piece, a long stick with hooks on it on which they would put meat for sacrificial ceremonies that reminded me of this work. *Chimène* is a woman's head and hand, like a plant or a flower. It is a sublimation of an experience, a sort of poem arising out of a particular emotion. It was inspired by a particular woman, someone who fascinated me for several years. She attracted me very much but there was nothing between us. Among other things, she was the wife of a friend. But it is obvious that I had some kind of an obsession about her and the sculpture was a way of possessing her. This head and hand reflected a gesture of hers that impressed itself deeply on me, to the point that I made a large number of sketches involving this theme during the next few years.

The next major work of 1930 was *The Harpists*, which comes out of the 1928 transparent. As I mentioned, that resulted from the concerts my wife and I attended at the Salle Pleyel in which we were seated near the harps and I became fascinated by the intimacy between the woman harp player and the instrument, the music itself and the shimmering of the strings in the light. All of this had a very strange, almost hypnotic impact on me. The 1930 bronze I entitled *The Harpists* since I seemed to see more than one figure. Also, there was a curious visual metamorphosis of the harp player and her instrument into a bird form. *The Harpists* is only about 17¾" high, but

during 1931 and 1932 I developed this idea into the monumental *Song of the Vowels* (see fig. 107), one cast of which, with its base, is 156 inches high.

There is a rather curious and amusing story in relation to *The Harpists*. It was bought from me by Madame Bucher, and she mistakenly entitled it *Harp* instead of *Harpistes*. She sold it to an American collector, Mr. Catesby Jones, and sent it to him in America under this title. At that time there was some rule at American customs that a work of sculpture must be made after something that is alive, so if this were a harp it might be dutiable. Fortunately, the man who bought it was a maritime lawyer and the people at customs knew him. One of them said that Catesby Jones did not buy anything that was not sculpture, so there must be a mistake. He consulted with Catesby Jones and then they got a dictionary in which they found the word "harpy." "That's it," said the customs man. "It's a bird." So Madame Bucher asked me as a favor to go with her to the American consulate in Paris and confirm the fact that the sculpture was named "Harpy." I said I would do it for her, although I would not swear to it if this were required. Fortunately the consulate simply asked me the question and then asked me to make a drawing of it, which I did. I am glad to say that the American customs regulations have now been changed to eliminate this kind of ridiculous situation. Also, you formerly could not bring in more than two casts of a piece and you can now bring in as many as you want. Mr. Catesby Jones in his will asked that this sculpture be placed over his grave, something that touched me very much. When he died, I designed a base to make it a proper monument. He was a fine gentleman, with an excellent eye and a very good collection, most of which went to the Virginia Museum in Richmond. Another cast of this belongs to Bernard Reis in New York (fig. 97).

A transparent of 1930 I entitled *Melancholy* (fig. 98) for no particular reason except that the technique was becoming extremely complex and this induced in me a feeling of melancholy. When I first began making the transparents, there were many technical problems having to do with their casting. But gradually these became resolved and I found that I could do almost anything technically, with the result that I gave up making them for the reason that they became virtuoso exercises. I was also, in *Melancholy*, thinking about Dürer's wonderful engraving *Melancholia*, and this may have inspired the

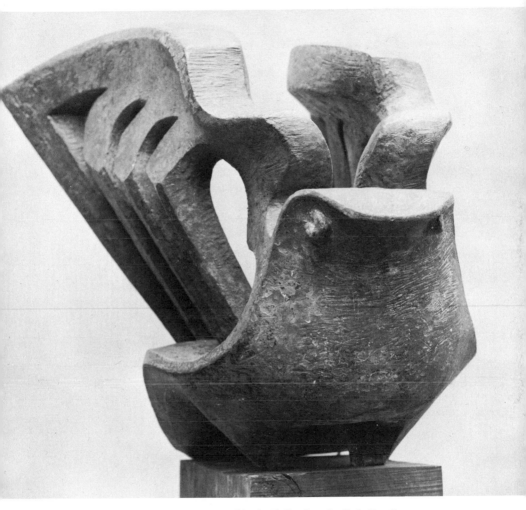

97. *The Harpists*, 1930. Bronze, 17¾″ h. Collection the Reis Family,
New York.

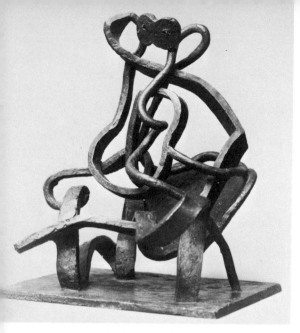

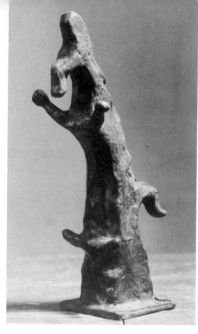

98. *Melancholy*, 1930. Bronze, 11½″ h.
Collection the Reis Family, New York.

99. *Mishugas*, 1930.
Bronze, 8¼″ h.

100. *Seated Woman*, 1930.
Bronze, 7½″ h.

101. *Return of the Prodigal Son*, 1930.
Bronze, 8½″ h.

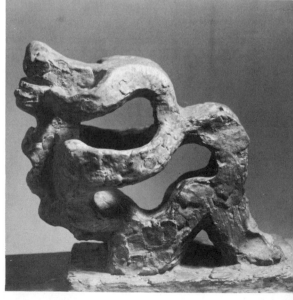

specific title after the fact. There were a number of sketches made during 1930 which were simply improvisations. One of them, strange and somewhat unpleasant, I gave the name *Mishugas* (fig. 99), which in Jewish means craziness. I had no thought or control over this. There were other curious and sometimes funny maquettes from this period suggesting caricature heads that I entitled *Cinderella*, the *Snuffer*, and *Head of a Woman*.

Many of the maquettes of 1930 are extremely open in construction, reflecting the discipline of the transparents (*Seated Woman*, fig. 100). In this the figure, like some of the earlier ones, is assimilated to the chair so that she becomes a woman-chair, an idea that appears in primitive art and earlier in my maquettes. *Cinderella* illustrates again the importance of the chance association. I remember seeing a woman's shoe with a high heel and it suggested a head to me with the heel as a nose, so I added eyes and there it was. That's why I called it *Cinderella*, because of the shoe. I think there are even laces in the back which identify it as a shoe. Things like this are amusing in retrospect, but when I make them, they are very serious. Out of them there sometimes arise the ideas for major works.

For instance, at this moment, in 1930, I made some maquettes for the *Return of the Prodigal* or the *Prodigal Son* (fig. 101). The sculpture was completed in 1930 (fig. 102). The maquettes may have been made before some of the others I have discussed, and there were a number of drawings that preceded them. This is one of the first Biblical themes, but at the time I was not thinking of it in these terms. It had a very personal association to me, the idea of the son who is returning home, the artist who is returning to nature; it is a continuation of the *Pierrot Escapes*, a longing for nature rather than abstraction. In the Biblical story the son returns to his father, but here I have him come back to his mother, Mother Nature. The work emerged from an intangible feeling and the name came after the feeling. The prodigal son was myself, who wandered into an unknown field, in the darkness, and who wanted to return to my mother. I realized later the relationships of this piece to the earlier versions of *The Couple*, an idea or theme that was to appear again and again in many different variants of my sculpture of the next few years. As I mentioned earlier my friend Juan Larrea, the poet, returned from Peru about this time and asked me what I was doing, so I took him to my studio and he looked at this piece and remarked that what he liked about it was how

the child was drinking as if from a bowl. I could not comprehend this, since the child is holding the head of its mother, but then I saw what he meant and remembered the curious feeling of thirst I had when I was making it.

Among the very last transparents were *Elle*, 1931 (fig. 103), and *Head and Hands*, both closely related to *Chimène* but perhaps a little too virtuoso in technique. After this point I made no transparents as such; the technique was used again in some of the *Blossoming* series of the 1940s and other works such as the *Variations on a Chisel*, 1959.

The theme of the struggle of Jacob and the angel began to obsess me in 1931 (fig. 104). This is a curious story. Jacob was sleeping and the angel came to him and woke him and challenged him to do battle, so that Jacob began to fight. Although the angel was a messenger of the Lord, and Jacob could not overcome him, he did fight neverthe-less, and after that, the Lord rewarded him for having fought and named him Israel. To me, this meant that God wants us to fight with him. From these tentative ideas emerged many sketches and, finally, a complete sculpture made in 1932 (fig. 105). Again, I realize that there is always the theme of the embrace, which is also a struggle, a tension of opposites that seems to occur continually in my sculpture.

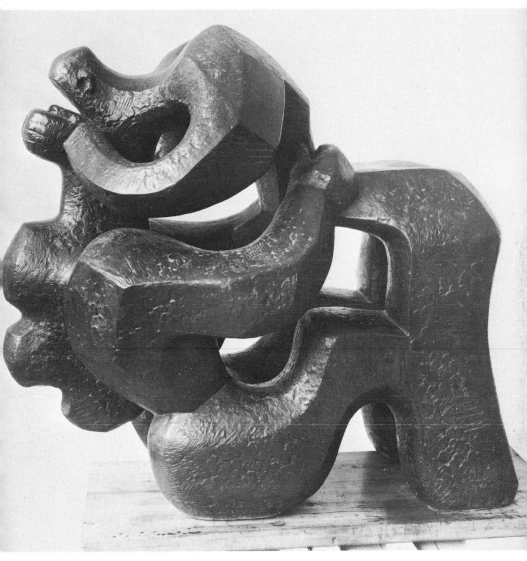

102. *Return of the Prodigal Son*, 1930. Bronze, 44″ h.

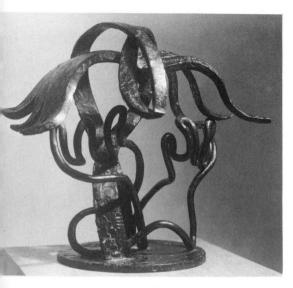

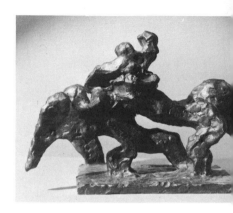

103. *Elle*, 1931. Bronze, c. 10¼" h.
Collection Mrs. Lois Orswell Daily,
Narragansett, R.I.

104. *Jacob and the Angel*, 1931.
Bronze, 8¾" l.

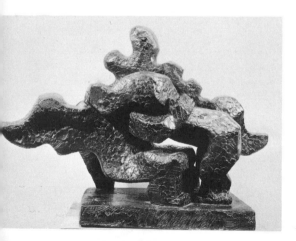

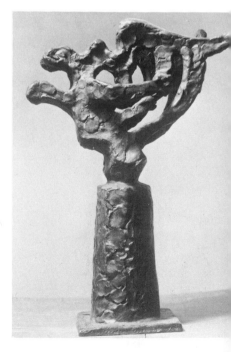

105. *Jacob and the Angel*, 1932.
Bronze, 47¼" l.

106. *Study for Song of the Vowels*, 1931.
Bronze, 14⅜" h.

# Chapter 9

In 1931 I returned to the subject of the harpists with the idea of making a monumental sculpture. This was the *Song of the Vowels* (maquette, fig. 106 and sculpture, fig. 107). I had been commissioned to make a garden statue for Madame de Maudrot for her house at Le Pradet, in the south of France, designed by Le Corbusier. I was entranced by the location, a vineyard with mountains at the background, and since I was still obsessed with the idea of the harp, I decided to attempt a monument suggesting the power of man over nature. I had read somewhere about a papyrus discovered in Egypt having to do with a prayer called the "Song of the Vowels," a prayer that was a song composed only of vowels and designed to subdue forces of nature. This title created some confusion because there is also a poem by Rimbaud called the "Song of the Vowels," "Le Chant du Voyelles," but this had nothing to do with the Egyptian papyrus, which had not been discovered at the time he wrote the poem. I cannot explain why the image of the harp and the "Song of the Vowels" should have come together except that both of them were in my mind at the same moment. The *Song of the Vowels* is a clarification of *The Harpists*. Now the two women harpists are clearly evident. The sketch is quite complete and differs little from the finished work. I seem to have known immediately what I wanted to do and to have carried it through without any major changes.

Figure 107 shows the sculpture in the garden of Madame de Maudrot at Le Pradet, France. There is another version with a

slightly smaller base at the Otterloo museum in Holland, and Nelson Rockefeller also has a cast. In making the work for Madame de Maudrot I was extremely conscious of the intense quality of the light, and this affected the design in the sharp indentations as well as the heavy, textural surface. I wanted it to harmonize with the mountain background. The base at Le Pradet is concrete, but in the Otterloo and Rockefeller versions I made it of bronze.

I remember a very interesting experience in relation to the Le Pradet *Song of the Vowels*. I hired a mason to help me with the base, an Italian who spoke little French. While we were working, the mason suddenly said, "I am very proud to work on this." And I said, perhaps a little rudely, "Why are you proud? Do you like it?" He said, apologetically, "Of course, some people like those unknown soldiers more." (Because in every town in France there are those awful monuments to unknown soldiers.) "But I prefer this." So I said, "Why do you prefer it?" and the mason said, *"Perché parla!"* ("Because it speaks!"). And I was proud and happy, because I felt about the lady who commissioned it that she merely wanted a work by me for her garden and for her Corbusier house and had no other interest, but this workman instinctively reacted to the sculpture itself.

Madame de Maudrot was nevertheless a very interesting woman and an extremely rich one. She also bought the *Reclining Woman* from me to place on the terrace on the other side of her house. While I was installing the *Song of the Vowels*, I lived and ate at her house, but there was never enough to eat. I was always hungry. I even had to go to the village to buy some pizzas to satisfy my appetite. One night at dinner I finally asked her, "Tell me, Madame, here you commission me to make a large, expensive sculpture which costs a great deal of money, and you invite me here while I am working, but you never give me enough to eat. Why is that?" She then explained that when her father was dying he told her that she would inherit a large fortune but that she must remember that it is the pocket money which can ruin you, so always to be careful of that. And this had become a rule of her life; large and important things she paid for without complaining, but she economized on all her domestic expenses.

My obsession with the woman with hair or the woman leaning on her elbows continued between 1931 and 1934, to the point that I made innumerable sculptures playing variants on the theme. In some of these the emphasis is on the hair and hands; in others the sculpture

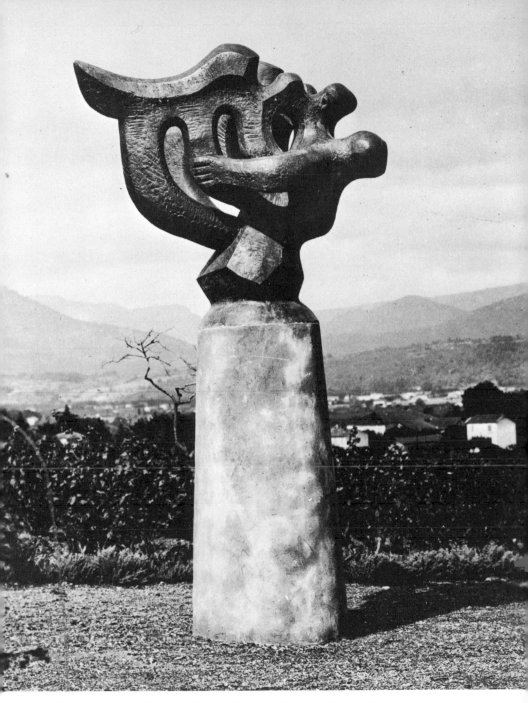

107. *Song of the Vowels*, 1932. Bronze, 80″ h. Collection Mme de Maudrot, Le Pradet, France.

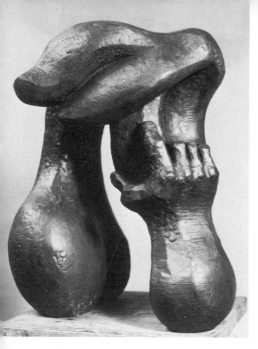

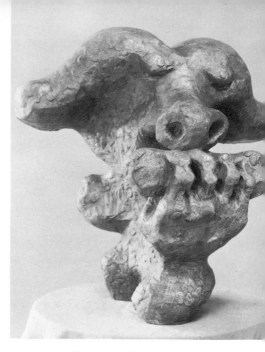

108. *Woman Leaning on Elbows*, 1933. Bronze, 27½″ h.

109. *Head and Hand*, 1932. Bronze, 5½″ h.

110. *Pastorale*, 1933. Gouache on gray paper, 24″ by 17⅞″.

begins to become a more solid study of a head and hands. Sometimes I opened up the space between the arms to the point where there is a suggestion of the sketches for *Jacob and the Angel*. In 1932 and 1933 I began to make massive finished sculptures of the theme *Woman Leaning on Elbows* (fig. 108).

In a version of 1932 and 1934, *Head and Hand* (fig. 109; drawing, fig. 110), the head takes on a brutalized animal form that is even suggestive of the Minotaur, a subject I was to explore some years later. I cannot explain entirely my obsession with this subject, aside from the association I have mentioned, but I do know that the gesture of the woman holding her hands up over her head occurs very early in my sculptures and continued and is reiterated much later in many different works. All of these involved a deeply personal, emotional experience that is manifest in the sculptures. Sometimes the floating hair becomes remarkably similar to the wings of the angel-like form I had seen in a cloud formation in 1929 and which became inextricably involved with the mother-and-child themes (fig. 111). Some of these studies of head and hands were formal explorations of interior or negative sculptural space, and the interest in this problem led me in 1932 to a series of sketches of helmet or skull heads in which the interior space is open and enveloped by a skin or bone structure pierced with great eye holes (fig. 112).

During 1931 I made a small sketch of a *Prometheus*, a reclining figure with arched back and screaming mouth (fig. 113). There was originally a vulture who was tearing at his liver, but this part of the sculpture disappeared or was destroyed and I preserved only the figure. This, again, is important to me as one of my earlier uses of a theme from classical mythology to illustrate some of my thoughts about the world, in this case specifically about the intellectuals who were moving into a period of darkness and persecution. I was haunted by the specter of fascism in Germany, and this little piece reflected some of my feeling.

The theme of Prometheus and the vulture I was to return to again and again during the next twenty years. The subject of conflict became increasingly obsessive during the 1930s, not only in the struggle of *Jacob and the Angel*, but in many others. There is a little maquette of the *Fight*, 1931, that was later to develop into ideas for an anti-fascist sculpture, *David and Goliath*. In 1932, when my friend the poet Larrea returned from Peru, he told me a story about fiestas

where the feet of a condor are sewn into the back of a bull and they are then let loose in an arena. There results a fantastic and horrible battle until one or both are killed. This story moved me deeply. At the moment when Hitler and the Nazis were in power in Germany, I was entering upon a period of profound depression and I felt that the bull and the condor, and particularly the human beings who delighted in their struggle, signified the insane brutality of the world.

I made two maquettes of the theme in 1932 (figs. 114a and 114b) as well as a relief in 1933, in all of which I tried to express the horror and the furious struggle of the event. These are modeled with a passion that reflects my emotions in the face of this frightening conflict. The clay is scarred, undercut and torn like the bodies of the fighters. The jagged textures and contours emphasize further the violence of the scene. This is a work that I should have made into a large sculpture; why I did not do so, I do not know. In its violence and textural freedom it looks forward to the most expressive sculptures of the 1940s and 1950s, in many of which the bull, which appears here for the first time, again becomes a symbol of suffering in many different contexts.

During 1932 and 1933 I returned to portraiture, of which the most interesting to me was the portrait of Géricault (fig. 115). I have always been a great admirer of this painter, a genius who died young, and I have some paintings of his. There exists a death mask of Géricault of which I acquired a cast. I wanted to make the portrait as realistic as possible, so I checked documents and existing portraits of him. This was my homage to a great artist whom I loved very much. I think it is a good portrait. Even the Museum at Rouen, which has a lot of his works because Géricault was born there, bought a copy. My American dealer, Curt Valentin, bequeathed me a small sculpture by Géricault of a fawn and a nymph.

A maquette entitled *The Strangulation*, 1933 (fig. 116), has a strange history. A woman who was a recent widow asked me to make a monument for her husband. I had the uneasy feeling that she had killed him. So I made this sketch, which is very cruel, of a woman who is strangling a man. I think she saw what I meant because she did not accept it. There were a number of sketches made during 1933 and 1934 having to do with erotic love (*The Embrace*, figs. 117, 118), which seem to have been some sort of release for me. During this same time, however, I began a theme that had a very personal

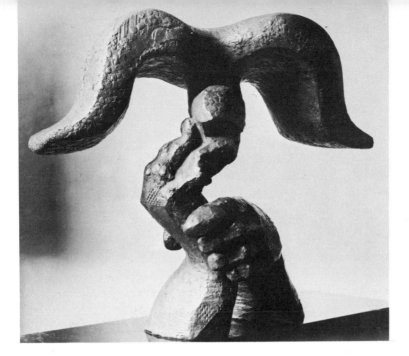

111. *Hands*, 1933. Bronze, 21⅛" h.

112. *Head*, 1932. Bronze, 8⅝" h. Stedelijk Museum, Amsterdam.

113. *First Study for Prometheus*, 1931. Bronze, 4½" h.

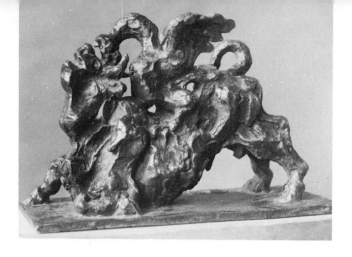

114a. *Bull and Condor,* 1932. Bronze, 7¾″ h.

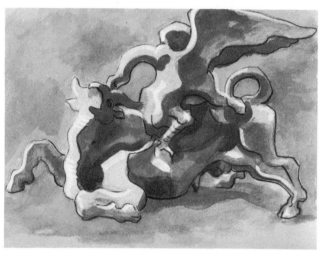

114b. *Bull and Condor,* 1932. Water color and pencil, 9″ by 11⅞″.

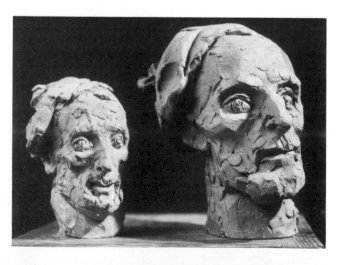

115. *Head of Géricault,* 1933. Bronze.

significance, that of the *Rescue of the Child*, 1933 (fig. 119). In the first of these the mother's arms are holding the child up away from danger, a motif on which I have played many subsequent variations. In the second, with outstretched arms, the child is held high above the head of the mother in a gesture similar to the way the cock had been held by the priest in the *First Idea for Sacrifice*, 1925. This work is loosely and freely modeled. The mother and child rise like an undulating column from the base of the crouching figure. The third version is the most complex in organization. The mother, still holding the child high, strives to escape from the great attacking serpents while the father struggles vainly to free them. Although this theme may have something to do with my relationship with my own mother, fundamentally the child is really my sculpture. This was a time when, with the spread of fascism, I had a terrible fear that everything I had done would be destroyed. There was undoubtedly a confusion in my mind, since my mother was ill at this time and died at the beginning of 1934; but all of these things are somehow related.

During 1935 I spent some time in Russia, which I had always wanted to visit again. As a result of my early experiences, I had been sympathetic to the Russian revolution, but I must say that my three months' sojourn there disillusioned me. I designed a project for a monument to the Russian revolution, a maquette of dancing figures on a column decorated with reliefs. The dancing figures derived from my sculpture *Joy of Life*, and the entire monument was intended to extoll the liberation of the Russian people through industry and agriculture. The Soviet Arts Commission was interested in the project and asked me to submit a large sketch. I sent a plaster version, which was not accepted. I visited Russia between August and October of 1935, partially in order to see my two surviving sisters and my brother as well as my nieces and nephews. Although I was disillusioned by the conditions in Russia, I was entranced by the marvelous museums and theaters.

During the 1930s my sculpture was characterized by a continuing search for monumental expression. Works created between 1929 and 1935 were usually organized in heavy block forms to achieve a great effect of density and weight. The sense of cubist control persisted much longer in the large sculptures than in the sketches. The *Study for a Monument for the Soviets* was only one of a series of projects for large-scale sculpture. During 1933 I had designed a series of

maquettes on the theme of *David and Goliath* that were specifically related to my hatred of fascism and my conviction that the David of freedom would triumph over the Goliath of oppression. In the first of the four remaining maquettes (1933) David stands over the recumbent Goliath, twisting a cord about his neck. In the subsequent sketches, the figures are reversed, with the huge Goliath rising up vertically and David pulling back with all his strength on the great cable cord which he has twisted around the throat of the giant. The final sketch, placing the figures on a column, reduces the size of the giant to a more human scale. The two figures straining mightily against one another establish a terrific state of tension. The project was executed on a somewhat larger scale and the plaster was exhibited in 1934 at the Salon des Surindépendants (fig. 120). I wished there to be no doubt about my intent so I placed a swastika on the chest of Goliath. The statue cost me considerable difficulty with German agents who in the guise of art critics began to show intense interest in visiting and examining my studio. However, it remained unharmed in the basement of the Musée National d'Art Moderne during the entire German occupation.

Most of the surviving maquettes of 1934 and 1935 are projects for monuments. Aside from the *David and Goliath* and the Soviet Monument, I made the initial designs entitled *Toward a New World*, which I was finally able to complete as *Enterprise* for Fairmount Park in Philadelphia, in the 1950s. The four surviving maquettes show with increasing complications figures carrying a flag. They are organized in a violently agitated pyramid, interpenetrated spatially, with the great flag in undulating motion, sweeping over and encompassing the group. *Toward a New World* was also one of the very few political sculptures I have made, suggestive of my momentary enthusiasm for the revolutionary cause of Russia, an enthusiasm which did not survive very long, because I have always been and continued to be on the side of freedom and against any form of oppression or dictatorship.

During 1935 I had my first exhibition in New York at the gallery of Joseph Brummer, an extremely interesting man, a Hungarian, one of several brothers, who had an outstanding gallery of antiquities in New York. He had a passion for sculpture, modern as well as ancient, which was the reason that he asked me to show. His gallery had an extremely good reputation and the show was beautifully presented and was successful. Unfortunately, I was not able to see it, although I

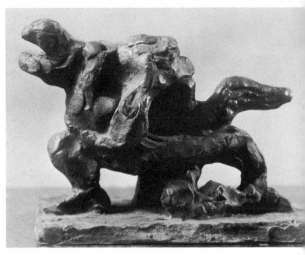

116. *The Strangulation*, 1933. Bronze, 5¾″ h.

117. *The Embrace*, 1933. Bronze, 6¼″ h.

118. *The Embrace*, 1934. Bronze, 19½″ h.

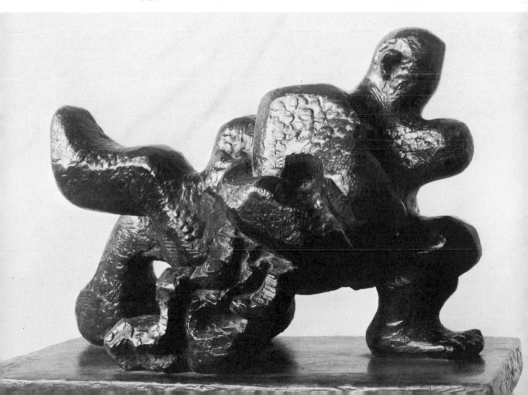

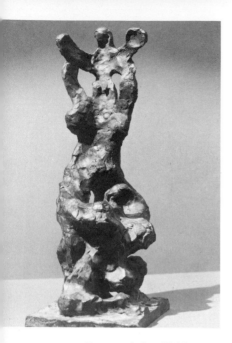

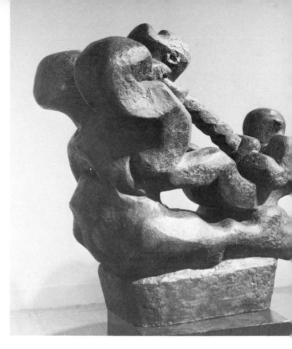

119. *Rescue of the Child*, 1933.
Bronze, 12½″ h.

120. *David and Goliath*, 1933.
Bronze, 30¾″ h.

121. *Scene of Civil War*, 1936.
Bronze, 9¼″ h.

122. *Study for Prometheus*, 1936.
Bronze, 7½″ h.

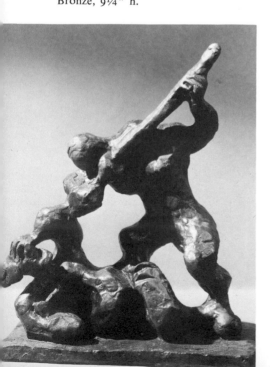

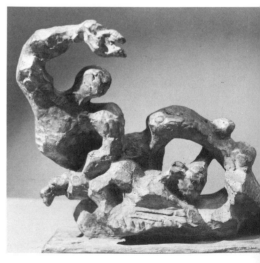

wanted very much to visit the United States, since there were many American collectors of my works. At that time, during the 1930s, not many American collectors were interested in sculpture. It was for this reason, some time later, that I advised my good friend and dealer, Curt Valentin, to specialize in sculpture by all the masters of the twentieth century. He followed my advice and, I think as a result of this, created a great market for sculpture among not only collectors but American museums. Valentin became the most important dealer in modern sculpture in the United States, possibly in the world. There are now enormous sculpture collections in the United States, such as that of Joseph Hirshhorn, which has recently been given to the federal government.

After the New York exhibition, Brummer brought Alfred Barr of the Museum of Modern Art in New York to see me in Paris, and Barr bought a cast of the *Figure*. This was in 1936 and was the first piece the Museum bought from me, although they now own several. The first time I met Alfred Barr was on the occasion that I had exhibited the *Figure* in a group show of young sculptors. When the show was over, I was taking the plaster back in a truck when a man came up to me and started to speak. Since I was busy, I asked him to wait and then to help me carry the sculpture. This he did, and then he and his wife rode in the truck with me to Boulogne and helped me unload it, following my orders patiently. Then we sat down and had a glass of wine and the man finally introduced himself as Alfred Barr, director of the Museum of Modern Art in New York. I was naturally embarrassed, but he was very nice and we became good friends.

During this period of the late 1920s and late 1930s, many collectors, museum directors, and sculptors came to visit my studio. There were few major sculptors then working in Paris. Rodin was dead. Maillol, Despiau, Laurens, and myself were almost the only ones. I remember that Henry Moore came to see me in 1928 and David Smith about the same time. I have always been happy to receive younger artists and to show them what I was doing.

There are no sketches surviving from 1935 but during 1936 there were a number of varied maquettes. The sense of fear I had recurs in *The Terrified One*, a herma figure which grows out of the many studies of the woman's head and arms. Two *Studies for a Bridge Monument* illustrate my continuing desire at this moment to make a great architectural sculpture, and the *Scene of Civil War* (fig. 121)

was inspired by the Spanish Civil War. This last shows a woman with a child and a man who is protecting her, shooting. I was desperately disturbed by the Spanish Civil War, which I could sense was a preliminary for a world war. Larrea, who was a close friend of mine, was not at all left-wing. He was the son of a very rich man and was a legitimist, but he fought against those who had overturned the legitimate, elected government in Spain. In Peru, Larrea had bought a great collection, spending a large part of his inheritance on it, and all of this he gave to the Spanish government, but when Franco came into power it was seized by the Falangists.

During 1936 there were also some sketches for a monument, a statue on a bridge with flags and people related to *Toward a New World*. This was again a project for monumental sculpture that was never realized, although I used it later in connection with an architectural competition in St. Louis having to do with the Louisiana Purchase. At this moment, in 1936, I was perhaps obsessed with the idea of progress, which may explain the motifs of the striding figures with the flags placed on what looks like the prow of a boat.

During 1936, the greatest new project was that for the Prometheus. This was a commission given to me by the French government for one of the gates of the scientific pavilion at the World's Fair in Paris, 1936–1937. Immediately the idea of Prometheus came to me because science is personified in Prometheus. I had earlier been interested in the theme of Prometheus, but this now all came into focus in terms of the large commission. First of all I made two sketches, Prometheus Keeping the Fire (fig. 122), with the torch, and then *Prometheus the Conqueror*. Examining these I felt that I had been too quick in my interpretation, so I made a further sketch in which, although it is simply the figure of the standing Prometheus, I envisaged the vulture that he is strangling. To me, from the beginning, the subject of Prometheus was that of the victory of light over darkness, of struggling mankind over the gods who wished to keep them in ignorance. The first sketches for *Prometheus* are probably related to some of those earlier Laocoön images, but then I had changed them radically when I developed the concept of the conflict with the vulture. The Prometheus has been one of my major obsessions and I have made innumerable maquettes, smaller sculpture sketches, and drawings playing variants on the theme. After the sketches in which Prometheus is strangling the vulture, I realized that this was too simple an

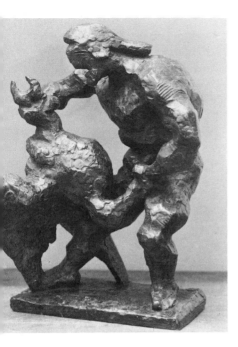

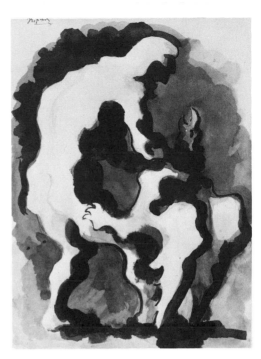

123. *Prometheus and the Vulture,*
1936. Bronze, 18″ h. Collection
the Reis Family, New York.

124. *Prometheus,* 1936. Gouache.

125. *Sketch for Prometheus Strangling
the Vulture,* 1936–1937. India ink on
paper, 13¼″ by 12¼″.

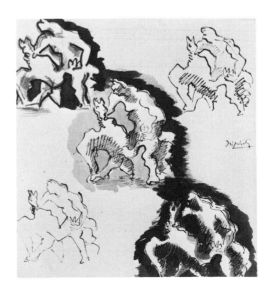

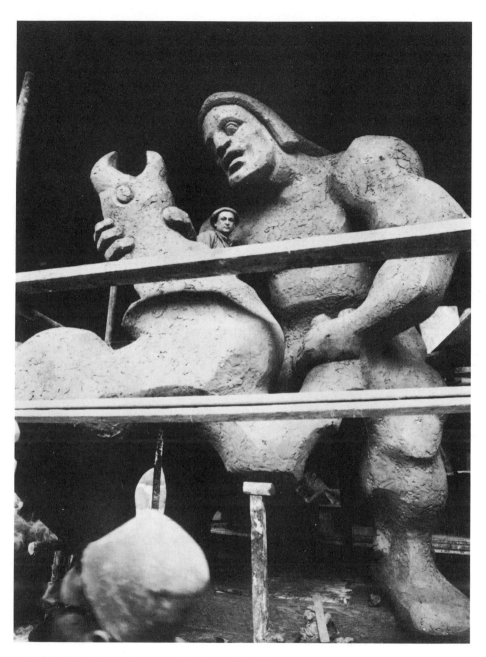

126. Lipchitz in Paris in 1937 with the model of his *Prometheus Strangling the Vulture*. Plaster, 30′ h.

interpretation; darkness was still there, the vulture was still eating the liver of Prometheus. So in the next sketch (fig. 123) I had him strangling the vulture, who at the same time, however, was digging into his body with his claws. It was conceived as a struggle, not a simple conquest, in which light, education, science were struggling against darkness and ignorance, which had not yet been conquered (figs. 124, 125). I remember that I was drawing night and day at that time, trying to work out all the implications of the theme. The Phrygian cap that I placed on Prometheus had a particular significance for me as a symbol of democracy; what I was trying to show was a pattern of human progress that to me involved the democratic ideal. So, in a certain way, this is a political sculpture, propaganda for democracy.

The plaster at the Grand Palais was about thirty feet high and placed some forty feet above the ground (fig. 126). This was simply an exhibition piece and there were no plans to make it permanent, so after the exhibition, it was destroyed, something that was terribly depressing to me. It was for this reason that, when I went to the United States on the first occasion that I was given a commission for Brazil, I remade the Prometheus. When I changed the form of the Prometheus to the figure strangling the vulture, I used a model, something rather unusual for me. The finished plaster of the Grand Palais piece, which was intended to be seen at a distance, was enormous and in very high relief. Also it was frontalized because it could only be seen from one side. When I remade the sculpture later on, I composed it more completely in the round. For the large plaster of the Grand Palais I had two helpers working with me, although I finished the final enlargement myself. This sort of enlargement is based on a geometrical rule that if you have three points that are known, you can find the fourth point in depth, a very old but precise technique used by the Greeks. The plaster was left rough because we had to do it very quickly. I think it took about six months for the enlargement, but before that I was working on the sketches in preparation. We had a crane to install it, and when it was in place I did a considerable amount of adjustment on it in order to make it visually harmonious from a distance. The plaster was coated with oils to protect the surface and to subdue its whiteness.

There were attacks in newspapers against my *Prometheus*, particularly from reactionary journals. Nevertheless, I thought it was effec-

tive. I remember that Corbusier liked it very much despite its defects. When it was taken down there was much controversy among artists and scientists, including Perrin, the Nobel Prize physicist. I was involved with the Prometheus idea during most of 1937 and 1938. The large plaster was made in 1937 and the exhibition terminated in 1938. By that time the Second World War was starting and I could not make many sculptures, so I concentrated on drawings. The two sketch portraits of Gertrude Stein were made in 1938 (fig. 127) and I also made three small sculptures of the *Rape of Europa* (fig. 128).

The latter derived from my continually increasing interest in classic myth, and also it had a personal association. All of my sculpture derives from something in my life, a desire or a dream. In the bull who carries off Europa and swims with her to Crete, the appendages at the back suggest a fishlike form. In my collection there is an extremely rare bronze Coptic piece in which the bull takes on different aquatic shapes. I think that I may have been influenced by this. The general forms of the bull and Europa probably derive from the earlier bull and condor, although, as is so frequently the case with my sculpture, the conflict and terror of the earlier version is here transformed into erotic love. I used the theme of the *Rape of Europa* later in a quite different context, the Europa as a symbol for Europe and the bull as Hitler, with Europe killing Hitler with a dagger. This reverses the concept to one of terror, whereas in the original sculptures of Europa the entire theme is tender and erotic love; the bull is caressing Europa with his tongue.

After 1938 and particularly with the invasion of Poland by Germany in 1939, it was impossible for me to work. I made many drawings and started sculptures which I could not complete. Times were again difficult as far as sales were concerned, so I was selling pieces from my collection. Many of the drawings I made had to do with the theme of the *Rescue*, 1939, in which a man is rescuing a woman. This was again an instance of wishful thinking, a desire to escape from the nightmare in which I felt I was involved. Other drawings I made were of love themes, because love was a kind of hope. This was a terrible period which lasted during 1939 and 1940. We left Paris in May of 1940 with the German invasion of France. Friends of mine, the Chareaus, came one evening and said that Hitler was coming and they would not leave Paris without us. They left their car for us; they were marvelous, they saved me at the moment when

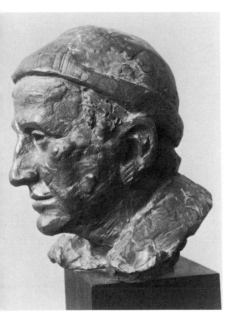

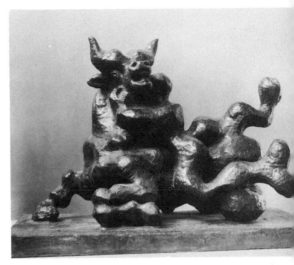

127. *Gertrude Stein*, 1938.
Bronze, 11½″ h.

128. *Rape of Europa*, 1938. Bronze, 23⅛″ h.
Collection Mr. Michael Zagajski, New York.

129. *Jacob and the Angel*,
1939. Pastel on paper.

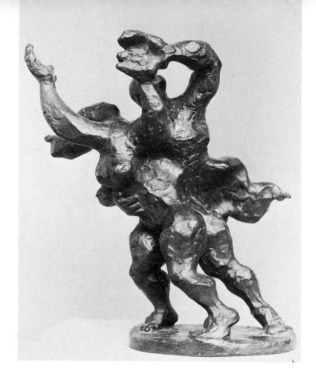

130. *Flight*, 1940. Bronze, 14½" h.

131a. *Arrival*, 1941. Bronze, 21" h.

131b. *Arrival*, 1941. Drawing. Collection unknown.

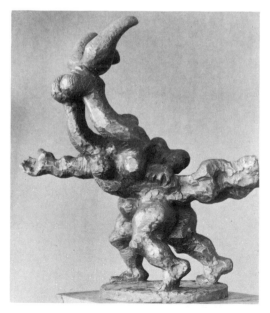

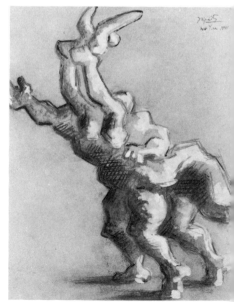

Hitler was at the outskirts of Paris, because I was terrified and so paralyzed I could not make a move. I had been to a friend, a doctor, and had obtained some poison from him, because I felt that I would rather die than fall into Hitler's hands. My wife was so courageous. We went first to some friends in Vichy, taking nothing with us. A few days later, Paris was occupied and my brother joined us with his fiancée.

Finally, we found ourselves in the free zone of France and I decided to stay in Toulouse, where I could work. My brother, who is an engineer-chemist, found a job in Vichy. Through the assistance of the Museum of Modern Art in New York I was later able to get to the United States. My brother remained in France and, although he had some terrible experiences, he was able to escape the Nazis. My dealer, Madame Bucher, took care of my house in Paris and hid the bronze sculptures, since the Nazis were looking for bronze.

In Toulouse I was able to start working again, making drawings and some portraits, since I had no money. It was at this time that I made one sculpture together with a number of drawings entitled *Flight* (fig. 130). This is a small sketch of a man and a woman running. They have only three legs between them and the man holds his hand up as though to protect himself and also protects the woman. It is very free and baroque in its organization, representing not only my emotions at this moment when I was fleeing with my family, but also a new and open expressionist type of composition. When I arrived in New York I made a companion piece, the *Arrival* (figs. 131a and 131b), of which there are a number of variants. In this, the mother holds the child who is saved. The *Arrival* is closely related to the sculpture *Return of the Child* (fig. 132) and *Rescue of the Child*. The entire series for *Arrival, Return of the Child*, and *Rescue of the Child* actually goes back to some maquettes I made in 1933. In a sense they may also be related to the *Mother and Children*, 1914–1915, in which one child is held up over the mother's shoulders. It is obviously part of the series of the mother-and-child theme, which has haunted me throughout my entire life. In this particular group of *Arrival* or *Return of the Child* there was the specific feeling of escape from the horror of the fascists to the refuge of the United States. The 1941 versions are ecstatic prayers of thanks, notes of jubilation that also take me back to the *Return of the Prodigal Son* (1931). At this moment of flight from France, I was encouraged by the

speeches of de Gaulle I would hear over the radio. In fact, when I made *Theseus and the Minotaur* somewhat later, in 1942, I introduced the Cross of Lorraine into some of the preparatory drawings. The idea of escape and rescue in these works had a particular connotation for me. I was deeply concerned with the escape of my family and myself but also, I remember that I was frightened about the fate of all my sculptures that I had left behind. As I learned that they were safe, sometimes the child became an image of those sculptures of mine —my children—that had been threatened but finally had survived.

Although I was enormously grateful for the help of the American Rescue committee, I was frightened about going to the United States, about which I knew very little; and also I had no money or other resources, or even a word of English. It was like starting my life all over again. Despite my concern, curiously enough I also felt a certain exhilaration; I felt young and strong, as though I were just beginning my career once more. Later, there was something of this same feeling after the terrible fire that destroyed my studio in New York. It was a complete disaster but at the same time it made me think about what I had been doing and what I should try to do in the future. I have never been afraid of poverty or of my ability to manage or start over again. Even now, in my eighties, I have this same feeling, something that keeps my spirit young and that enables me to go on, no matter what catastrophe may occur.

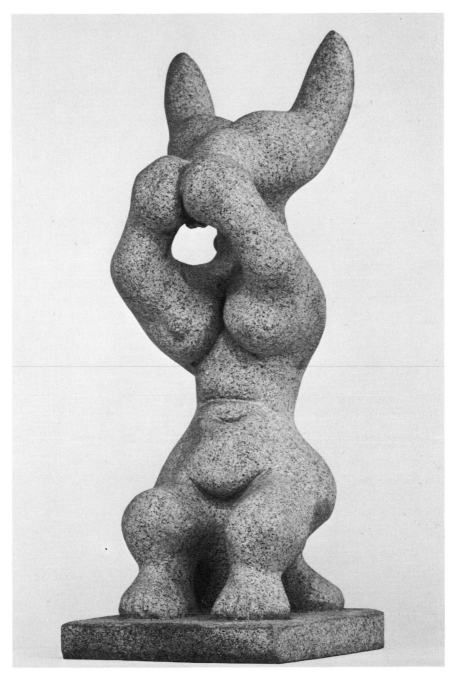

132. *Return of the Child*, 1941. Cast granite, 45¾" h. The Solomon R.
Guggenheim Museum, New York.

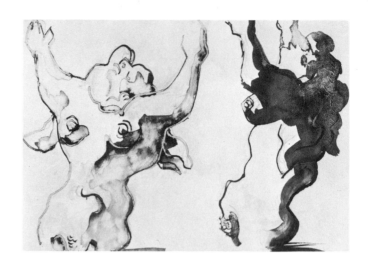

133b. *Study for Mother and Child*, 1939.
Gouache, 9⅛" by 12¼". Private
collection, New York.

133a. *Study for Mother and Child*, 1939.
Tempera and wash, 21½" by 14½".
Private collection, New York.

133c. *Study for Mother and Child*, 1939.
Pastel on canvas, 25½" by 19".
Collection unknown.

# Chapter 10

In New York I hoped to be taken on by the dealer Joseph Brummer, who had given me an important exhibition in 1935, but he had stopped dealing in modern art and was only handling antiques. However, he introduced me to Curt Valentin, a wonderful man who became my New York dealer. I arrived in New York the thirteenth of June 1941, and must have met Valentin about the sixteenth or seventeenth. I had only been able to bring with me two plasters and some drawings. Valentin immediately took the drawings and, after a few days, called me and gave me six hundred dollars for those he had sold, taking no commission himself. This was the first money I earned in the United States, and, since I then had only a few dollars in my pocket, it was very important to me. During the latter part of 1941 I was working on the *Mother and Child* (drawings and gouaches, figs. 133a, 133b, 133c; sculptures, figs. 134, 135), which was bought by Edgar J. Kaufmann and later installed in his house, Falling Water, at Bear Run, Pennsylvania, designed by Frank Lloyd Wright. The *Mother and Child* was not finished for some time but Kaufmann paid me one hundred and fifty dollars a month in the interim.

New York City was a fantastic experience for me. Despite the fact that I was setting up a studio and trying to get back to work, I visited all the major museums constantly. I was acquainted with the works in the Museum of Modern Art; but the Metropolitan Museum, the Frick Collection and the Morgan Library were all revelations to me. The

only difficulty was that I was in such a euphoric mood, despite the fact that I had virtually no money to live on, that it was difficult for me to begin making sculpture again.

I had brought from Europe only two small sculptures, the *Flight* and a *Rape of Europa*, but I was soon able to set up a studio on Twenty-third Street in New York City and to begin to work again. Immediately that I could work, I became young once more, despite the fact that my health, as a result of the tragedies in Europe, was still not very good. A flood of energy swept over me and I began to work like an insane man. The first piece I made in New York was *Arrival*, my answer to *Flight*. The drawing for this, the first I made in America, I have always kept. I am superstitious in this way and this drawing, the beginning of my life in a new land, had a particular significance for me.

Through the help of Joseph Brummer, I was able to begin making bronze casts at the Roman Bronze Foundry in Long Island City. In 1942 I switched to the Modern Art Foundry, a small foundry operated by a man by the name of Spring who spoke Polish. I had forgotten most of my Polish but I learned it again from him. During the Second World War, since bronze was difficult to obtain, this little foundry became bankrupt and I helped Spring to make a new one. He wanted me to become his partner, but I told him I would rather be a friend than a partner. Since that time I have used this foundry almost exclusively in the United States.

The next, and even more important, piece is the *Mother and Child*. There are many drawings for it which were originally made in Paris in 1939; but I could not begin on the actual sculpture until after I came to the United States. This to me is a frightening but at the same time a hopeful work that resulted from my feelings about the war. Although there are many obvious relationships with the previous versions of the mother and child, particularly that of 1930, this one was really entirely different. The 1930 version grew out of the tragic period when I lost my father and sister and was questioning, "Why was I brought to suffer on this earth?" It is a very personal piece. The later version that I started in 1939 with the drawings I made in Paris and that I completed between 1941 and 1942 has to do with the Second World War. There is despair involved in this sculpture but also, I feel, a kind of hope and optimism and even a form of aggression. This piece has a curious history which I did not realize until

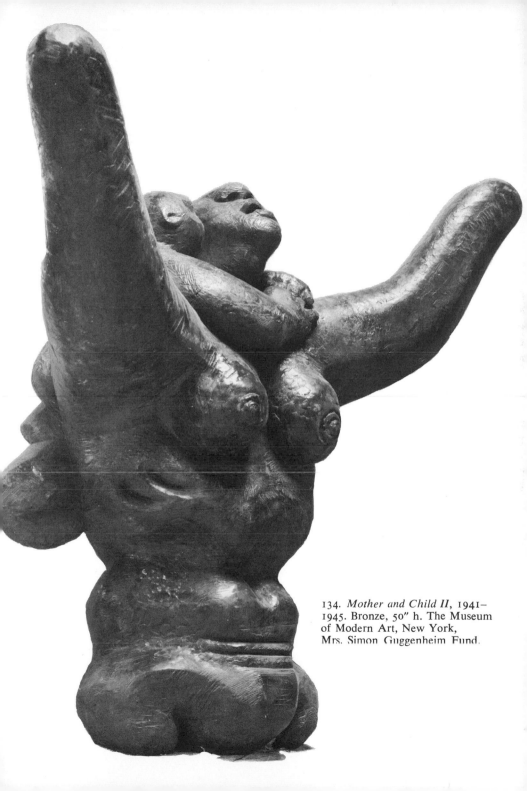

134. *Mother and Child II*, 1941–1945. Bronze, 50″ h. The Museum of Modern Art, New York, Mrs. Simon Guggenheim Fund.

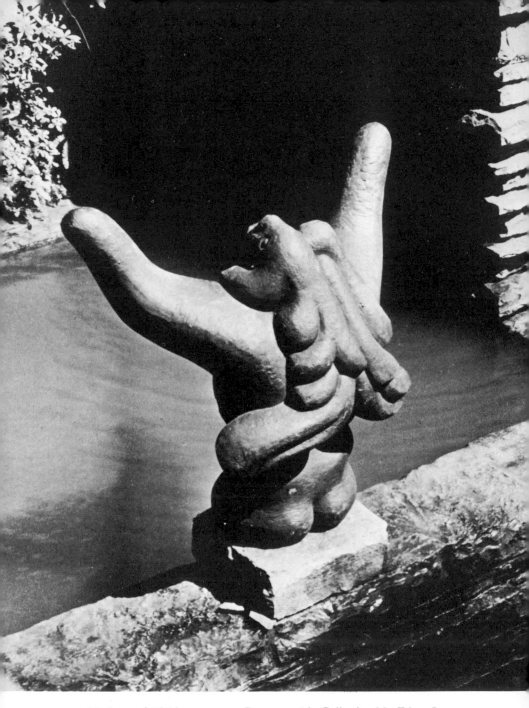

135. *Mother and Child*, 1941–1945. Bronze, 50″ h. Collection Mr. Edgar J. Kaufmann, Bear Run, Pa.

after the fact. In 1935 I was in Russia and one night, when it was dark and raining, I heard the sound of a pathetic song. I tried to trace it and came to a railroad station where there was a beggar woman, a cripple without legs, on a cart, who was singing, her hair all loose and her arms outstretched. I was terribly touched by this image, but I only realized years later, when I made the *Mother and Child*, that it was this image that had emerged from my subconscious. Although the sculpture is obviously much changed, the woman is without legs and, in the final version, without hands. The winglike projections at the side are the legs of the child that I added. For some curious reason, the child's projecting legs and the woman's breasts seem to form themselves into the head of a bull, something that gave a quality of aggressiveness to the sculpture. That, I think, indicates my feelings at this time, in the midst of the war.

The *Return of the Child*, 1941, is again a mother-and-child group in which the child is a symbol of my sculpture that was returning to me. Immediately after this I made drawings for the new *Rape of Europa*, 1941 (figs. 136, 137), in which Europa is fighting against her rapist (Hitler) and trying to kill him. There are a number of drawings of this, very intense in feeling, almost like a prayer, in which Europa is overcoming the monster. These works of the period around 1940 take on a new kind of violence with broken contours and dramatic gestures, perhaps the result of the emotions I felt in relation to the war and the disruption of my entire life. The earlier version of Europa and the bull is a rather simple and lyrical interpretation of the classic myth in which Zeus carries the nymph off to Crete; but in the later version Europa has become specifically modern Europe threatened by the powers of evil and fighting for her life against them.

In 1942 I made a portrait of Marsden Hartley, the American painter (fig. 138). How this happened is a rather interesting story. I was at the opening of an exhibition at Helena Rubinstein's. At that time I was having difficulty making a living so I said to myself that, since I liked to make portraits, perhaps I could get some income by portrait commissions. I felt that it might be useful for me to demonstrate my abilities in this field by making a new portrait of an American. In the crowd at the opening I saw a man who seemed to me to have a typical American face. He was speaking to a lady whom I knew and speaking in French. As soon as possible I ran over to the

lady and asked her if she would ask whether this gentleman would consent to pose for me. Then I saw them talking together and a large smile broke out over his face. We were introduced (although I still did not know who he was), and he said he would be delighted to pose. I made three portraits of him, one in terra cotta, now in the Metropolitan Museum, New York. One time, when he came to my studio, he said, "Jacques, I have just seen an old man sleeping on a bench, like this," and he assumed the pose of the sleeping man in such a graphic manner that I immediately said, "Marsden, will you hold that pose so I can make a sketch of you like that?" (Fig. 139). I also made a third sketch, later cast in bronze in seven issues.

Marsden Hartley and I were never close, although I liked him and he helped me with my English. After he died, the Museum of Modern Art had an exhibition of his works, and I remember that Monroe Wheeler of the museum came to me to see whether I had any personal reminiscences or letters of Hartley. In our talk Monroe asked me whether there was an answer to Hartley's letter to me in Paris in 1935. I was somewhat confused because I had never received any such letter and that was years before I had met Hartley. Apparently he had written me after seeing my exhibition at the Brummer Gallery, but for some reason the letter had never reached me. A copy had been found in his papers. I asked Monroe to send me the copy, and it was a beautiful letter of appreciation from one artist to another. Hartley was an interesting man of great sensitivity and, I think, an important American painter. He had a wonderful head, a very sensitive face, and I believe the portrait of him is a good one.

After the portrait of Marsden Hartley, I did not continue with my program of commissioned portraits since my other works began to sell, largely through the efforts of Curt Valentin. The Hartley portrait, of course, was made for myself as an exercise and demonstration. In 1942 I also made a portrait of Valentin in terra cotta, of which I made one bronze copy for his brother after Valentin's death (fig. 140). I have made no other casts, since the portrait never really satisfied me, although I have always kept the terra cotta as a memento of Curt, who was a very good friend. When I look at it now, I think I perhaps like it better than when I originally made it. It is not only a good resemblance but I think it catches the penetrating, analytical quality of Curt. Valentin, of course, posed for this. In almost all my portraits I have worked from the living model, since I think it is es-

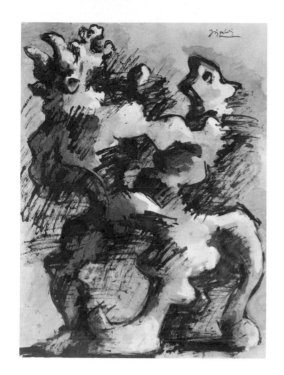

136. *Study for Rape of Europa IV*, 1941. Bronze, 21″ h.

137. *Rape of Europa*, 1941. Bronze, 34″ h. Collection Mr. and Mrs. R. Sturgis Ingersoll, Penllyn, Pa.

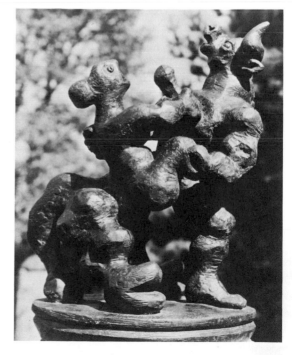

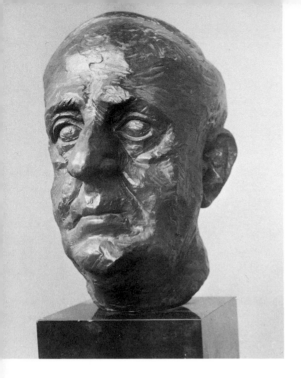

138. *Portrait of Marsden Hartley*, 1942.
Bronze, 14″ h. Collection Mr. and Mrs.
Hudson D. Walker, New York.

139. *Marsden Hartley Sleeping*, 1942.
Terra cotta, 11″ h. Collection
Mr. Benjamin Sonnenberg, New York.

140. *Curt Valentin*, 1942. Terra cotta,
11″ h. Collection unknown.

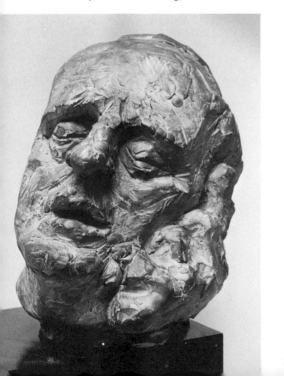

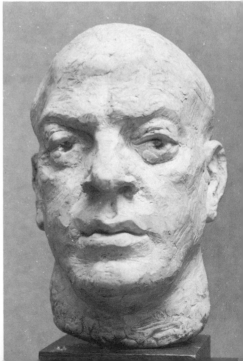

sential to have the man before you and to establish a relationship with him. Only on two or three occasions have I made posthumous busts from photographs—perhaps most notably that of President Kennedy, and I have to say that I have never been satisfied with them, with the exception of the *Géricault*. In fact, I have sworn never to do it again.

# Chapter 11

After I acquired my new studio on Twenty-third Street, the first major
sculpture on which I began was *Benediction*. This is a complicated
work which in a sense was never completed in the form I originally
visualized it. Its source had to do with my flight from Paris. When we
were in the Pyrenees in a small village, we learned that Paris had been
occupied, tragic news for all of us. It was a beautiful day, with a
marvelous sky, something I could never forget, but nevertheless we
were very sad. Suddenly, the idea came to me to sing a sort of lullaby
to Paris; and I thought, "Well, Paris will sleep now for a moment, but
I hope it will not be too long, and I want to make a sculpture like a
lullaby." So I started to make drawings. Then I began working on the
sculpture in New York which I later called *Benediction*. I remember
that when I had largely finished it, I had no title for it. I asked a
friend, a lady, if she could think of a title and explained what I had in
mind, and she suggested *Benediction*. It is still a lullaby, a woman
who is in a sense playing on a harp which is a part of herself. Thus it
has relations to such earlier pieces as *The Harpists*, but the forms are
entirely different. In this case they are relatively smooth and vol-
umetric with a poetic, curvilinear flow. There are many different
variants of *Benediction*, because I was looking for something that I
could not quite realize. I intended it as a full-length figure, but for
some reason I could not finish the legs, so it became a torso. Perhaps
this was a result of the fact that I felt at a certain moment it was
complete in itself. I still have sketches of the total figure in my studio,

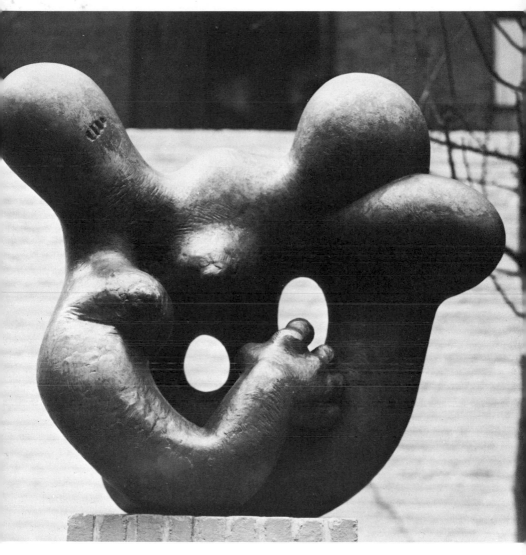

141. *Benediction I*, 1942. Bronze, 42″ h. Collection the Reis Family, New York.

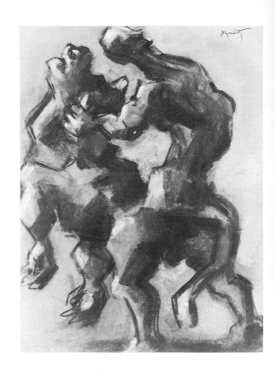

142. *Theseus and the Minotaur,* 1942. Gouache.

143. *Theseus and the Minotaur,* 1942. Bronze, 25¼″ h.

144. *Yara I,* 1942. Bronze, 22″ h. Collection Mrs. Carlos Martins, Washington, D.C.

but I do not know whether I shall ever complete the original concept or whether it will be necessary to do so (fig. 141).

The sculpture of Theseus killing the Minotaur, 1942, followed immediately after *Benediction* and is entirely different in form and concept. It is perhaps closest to the second version of *Rape of Europa*, in which Europa stabs the bull. I made many drawings for this piece in different techniques (fig. 142) as well as sculpture sketches (fig. 143). This subject also has to do with the war. The Minotaur is Hitler and I was thinking about de Gaulle as Theseus. In some of the drawings I put the Cross of Lorraine. I had heard the first speech of de Gaulle from England, a speech in which he said that France had lost a battle but not the war, and that it would survive and become victorious. When I finished the sculpture, I realized that the monster is also a part of Theseus, as though there were a Hitler in each of us whom we must destroy. Theseus is killing part of himself. As I have said many times, I am a very superstitious man. When I made a sculpture like *Theseus* or the second version of *Rape of Europa*, I was in a sense making a magical image, like a witch doctor who makes the image of an enemy whom he wishes to destroy and then pierces it with pins. Through my sculpture I was killing Hitler.

In 1942 I was working with the Spring bronze foundry and suddenly I developed a nostalgia to do transparents such as I had done in France in 1925. These were different from the earlier ones in the sense that I had now solved all the technical problems so I could work in an extremely free, lyrical manner. They also had a very close personal association, since they were related to someone with whom I was in love at that time. Most of them, thus, are made to express the sense of an exaltation of the woman. They are works inspired by passion and I think they reflect this fact. (*Yara I*, fig. 144, *Blossoming*).

*The Pilgrim* (fig. 145) was made directly in wax in 1942, like most of the previous series. This is a strange, even fantastic work in which all the parts of the figure seem to be blooming or flowering. His head is like an exploding bomb. He is disemboweled, with something like a snake entangled with a rose within his bowels. This figure also has to do with my feelings about that time, but I do not regard it as simply depressing or macabre. To me it is like a flower, a sunflower, something in which there is hope within this period of disaster. When it is looked at formally—and I find it difficult to separate the forms of my sculptures from the ideas involved in them—it appears as unquestion-

ably one of the strangest and most expressionist figures I ever made, one that was to lead to other similar ideas during the next few years. This period in my life, 1942 and 1943, after I was settled in the United States, was one of the lyrical phases with which I am periodically involved, a phase of hope and love and joy, even in the midst of disaster. This is something I cannot explain but it happens with me from time to time and then it disappears.

About this time I started to study engraving with Stanley Hayter, a fine technician. Engraving was most attractive to me but it seemed to interfere with my sculpture, so that it actually frightened me. I also made some lithographs and recently I have turned to lithography again. I always feel that an artist should continue to study and to learn even in techniques which are not his natural métier. I was making many drawings at this time (1942–1943), some related to the sculptures, such as *Theseus and the Minotaur*, and others on themes like *Jacob and the Angel* or the *Flight* or *Arrival*. One that is of particular interest to me is a rough sketch for *Hercules and Antaeus,* c. 1942 (fig. 146), a theme that fascinated me. Antaeus was the son of Mother Earth; he was unconquerable as long as his feet were implanted on the earth. Hercules conquered him by lifting the giant off the ground until he lost his strength. This story had so many implications for me. Sometimes the drawings or gouaches resolved my ideas to the point where I felt no need to make a finished sculpture. Such was the case with *Road of Exile*, of which I made a number of versions and also an engraving. I wanted to make a sculpture of this, but for some reason the drawing became so resolved that there was nothing else I could do with it. *Road of Exile* is obviously part of my feeling for *Flight* from Europe, *Arrival* in the United States, and the *Benediction*, which I also was never able to resolve completely.

The next important wax I made was *The Prayer* (fig. 147), perhaps the largest sculpture I had made directly in wax. This belongs to Sturgis Ingersoll, and there is only one cast of it. It is something over a meter high and is related to *The Pilgrim*. Technically, it was extremely difficult and caused me terrible suffering when I was forming it and when it was being cast. I made many modifications in the wax and even, through weldings, in the bronze. It is at an extreme opposition to the smooth, volumetric style of the *Benediction*. It was done at the most terrible moment of the war; it was a prayer, a Jewish prayer of expiation; you sacrifice the cock which has to take all your sins. In

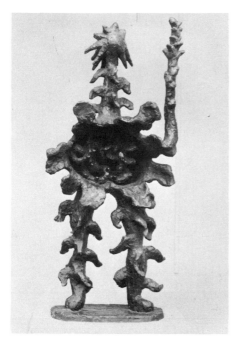

145. *The Pilgrim*, 1942. Bronze, 31½" h.

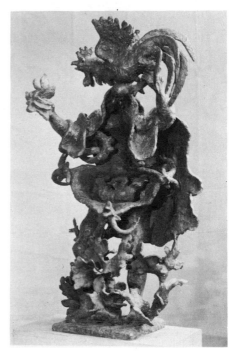

147. *The Prayer*, 1943. Bronze, 42½" h.
Collection Mr. and Mrs. R. Sturgis
Ingersoll, Penllyn, Pa.

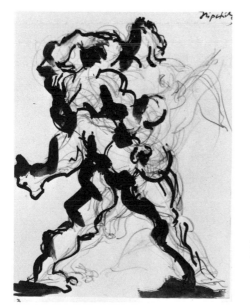

146. *Study for Hercules and Antaeus*,
1942–1945. Drawing.

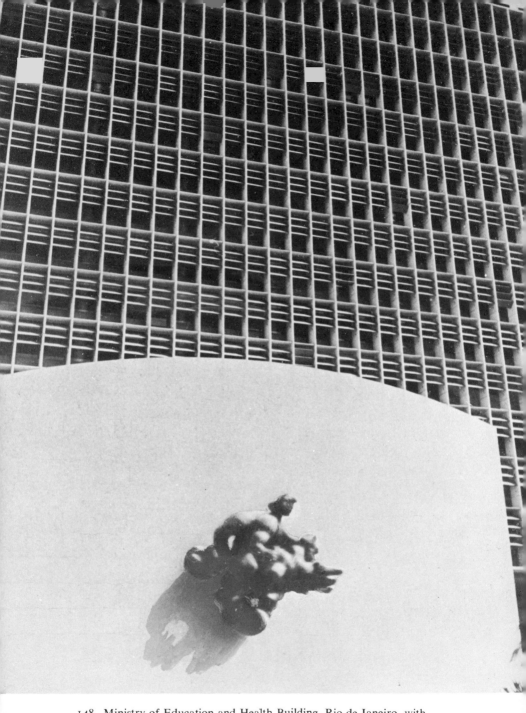

148. Ministry of Education and Health Building, Rio de Janeiro, with superimposed photograph of Prometheus sculpture in scale of original design.

the left hand the man holds a book, in the right hand the cock; the man wears the Jewish prayer shawl. The cock is actually killed by a man who is trained to do this. This prayer takes place before the Day of Atonement. Actually the figure is not a rabbi; it is Everyman, every Jew who has to do this, who is asking for forgiveness. The figure is completely disemboweled; in the open stomach are heads of goats, and the innocent victim, a lamb. The entire subject is the Jewish people, whom I thought of as the innocent victims in this horrible war. I find this whole subject so difficult to explain because it emerged from so many different feelings. I was praying, I was crying when I made this work. After Sturgis Ingersoll bought it and gave it to the Philadelphia Museum, I wanted to buy it back again because it meant so much to me. This was a piece entirely different from the massive, volumetric ideas of the *Benediction* or even of the solid sculptural forms of the *Theseus and the Minotaur*, in which it seemed I was tearing the guts out of my sculpture. It had something to do with the horror I felt about Auschwitz and the other Nazi concentration camps.

# Chapter 12

Almost immediately after I arrived in the United States, the Museum of Modern Art was instrumental in getting me a commission for a *Prometheus and the Vulture* for Brazil. Nelson Rockefeller was then in charge of Latin American relations, and he told me about the problems which the architect Niemeyer was having in finding a sculpture for a new Ministry of Education and Health Building in Rio de Janeiro. There was a marvelous area for a sculpture, and Niemeyer felt that only I could do it. I asked for blueprints of the building and produced a sketch to scale. This was a *Prometheus* related to the 1936 work I had done for the World's Fair in Paris, but much more developed. The model was about one-third the size of the projected sculpture, but through some fantastic mistake the work was placed on the enormous wall in the reduced scale of the model rather than in the full scale intended. This was for me a terrible tragedy, and I simply deny it as a work of mine. Had it been done on the correct scale, it could have changed the whole pattern of architecture-sculpture in South America. This was such a tragedy that I cannot even talk about it today. The *Prometheus*, which to me meant so many things, including the victory of light over darkness, of education over ignorance, was so important, and the fact that the temporary version in Paris had to be destroyed after the exposition—all of these things were so immensely significant in my thinking that this stupid reduction in scale in Brazil was a horrible tragedy. The *Prometheus* on the wall of the Ministry of Education was meant to be about twenty feet high (fig.

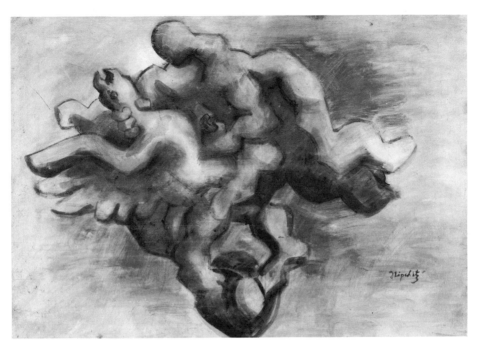

149. *Prometheus Strangling the Vulture*, 1944. Tempera on wood, 21¾″ by 31″.

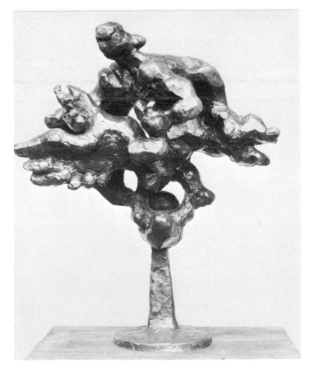

150. *Prometheus Strangling the Vulture*, 1943. Bronze, 16½″ h.

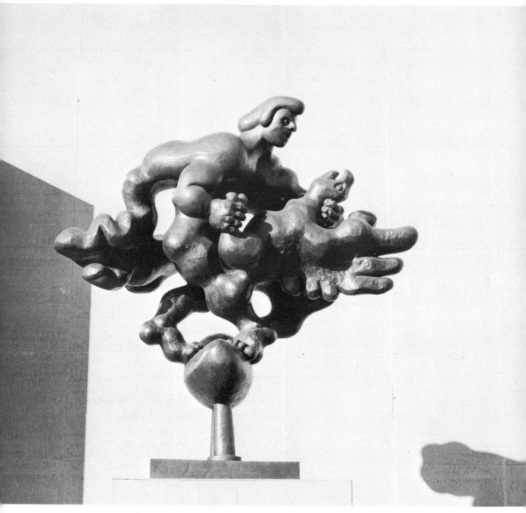

151. *Prometheus Strangling the Vulture*, 1944–1953. Bronze, 102″ h. The Philadelphia Museum of Art and the Walker Art Center, Minneapolis.

148). The shadow as the sun moved around the wall was essential to the effect. This sculpture was so important to me that I made many different studies of it (fig. 149). The Philadelphia Museum took one and then I was able to make another cast for the Walker Art Center in Minneapolis (fig. 150). I made many different variations on the theme but it is always the same idea, the fight of light against darkness, the fight of education against ignorance (fig. 151). The making of *Prometheus* took up most of 1944. During that year I met Yulla, my present wife. She was brought to my studio by the poet and Zionist leader Leif Jaffe. Jaffe had been a friend of my parents, had lived in the same town, and I had met him as a boy. I made a portrait of him and he brought Yulla, who is a sculptor, to look at it. So she came to me as a critic and then became my wife.

The next maquette I made in 1944 was a rough design for the *Embracing Couple*, which was to develop into the *Song of Songs* (fig. 152). At the time I was working on this sketch, a friend of mine, an architect, told me that he wanted to give his wife a present, a sculpture for her music room. I looked at the apartment and felt that the idea involved in this piece might be appropriate; so I made a somewhat larger sketch in 1946, still rough and free, and finally the finished sculpture, which was first done in stucco to have it light for hanging on the wall. The forms as finally realized have a curvilinear flow appropriate to the musical theme. I finally made a bronze version, changing the shapes and proportions somewhat. It was thought of first as a relief, but then I placed it on a support, transforming it into a free-standing sculpture that suggests a relief form. This I had done many years earlier when I transformed some of my cubist reliefs into free-standing sculptures by placing them on a base, and the idea actually led to that interest in severe frontality that dominated in such works of the twenties as the *Ploumanach*. The title, *Song of Songs*, of course comes from the Old Testament, and the theme is a love song, extremely lyrical and tender, since it was made for a very loving couple.

At the same time, in 1944, I was working on the theme of Pegasus, of which I made a great number of small sketches. These were ideas I was working out for myself on a small scale, after having finished the monumental *Prometheus*. The title finally became the *Birth of the Muses*. According to legend, Pegasus, the winged horse, stepped on Mount Olympus; where his four feet rested springs of water emerged,

and in these springs the muses were born. The idea of the legend attracted me very much and I attempted to catch its feeling—although in no literal or figurative sense—in the maquettes. In the first maquette Pegasus is placed frontally, but as the idea developed I turned him more in profile to emphasize the feeling of a high relief. The architect Philip Johnson asked me to make something to be placed over a fireplace in a townhouse belonging to the Rockefellers, and I felt this subject would be appropriate both in terms of the location and the interest of the Rockefellers in the arts (fig. 153). This is a freer, more deeply undercut and heavily textured piece than *Song of Songs*, though both suggest the dynamism of the flying horse. The house was later given to the Museum of Modern Art but the works of art in it were dispersed, and the *Birth of the Muses* is now in one of the theaters at Lincoln Center. It was actually designed as a relief sculpture, although it is completely finished in the round, but I also made sketches of it as a free-standing work on a pedestal. I think this is one of the important new pieces of the 1940s, involving many new ideas that I have continued working on to the present time. In fact, my monumental *Bellerophon Taming Pegasus*, which I am now doing for Columbia University, may be said to have had its origins in the *Birth of the Muses*. I have a free-standing bronze of the *Birth of the Muses* in my garden, where I see it constantly when I look out the window, and the shapes and dynamic movement continue to interest me to the point that I am constantly thinking of changes and variations I would like to play on it. Since it was made for a particular square base, it has a somewhat square shape. Thinking of it as a free sculpture, I would like to change the proportions, to make the tail longer, the water higher; to make it not all so square.

The idea for the *Birth of the Muses* started with these little sketches in 1944, but the final sculpture for the Rockefeller house was not completed until 1950, some years after I had returned to Paris for my first visit after the war.

Another piece I made before going to Europe was the *Joy of Orpheus*, 1945 (fig. 154). It has to do with the love of my wife. The woman is sitting on the man's lap. They are happy and her arm is raised in the air; and all of it takes on the form of a harp. I think of it as a very interesting sculpture, poetic and beautiful. It comes so directly from my emotions, although everything I do comes from my emotions.

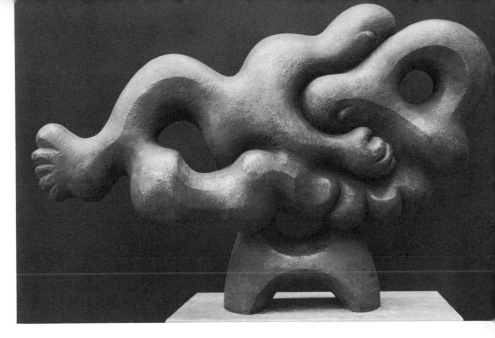

152. *Song of Songs*, 1945–1948. Bronze, 36″ l.

154. *Joy of Orpheus*, 1945.
Bronze, 18½″ h.

153. *Birth of the Muses*, 1944–1950. Bronze, 5′ h.
Lincoln Center, New York.

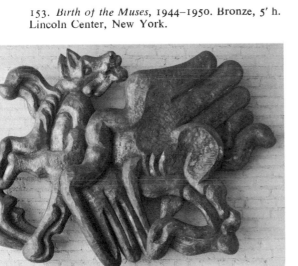

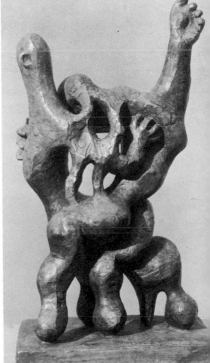

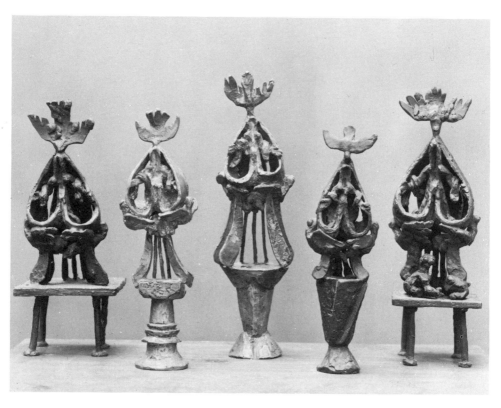

155. *Five Studies for Notre Dame de Liesse*, 1947–1950. For the Church of Assy. Bronze, 8½″ to 10½″ h.

Nineteen forty-six was a crucial year for me, because I returned to France for the first time since leaving it at the beginning of the war. The Maeght gallery wanted to have an exhibition of my works, and I used this as an excuse to go back and to see what had happened. During the opening of the exhibition a man approached me and asked if I would like to make a Virgin for a church. He had been commissioned by Father Couturier to ask me. I said, "But, you know I am Jewish?" The man said, "If it doesn't disturb you, it doesn't disturb us." I liked his answer and said that I would think about it. From this emerged my Virgin, which I feel to be one of the most important things I have ever done. It has also been, in an emotional sense, one of the pieces with most significance for me.

When I left France in 1941 I had been forced to leave everything, my studio, my house, my collection, and I was reconciled to the idea that everything was lost or destroyed. I had begun a new life in the United States, and for some reason I did not feel too badly about the destruction of my old life. But when I returned to France I found that not everything was lost; a great number of things could be retrieved, and so I started to run all over France like a poisoned mouse to recover my possessions—I even bought some of my own things back. As a result, I stayed a long time and even wanted to settle in France again. My house was still there, although a little dilapidated. But I found that the spirit had changed. My old friends had dispersed and I did not like the atmosphere, so I went back to America. I still adore Paris, in which I may say that I grew up as an artist, but I am now happy in the United States. I did see some old friends, including Picasso, at an exhibition at the old Musée de Luxembourg, where I exhibited the plaster of the *Song of the Vowels*. At the opening somebody was lecturing about my sculpture, and I was listening to this nonsense when there was a touch on my shoulder and it was Picasso. We kissed each other very emotionally and he said, "My boy, I was at your exhibition at the Maeght gallery and you worked marvelously over there." We were both so moved that we were in tears and left immediately. Picasso is perhaps the only surviving member of my old friends, and I visit him from time to time where he lives near Cannes. When I returned to the United States my first wife did not want to come back with me. She did not like America; so I went back alone and later, after our divorce, I married Yulla. As I have said earlier, I still admire and like my first wife very much. She is a

wonderful human being. Our married life was difficult but we have always been good friends.

When I returned to New York Father Couturier came to me with another priest and asked if I were still willing to make a Virgin for their church. I said yes, I had thought a lot about it, and I would make it under certain conditions: I wanted an inscription on it because I didn't want any misunderstanding. I showed the inscription to Father Couturier, who put it in his pocket and said he would write me about it. For months there was no word, but finally I received an enthusiastic letter about my inscription, respecting the spirit that dictated it. The inscription was: "Jacob [my Biblical name] Lipchitz, Jew, faithful to the religion of his ancestors, has made this Virgin for the better understanding of human beings on this earth so that the Spirit may prevail." So I started, and then she was destroyed in the fire in my studio; and I started all over again in the new studio. When I cast it and was working on the finished bronze and it was suspended in the air, I had the vision that I could make something more with this. The idea led to the *Peace on Earth*, a very large work, and has affected a number of monumental sculptures I have made since.

I took no fee to make the Virgin beyond my expenses, which I had to have, since I had no money. Then a curious, almost miraculous, thing happened. Father Couturier published the sketch in a French publication, and as a result I received a letter from a lady in Texas, Mrs. Jane Owen. She said that she had three children and every first of May, the day of the Virgin, she had a party and would like to have a model of my Virgin. She asked that I send it to her and said she would pay the cost of transportation. I found this very naïve. Obviously, she did not know what sculpture was. So I wrote her a very nice letter saying that as she had to take care of her children I had to take care of mine, and that it was impossible because it was fragile and could not travel and also I was in the process of working on it. Next there came a telephone call. This was in 1950; I was working on a scaffold on the *Pegasus* and had had a telephone installed up there. The call was from the lady saying that she had received my letter but to send the piece anyway and that she would take good care of it. All very nice. I said it was impossible but that I would send photographs and if she wanted to enlarge them and use them for her party that would be all right. So I did. Next I received a letter from her asking if she could come to see me. Of course I said yes, and one day, as I was

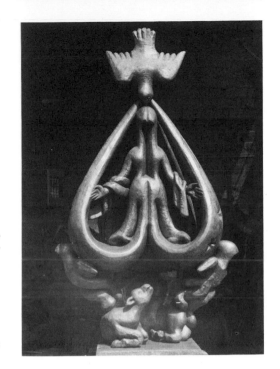

156. *Study for Notre Dame de Liesse,*
1953. Bronze, 33" h.

157. *Sketch* for the Gate of Roofless
Church, New Harmony, Indiana,
1958. Bronze, 17½" h.

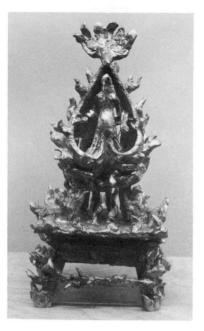

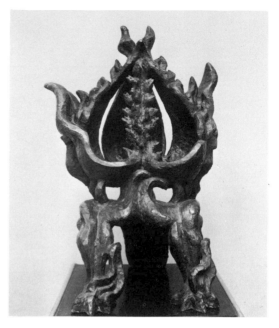

158. *Virgin in Flames*, 1952.
Bronze, 13½" h. Collection
Mr. Leigh B. Block, Chicago.

159. *Lesson of a Disaster*, 1952.
Bronze, 27" h.

160. *Dancer with Hood*, 1947.
Bronze, 18" h.

working, a lady came in, thanked me for the photographs, and asked me to tell her how the sculpture was developing. So I told her that I had no money to start the bronze casts, and, to make the story short, she arranged that we should make three casts, one for the Church, one to sell, and one for me to keep for my daughter. There is a curious postscript to this story. One day I received an offer from the Abbey of Saint Columba on the island of Iona off Scotland. Saint Columba came from Ireland in the sixth century and built an abbey, and from this abbey Christianity spread over the northern part of Europe. I sent them the cast that belonged to my daughter, keeping the money for her; and I feel happy that my three versions of the Virgin are all in some focal point. She is at Notre Dame de Liesse in Assy; on the Island of Iona, one of the centers for the propagation of Christianity; and in New Harmony, a colony of Germans who adored Santa Sofia, Wisdom, in the possession of the lady who made it possible for me to make them. She had Philip Johnson design a roofless church for my Virgin, and for this church I also made a monumental gate (figs. 155, 156, 157).

The original Virgin, commissioned by Father Couturier, who himself was a painter before he became a Dominican monk, is now in the Church of Assy in France. Father Couturier, who was an extremely interesting man, unfortunately died young, but was instrumental in commissioning many modern artists, including Léger, Rouault, Bonnard, and others, to make contemporary religious works for his church. Father Couturier had first come to see me in 1947 and I made many sketches for the Virgin between 1947 and 1948. The vision of the Virgin was extremely difficult. I read a great deal about the Catholic religion in order to make myself familiar with the ritual and yet I could not somehow see it. Then one day, riding in the subway, I suddenly saw it and saw how to make it and quickly made a small drawing. I was frightened by the idea of making a Virgin, an image to which people would pray. It took me much time to find a solution, a point of view. As finally realized, she is placed in a *mandorla* with the dove, the Holy Spirit, above her and the lamb below, as a base. There were some sketches I had made before the final version that differed from my original vision but these were destroyed in the fire of my studio, and I felt in a way that I had disobeyed my vision, that the Virgin didn't want to be born like that, and so that I had to go back to my original concept. My daughter,

Lolya, was born in 1948 at the same time as the conception of the Virgin and there must be some connection.

When I came to my studio and found the Virgin destroyed, I made a small sketch, the *Virgin in Flames*, 1952 (fig. 158). There is another related work which I entitled *Lesson of a Disaster* (fig. 159).

When my new studio was built in 1953 the first thing that I began to work on was the Virgin. It came out quite different from the ones that had burned, and I would say that it is better. The fire changed my life. On my return from Paris, in 1947, perhaps because of the relationship between that trip and my original escape to the United States, I worked on themes of *Rescue*. This was another period of crisis in which I was not sure what I should do, where I should go. I was married in 1947 and I was still living on Washington Square, and the sculpture I entitled *Happiness* emerged from my feeling at this time.

I was now settled in the United States and was happy because I was working. This is my passion, to the point that I rarely go to the theater, to concerts, or to films. At night I am so tired I just go to bed, but fortunately I sleep very well and in the morning I feel like a newborn baby. My only vice has continued to be that of collecting. Shortly after I came to New York I discovered the antique dealers on Third Avenue, and I have haunted them ever since. After my fire in 1952 I was despondent, but a week later I was at the antique dealers', and they helped me to emerge from this awful catastrophe and begin my life again. It is only now that I am over eighty years old and that I feel I must spend all my time working that I cannot go to the antique dealers any more. But I must admit that occasionally I am seduced.

My collection of objects from all periods in history is of immense importance to me, even if some of the pieces in it are not so important, so significant in themselves; but it is like a university to me. I have learned something from every work, something that has helped me to understand certain things about sculpture in general and about my own sculpture in particular. It is a sculptor's collection, and this is why I hope it can be kept together. I think that future generations of artists and art students can learn about themselves and their own work by studying it. When I speak of my learning from the collection, I do not, of course, mean taking subjects or even motifs. Rather, what I have learned by constantly handling these objects and looking at them, living with them, are such things as forms, techniques, the ways

in which an ancient or primitive sculptor-artist approached his materials.

For instance, I am continually fascinated by the ways that ancient and primitive peoples experimented with bronze; how frequently daring and imaginative they could be in their handling of the material, much more so than many bronze sculptors of Renaissance and modern times. I have been a bronze worker now for over sixty years, constantly in foundries, since bronze is a material I love, and I think I have seen and myself experimented with almost everything that can be done in bronze. Yet, when I say this, I realize that I am constantly finding new possibilities. My approach to bronze sculpture is at times more poetical than traditionally sculptural. I remember I had the idea almost twenty years ago of seeing whether I could combine certain natural objects, not only twigs and branches but even leaves or flowers. This was a curious and poetic concept that appealed to me, but it took me perhaps fifteen years before I actually made the first attempt to incorporate some actual flowers. I called this series *To the Limit of the Possible*, meaning the limit of the possibilities of bronze casting. But as I have learned more, these limits have become even further extended. I work both with sand molds and the lost-wax process, but I really prefer the lost-wax because this I can handle and retouch. In the sand-mold process, once a sculpture is cast you can do very little with it except rework the surface. In many waxes, when I do an edition of seven, I make changes in every one so that each in a sense is unique. I have recently thought of a new technique in which I make the sculpture in wax and then put it in hot water so that it is extremely malleable and I can change it drastically. I have not had too much time to experiment with the possibilities of this process since I have been engaged in huge commissions, but I am now, in 1971, making a series of small bronzes on Commedia dell'Arte themes which excites me very much. I have tried other metals, such as aluminum, but bronze is my first and continuing love because it is so alive, so direct, warm, and fluid. Each piece has my fingerprints all over it.

# Chapter 13

Nineteen forty-seven was a very exciting year for me both in my work and in many other ways. My wife became pregnant that year and the idea of having a child created a euphoric mood. That year, incidentally, I was made a Chevalier, or knight, of the French Legion of Honor, something that pleased me because I am still close to France, but othewise I do not attach too much importance to it. The rule is that if there is an older member of the Legion in the city, he is delegated to perform the ceremony. In this case it was Amédée Ozenfant, whom I had known since the early days, who knighted me, and the ceremony was simply a pleasant excuse to open a bottle of champagne. I have received many decorations and awards in my long life, but this little ribbon of the Legion of Honor is the only one I like to wear occasionally.

During 1947 I worked on an extensive series of the *Dancer*, or *Dancer with Hood*. I was interested in the idea of the floating veil in its relationships to the twisting movement of the figure and the movement of her long braids of hair. The small sketches, of which I made several variants, are generally light and open with the arms and legs highly tapered, but the finished work (fig. 160) is much heavier, since I always believe that sculpture which is too thin is not successful; the light on the surface eats up the forms, and to protect myself against this illusion I emphasize the volumes, I make them fuller to compensate for the effect of light. Even though the subject is a dancer, the work is not actually a dancer. It is a piece of sculpture, and it must be

thought of in purely sculptural terms. *Dancer* is a highly complicated work in its movement in space, its organization in depth and in the variety of shapes, even the variations in the handling of the bronze from the smoothly rounded volumes of the drapery to the more broken, jagged quality of the hair. I think the side view with its complex of different shapes is particularly interesting. At times this view suggests to me some sort of strange beast of the imagination. This feeling for fullness in my sculpture is very important to me. I felt that Giacometti was a talented man, but to me an enormously thinned-out sculpture is always pessimistic. I am an optimist, I love life, and I cannot support its degradation. You will always find that my large sculptures, which may look heavy in the studio, when placed out of doors in full light themselves become much lighter, while not losing their sense of solidity and mass. During 1947 there were some little maquettes on the theme of the *Embrace*, some of which were perhaps related to similar maquettes of the 1930s, although in the earlier ones the embrace is much more violent and sexual and the technique of the maquette more broken, scored, and jagged. In the new ones, the embrace is more tender and even chaste and the sketches are more rounded or volumetric. Although these maquettes are the roughest original ideas for sculpture, frequently modeled in half an hour, they still reflect the stylistic changes that were continually taking place in my larger works.

The most important series of sculptures of 1947 are those collectively entitled *Miracle*. In 1947 a shipload of Jewish immigrants came from Europe to Palestine. At that time the British held a mandate over Palestine, and they refused to allow the Jews to disembark. The ship, which was named *Exodus*, was forced to go from port to port, and no one would permit it to dock. It was a terrible event, one that made me sick with anger and despair. There were many prayers and fasts among Jews for the safety of this ship, and I also fasted. It was during my fast that the idea for this sculpture appeared. I was certain that Israel would ultimately become a state, and the sculpture was in effect the birth of this new state of Israel, a candlestick with the Jew praying. Entitled *Exodus 47*, it was actually a second version of the theme. In the first, *Miracle I*, there is merely the figure praying in front of a Menorah, which takes the form of hands imploring a miracle. After that I made *Exodus 47*, in which the forms in the middle of the candlestick reminded me of the Tables of the Law; so

this resulted in a third version, *Miracle II* (fig. 161), in which I consciously introduced the Tables. I first actually visited Israel in 1963 and I went again last year. It's incredible what has been done there in only about twenty years. The people are proud and courageous and they literally are transforming the desert into a garden. I went to all the holy places, not only Jewish but Christian and Moslem, and was most moved by them, although they are actually very poor and modest, not at all like St. Peter's in Rome. *Miracle II* was a prayer of thanksgiving that Israel had officially become a state in 1948. In this piece I returned to the concept of the praying figure of the Jew in his shawl united to the Menorah and to the Tables of the Law. On the tablets are written the numbers in Hebrew. The final version is large, some eleven or twelve feet high, on a monumental base modeled after one I saw in Israel that probably came down from Roman ties.

In 1948 and 1949, still with the birth of Israel very much on my mind, I turned to the theme of sacrifice. I had used the same or a similar idea in *The Prayer* of 1943, in which, however, the man is holding the cock up over his head. For the prayer to be effective, an animal must be sacrificed for one's sins. The 1943 *Prayer* is also extremely open and fragmented in structure, one of the boldest experiments in bronze casting I had made up to that point. The 1948 *Sacrifice* represents a great change and development in my sculpture. This is much heavier and forceful, even fierce, in concept. There is a small, preliminary version of *Sacrifice* (fig. 162) in which the man (he is not actually a rabbi but an individual specially ordained to perform the sacrifice) is killing the cock with his left hand, something that did not seem reasonable to me, so when I made the first finished sculpture, *Sacrifice I*, 1948–1949 (fig. 163), he is using his right hand. This is more massively conceived than the sketch. This subject fascinated me to the point that I made many drawings for it, and it caused me a great deal of trouble. In actuality I was working on several versions of it until at least 1957. A cast of the first version was sold to the Albright Knox Gallery in Buffalo, and the Whitney Museum has one more or less similar. The original plaster from which the Albright bronze was made was destroyed in the fire of my studio; but, fortunately, the Albright permitted me to make a mold from their bronze, so I was able to start over again. Immediately, however, I began to change the forms and even some of the iconography. The

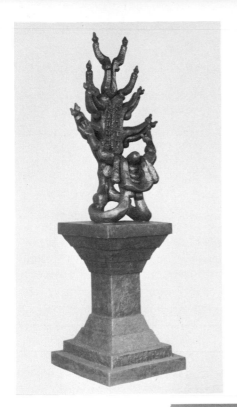

161. *Miracle II*, 1948.
Bronze, 110″ h.

162. *First Study for Sacrifice*,
1947–1948. Bronze, 19″ h.

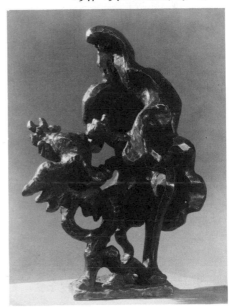

163. *Study for Sacrifice*,
1948–1949. Bronze, 19½″ h.

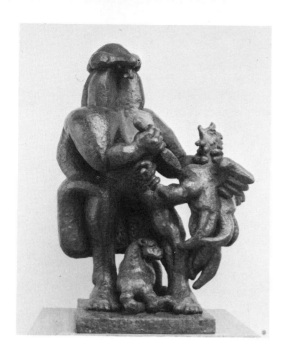

164. *Sacrifice III*, 1949–1957. Bronze, 49¼″ h. Collection Mr. and Mrs. Ted Weiner, Palm Beach, Calif.

165. *Mother and Child*, 1949. Bronze, 52″ h.

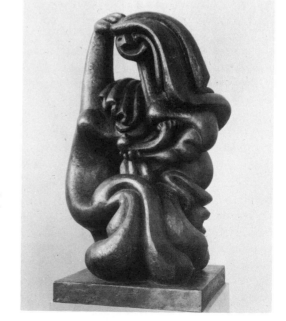

figure becomes more upright and hieratical, the cock's wings and feathers more dramatically scattered, and a reclining lamb is introduced between the figure's legs (fig. 164). Why I should have done this I cannot recall, since the lamb is rather a Christian than a Jewish symbol and is definitely not a victim of the sacrifice. I may have been thinking of the continuity of the Judeo-Christian tradition, and I may, as well, have wanted something between the legs to lend stability to the entire composition. There is also another *Sacrifice III*, not actually finished until 1957, in which once again the forms and even the dramatic action change radically. Incidentally, the sacrifice is not portrayed in the actual manner of a ritual for which there are special ritual knives. The use of the dagger is deliberate, to heighten the sense of drama. I think this is one of my major works. It certainly is strong and complete, but it unquestionably comes out of some continuing feeling of anger. I could not make it today because my mood is different, much happier, more optimistic. *Sacrifice* is heavy and enigmatic, even brutal, and now, in my present mood, I want my sculptures to be saturated with light, to be like mirrors attracting and reflecting light.

After the *Miracle* and *Sacrifice* series, which were very different from almost anything I had ever done before, reflecting a spirit of anger and even pessimism, my mood changed dramatically as a result of the birth of my daughter, Lolya. It was a fantastic experience at the age of fifty-nine finally to have my own child, particularly a daughter, which is what I wanted, partially because I wanted her to have my mother's name. The result in my sculpture was a series of extremely lyrical works on the theme of the mother and child. These have the curvilinear movement in-the-round of the dancers of the earlier 1940s, but the mood is now much more tender and obviously maternal (fig. 165). Another, even more complicated, version of the *Mother and Child* was made in several different variants between 1949 and, I think, 1954, so it is possible to see how much this theme continued to obsess me.

The two concepts, my feeling for Israel and my feeling for the mother and child, came together in the *Hagar I* of 1948 (fig. 166), which has to do with Israel and the conflict between Israel and the Arabs. Despite my admiration for and love of Israel, I feel strongly that the Jews and the Arabs should make peace, that they should live together as brothers, which they were able to do for many centuries.

Hagar was a concubine of Abraham and when he married Sarah, Sarah did not wish to have her or her child, Ishmael, so Abraham finally sent them away. They suffered in the desert until they were rescued by an angel. I wished to show my sympathy for Ishmael, who is thought of as the father of the Arabs in the same manner as the Hebrews are the sons of Abraham; so this is a prayer for brotherhood between the Jews and the Arabs. It is a concept which combines tragedy and suffering with tenderness and hope for the future.

In 1949 we were forced to move from our place in Washington Square, and, after looking extensively in Manhattan, we decided to try the suburbs. It was thus that I found my house in Hastings-on-Hudson, although I first had a terrible experience when I looked at a beautiful place in New Jersey, and, after I was all ready to buy it, discovered that it was restricted. This was my first experience of restrictions against Jews in America and it terrified me. Fortunately, we found nothing like this in Hastings, and we have lived there most happily.

I still kept my studio in New York and until the fire in 1952 I commuted to the studio and, for years thereafter, to the foundry in Long Island.

In 1949 there were also some sketches entitled simply *Biblical Scene*, a scene of sacrifice, but conceived in a most open and monumental form with many interpenetrations between the figures and the sacrificial goat (fig. 167). The original sketch for the figure and the goat was only 12½″ high, but I then developed it to 20″, placing the figures at the top of a sort of mountain peak that served as a great pedestal with other figures below. I was thinking of the possibility of doing something on a monumental scale, and this was one of my first such attempts. I had not been able to continue with the Virgin of Assy because there was no money available, so that most of the pieces I was making were on a less ambitious scale, since it was necessary to do things that could be sold to museums and private collectors. The idea of a great monument continued to haunt me, however. The larger version of this Biblical scene was destroyed in my fire and I did not have the heart to begin it again, although I still think it is a most interesting idea. When I had built my new studio in Hastings I was able to begin serious work on the Virgin and that took all my time. In 1950 I was working on the final version of the *Birth of the Muses* (see fig. 153), the first sketches for which, in the form of *Pegasus*, date

167. *Study for Biblical Scene*, 1949. Bronze, 20″ h.

166. *Hagar I*, 1948. Bronze, 34½″ l.

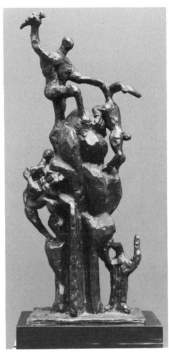

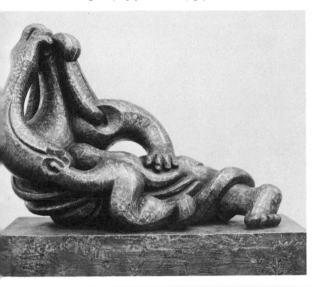

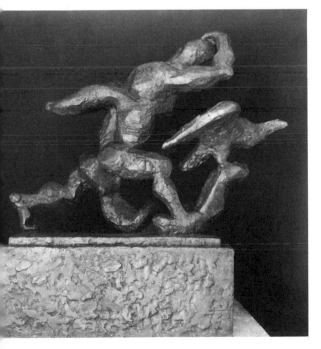

168. *Study for Enterprise*, 1953. Bronze, 29½″ h.

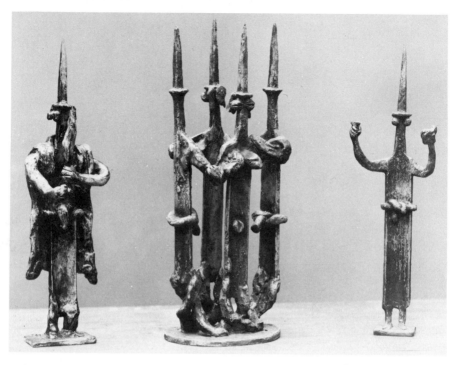

169. *Hebrew Objects* (*Variations on a Chisel*), 1951. Bronze, 8¾" h.
Collection S. Schocken, Scarsdale, N.Y.

170a. *Begging Poet*, 1951–1952.
Bronze, 8½" h.

170b. *Poet on Crutches*, 1952.
Bronze, c. 8" h.

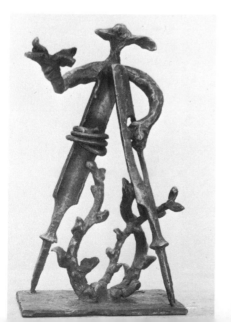

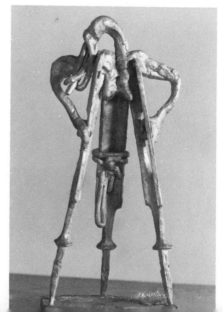

back to 1944. And then, in 1951, money became available through Mrs. Owen to start developing and casting the large-scale versions of the Virgin.

I was now beginning to have the opportunity I had so long desired to work on a more monumental scale. A commission came in 1950 from the Fairmount Park Association in Philadelphia. This association, founded by a Philadelphia family, established a sort of park for sculptures to tell the story of America. My theme was that of American enterprise. In the first sketch I had a striding figure, very open and free in concept, who seemed to be stepping on an eagle and who carried a dove of peace as well as the caduceus, the winged staff with serpents twined around it that is the symbol of Hermes, or Mercury, the god of commerce and transportation, among other things. I wanted to combine the stories of the eagle with the dove of peace and the idea of progress. The committee refused this sketch for the curious reason that they thought Americans would object to the implication of someone stepping on the eagle, while in reality I wanted to make the figure in the steps of the eagle. So I made a number of other sketches which were destroyed in the fire of my studio and finally one in which the eagle is leading the figure. This piece, on which I worked until 1954, went through many transformations, since it was one of the most important commissions I had received until this date and since I now felt myself so completely an American that I was fascinated by the American theme. The finished work is about twelve feet high, placed on a beautiful base of black marble (*Study for Enterprise*, 1953, fig. 168).

During this period in the early 1950s my work was beginning to be shown widely in general exhibitions. The first of these was a large retrospective originated by Thomas Colt, director of the museum in Portland, Oregon. It was also shown at the San Francisco Art Museum and the Cincinnati Art Museum in 1951. The catalogue was written by Andrew C. Ritchie of the Museum of Modern Art and later director of the gallery at Yale University. Then the Museum of Modern Art organized a major show in 1952 that also traveled to the Walker Art Center in Minneapolis and the Cleveland Museum of Art. Henry R. Hope, head of the Department of Art of Indiana University, an old friend of mine, directed this exhibition and prepared a monograph, one of the first important studies of my works to appear in the United States. There were other exhibitions, such as one at the Arts

Club in Chicago, and my dealer, Curt Valentin, showed groups of my works on a regular basis.

One of the greatest tragedies of my life was the burning of my New York studio in 1952. It was on a Saturday and I was in Hastings with two visitors when, about seven o'clock, there was a call from the New York police department saying that my studio had burned and that I had better come at once to see what could be saved. This was the fifth of January, 1952. One of my visitors drove me to New York but we could not go into the building that evening because it was too dangerous, so we returned early the next morning and it was horrible; the studio was practically nothing except a hole in the ground. Almost everything in the studio had burned away, and some parts of plaster that had not burned were demolished. The model of the Virgin had disappeared. The table on which it had been standing had burned and the statue itself had simply melted. The armature for the *Enterprise* was nothing but some bent iron. I had some bronzes stored in adjoining rooms and these, fortunately, were untouched, but the studio no longer existed. Papers and paintings, including a Courbet I had recently bought, had been thrown out onto a balcony by the firemen. My pieces from my collection, some of my best African pieces that had not yet been unpacked, were destroyed along with a portfolio of drawings, such things as three Cézannes, a Goya ink drawing, and others by Poussin and Gris. My first reaction was that of horror, as though my entire life, all my children, had been destroyed, but then this changed to a kind of fury, a passionate need to begin working again to recover all the lost years.

Somewhat earlier, in 1951, I had been talking to a friend of mine, an American painter, about painting and sculpture when he noticed a sculptor's chisel on a workbench—without its handle. He looked at it and said, "But that is a sculpture." I said, "No, it's not, but it could become one." So I took a little plasticine and made a sort of figure of the chisel. After this initial experiment I became interested in the idea and made the chisel in wax and cast it in wax at the foundry. After the fire I had nowhere to work and the foundry offered me a room. I did not know how to begin. Here I was sixty-one years old, and I felt empty. So I decided to make a sculpture every day with the wax chisels I had made at the foundry, without thinking too much about what I was doing, just working. In twenty-six working days I made twenty-six sculptures, and I was cured of my depression. These little

chisel figures were very spontaneous pieces done rapidly and directly, without much conscious thought. From their almost subconscious spontaneity they could be referred to as "semi-automatics." But I was able to do them rapidly and to make many varied images. I do not come to my studio and wait for inspiration, for angels to speak to me and tell me what to do. Every day I begin to work immediately, real and important work, work that involves things and learning and teaching other people. If the result is successful it is not through any accident but through the experience of a long life of thought, experiment, and continual hard work. I think it is an expression of my ever-growing optimism that these figures, which are light and cheerful and gay, should have emerged so immediately from one of my moments of desperate tragedy. After the Jewish ritualistic series (fig. 169), I varied the formula with a series of crippled poets begging (figs. 170a and 170b) in which I used two or more chisels. These crippled, begging poets had a specific association because immediately after the fire, which was reported in the paper, I began to receive letters of sympathy, many enclosing money, letters even from people I did not know. I was most touched, but I could not accept the money, with the exception of the first check for ten dollars, which I kept out of a sort of superstition, sending the donor a beautiful drawing in exchange. We returned all the checks, but these donations gave a friend of mine the idea of raising money by selling my sculptures against advance payments. Curt Valentin agreed to the idea and even said that he would take no commission. Thus, we were able to raise enough money to begin my studio in Hastings. Then there followed a series of enmeshed centaurs (fig. 171) more complicated in their linear entanglements and related to earlier transparents. Others in the series have personal associations, such as one in which I am battling with my friend Curt Valentin. Others are simply dancers or a bird. The final one (fig. 172) is a sort of Menorah, a symbol of thanksgiving that I had freed myself from my depression and was now a working sculptor again.

This was a brief moment of thanksgiving, for it was immediately followed by another tragedy. One very hot day in May I came to my foundry studio, and the son of Spring, the head of the foundry, told me that something terrible had happened; the wax cast of *Sacrifice*, taken from the bronze I had borrowed from the Albright after the plaster had been destroyed by fire and on which I had been working,

had melted and collapsed. It was a castrophe. For a moment I was demoralized, and then Johnny Spring said, "Mr. Lipchitz, if I were in your place, I would quit." This made me so angry I replied, "You had better help me put it together again instead of saying such stupid things." My anger got me to work and I stopped making the chisels and started once more on the larger pieces. After working on the wax of *Sacrifice* I began making some new things, the wax which I called *Lesson of a Disaster* having to do with the fire, and the little sketch of the *Virgin in Flames*. Both of these sketches, particularly the *Virgin in Flames*, which is like the reborn Phoenix emerging from the flames, were to me symbols of renewal or rebirth.

After the fire I also made a number of portraits of collectors, one of whom, like Henry Pearlman, who is a lovely man with an incredible Cézanne collection, I think perhaps commissioned the portrait partly in order to help me financially. This is a good strong portrait that I believe reflects the simplicity and at the same time the force and intelligence of this remarkable man. Another portrait I particularly like is that of Otto Spaeth (fig. 173), who was an angineer and an art patron, a man of great sensitivity and knowledge who was actually something of a genius.

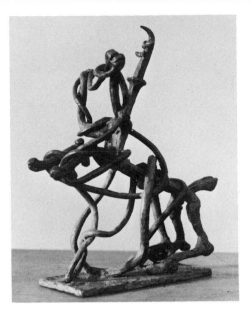

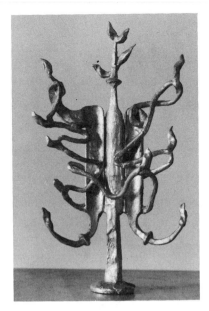

171. *Centaur Enmeshed*, 1952.
Bronze, 7½" h.

172. *Menorah*, 1952. Bronze, c. 9" h.

173. *Otto Spaeth*, 1952. Bronze, 14½" h.
Collection Mrs. Otto Spaeth, New York.

174. *Only Inspiration*, 1955–1956.
Bronze, 9" l.

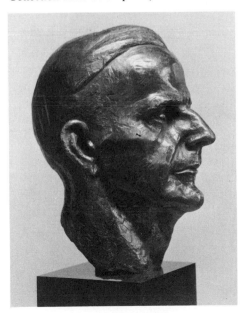

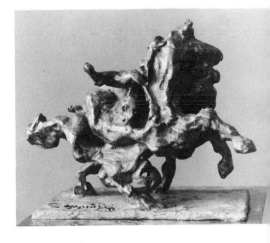

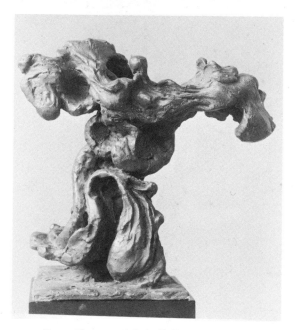

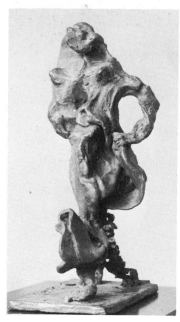

175. *Remembrance of Loie Fuller*, 1955–1956. Bronze, 10″ h.

176. Untitled, 1957(?). Bronze, 11″ h.

177. *Sketch of Mrs. John Cowles*, 1956. Bronze, 16″ h.

178. *Sketch for Lesson of a Disaster*, 1961. Bronze, 27″ h.

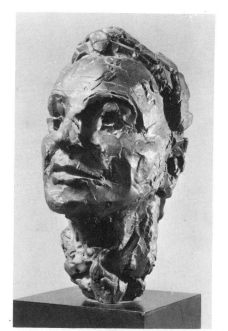

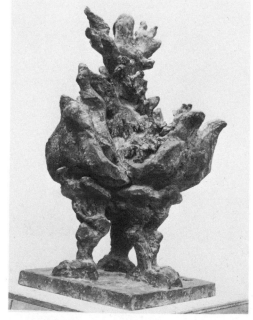

# Chapter 14

My new studio was built during 1952, and when I first saw it empty of all my sculptures it seemed huge and barren; but it was amazing how quickly it filled up, not only with new works but with older pieces, my plasters, and the rest of my collection that was brought from Paris. Now the only problem is that I do not have nearly enough room.

I actually started working in the studio some time in 1953, on the final version of the Virgin. The *Spirit of Enterprise* was finished in 1954. I had previously made innumerable sketches at different scales and I felt that the final sculpture built successfully on all these earlier experiments. The monumental works (the Virgin, finally named *Notre Dame de Liesse* [*Our Lady of Joy*], and *Enterprise*) took up most of 1953 and 1954. In 1955 I began to make my semi-automatics as a reaction to my labors on the monumental sculptures and also as a result of a rather amusing incident. As I recounted earlier, my assistant, Isadore Grossman, one day came to me in a fury, saying that the teacher had been talking about modern sculpture and a girl had asked him what he thought of the sculpture of Lipchitz. The teacher had had a lump of clay in his hands and had let it fall on the floor, where it splattered, saying that that was a Lipchitz. I only said, "That is a rather interesting idea. I think I might try to make some such sculptures." So arose the idea of the semi-automatics, in which I would just splash or squeeze a piece of warm wax in my hands, put it in a basin of water without looking at it, and then let it harden in cold water.

When I took it out and examined it, the lump suggested many different images to me. Automatically a particular image would emerge several times and this I would choose to develop and clarify. Up to this point my acts were purely automatic; from here on they were completely conscious. These latter ones were far freer, even though in the last analysis they were controlled by all my experience.

I learned a great deal from the semi-automatics, including one important point, that the artist is not completely free. For example, one day a lump of wax suggested a playful subject to me, a circus horse and acrobat. When I finished the day's work I received some unfortunate news, and, as a result, the next morning when I attempted to resume this playful subject, it came out entirely differently as a tragic theme with the man falling from and being dragged by the horse. I named this piece *Only Inspiration* (fig. 174) to suggest that the artist is not really free. It is only inspiration, some force outside of himself that is directing him. What you do is controlled by events or your feelings on a particular occasion.

The idea of the automatic work of art was used by the surrealists but existed long before them. I found it in the drawings of Rodin where he would drop a spot of ink on paper and then bend the paper to allow the ink to flow haphazardly, creating strange images. Leonardo da Vinci advised young artists to look at the clouds or at the cracks in old walls, where they would find images that could inspire them.

This does not mean in any sense of the word that good art can emerge purely from accidents. There must always be at some point the control, the knowledge, and the experience of the artist. And this knowledge cannot come from books. It must come from having touched and molded the raw materials. The knowledge of the artist is a visual knowledge, or a knowledge that comes through his fingers.

In the semi-automatics I always tried to maintain and respect the molten quality of the soft wax and to direct or clarify only those elements that suggested some specific image to me. Many of the semi-automatics took the forms of dancers, undoubtedly because the molten material formed itself into swirling movement. Some of these, such as the *Prophet* or the *Man with the Rooster*, were obviously inspired by sculptures I had myself made earlier. Sometimes they became images of actual people I had seen many years before, such as

the *Remembrance of Loie Fuller* (fig. 175), a dancer from the beginning of the century who used to dance with swirling veils.

The curious thing about these semi-automatics is that what I have really always wanted to do was the reverse—to begin my sculpture completely consciously and then be able to finish it automatically. In other words, to make a sculpture that was controlled by all my experience and abilities as a sculptor, but came out finally as though it were an accident of nature. Always, you understand, it must be "of nature." And always within the seemingly accidental freedom there must be the control and the content of a genuine work of art.

Another curious fact is that my ideas about sculpture have been conditioned by certain bottles—not bottles from which I had been drinking, since I have never felt the need to find inspiration in liquor or in drugs, but bottles I saw at certain crucial moments. The first, as I have mentioned, is the *Bottle Developing in Space* by Boccioni, which I saw in the futurist exhibition in Paris in 1912. This had a considerable influence on me and helped me find my own road away from realism and toward purely created force. Years later, I saw another bottle, in this case a real one, which had been in a volcanic eruption and had been deformed in an absolutely extraordinary manner. It was still a natural, or man-made, object, recognizable as such, but it had been changed into something new, natural, but never seen. I once gave an interview to Paul Dermé in 1920 which was published in the *Esprit Nouveau* in Paris. He asked me, "Jacques, what would you like to do?" and I said, "I would like to make monsters, but monsters that seem to be natural; as if nature had made them." Well, this obsession has been with me constantly, all my life. In the semi-automatics I was transforming the unconscious into the conscious, but, much as I liked these things and learned from them, the result did not seem quite complete. The work of art should go from the unconscious to the conscious and then finally to the unconscious again, like a natural, even though unexplainable, phenomenon. This is an idea I am still to work out and, who knows, perhaps some day I will succeed.

The difficulty in such a concept lies perhaps in the experience of the artist, particularly such a long experience as I have had. Suppose I make a sculpture in a malleable material, and then, when it seems finished, I close my eyes and attempt to work on it automatically. By

this time I am so familiar with it that my hands know every part of it even though my eyes are closed, so that it is almost impossible for the final result to be completely automatic. But I keep trying, sometimes with some fascinating results. When I was a young man, a cubist, I wanted desperately to be different from nature, against nature, an absolute in myself. Like many of my colleagues I despised the *art nouveau* of the early 1900s, which was all naturalistic flowing movement. In the same way I had been against Rodin, in whose late works there were many qualities that really belonged to the *art nouveau* tradition. As an aside, I should say that I was always an admirer of Gaudi, whose wonderful architecture I saw in Barcelona. I felt from the beginning that this was a man of genius. But as I matured I realized that despite its predominantly decorative emphasis there were naturalistic qualities in *art nouveau* from which I could learn, just as ultimately I began to learn from and to revere Rodin. Incidentally, Rodin made drawings of Loie Fuller with her veils swirling around her, and there were many other different *art nouveau* sculptures of her, since even her dances seemed to embody the spirit of this particular art movement. So it's amusing, although not unnatural, that one of my semi-automatics should have turned into a Loie Fuller even though I had not thought about her and her dances for fifty years.

As I have emphasized, the titles were given to the semi-automatics after they were completed, in terms of associations, subjects of previous works, or perhaps something that had happened to me or my family at the time. They were made during 1955 and 1956, but there is one made the following year, some time during 1956 or 1957 (fig. 176), in which I used the same technique but added a deliberate element that pushed it beyond the limits of the semi-automatics. It is simply a figure, a woman with swirling robes, one arm on her hip. The point of this is that as an experiment I introduced a real flower into the cast and it actually came out in the bronze. I was enormously excited by this innovation, something about which I had been thinking for a long time, and it inspired me to go on with the series that I called *To the Limit of the Possible* (1958).

After the semi-automatics I made some more portraits, including those of Mr. and Mrs. John Cowles in 1956 (sketch, fig. 177). The Cowles are a publishing family in Minneapolis. I met the Cowleses when I went to Minneapolis for the opening of my exhibition at the Walker Art Center. They have a beautiful collection including a por-

trait of themselves by Kokoschka. The Walker Art Center, incidentally, bought a large cast of my *Prometheus* and also *Theseus and the Minotaur*. I particularly like the original sketch for the portrait of Mrs. Cowles. This is extremely free and rough but I think suggests the intelligence and the dynamic personality of this lady. In the same year, 1956, I attempted a sketch of my wife, Yulla, which is also quite free and quickly done. I made a finished version which she disliked— she almost divorced me when she saw it!—and I think she is probably right. It is difficult to make a portrait of your wife.

Then, in 1957, I did some variations of *Lesson of a Disaster*, the sketch of which resulted from the destruction of my studio. This was an idea that I always felt could be made into a monumental sculpture, and I continued to experiment with it throughout the early 1960s. The last plaster I made must have been about 1964 or 1965, a work about nine feet high, a curious structure that is like a growing plant on the legs of an animal (study for large plaster, 1961, fig. 178). It emerged from the vision I had after my fire of the *Virgin in Flames*. The concept is difficult to explain. There is a phoenix at the top which is feeding a nest of small birds, and the flames are transformed into a blossoming flower. I think the whole idea had to do with hope and renewal after the disaster. In 1969 I gave the large plaster of *Lesson of a Disaster* to the foundry on Long Island to be cast, so I have not actually seen how it has turned out.

After *Lesson of a Disaster* I started on *Between Heaven and Earth*. As I have indicated earlier the idea for making this work came from the Virgin in 1953. I was working at the foundry and the bronze was suspended in the air; suddenly, as I looked at it, I had the impression that if it were continued at the bottom it could be like a chalice. This was simply a thought at that time and it took me until 1957 to carry out the thought. As I conceived it, the figures below constituted humanity receiving the Virgin. The idea has something to do with the songs and rituals of primitive people and also, curiously, in my mind about some of the regulations and taboos involved in the beginning of cubism. This later fact pushed me further in the direction of freedom and lyrical expression, away from the dictatorship even of ideas, toward images of the unity of humanity.

I made many sketches on this idea of *Between Heaven and Earth*, but figure 179, which has something of the character of a chalice, seemed to me to be the most satisfactory. There are many elements

involved in it: the mother and child, a pair of lovers. When I saw the piece suspended in the air in the foundry, suddenly the Virgin took on new implications that went beyond Christianity to the ideas of all humanity. *Between Heaven and Earth* was not finished until after my sickness in 1958 (fig. 180). In its final form I do not consider it a specifically religious or Christian sculpture; rather, it becomes religious in a universal sense. The piece, of which I have made three casts, has been widely exhibited, at the Documenta Exhibition in Kassel, Germany, at the Musée Rodin in Paris, and in many other places. One of the casts I have presented to my home town of Hastings-on-Hudson, a place which I love and to which I feel very grateful. Some people in Los Angeles must have seen the piece or reproductions of it, because a Mrs. Chandler of the Los Angeles Music Center Committee wrote to me and asked if I could make a large version for them.

I said that I would have to see the location; so I went, made measurements of the space in relation to the theaters and other buildings that surround it and, finally, through my sense of scale rather than through exact measurements, decided on the size that would be necessary. The architect who designed the complex had not wanted sculpture in relation to his buildings, but Mrs. Chandler and Mr. Dreyfus, the industrial designer, had felt that something was needed. They had tried many sculptors for two years but were not satisfied until they saw this work of mine. I was extremely happy, because I had always wanted to make it on a very large scale.

When I had started to make the Virgin (*Notre Dame de Liesse* for Notre Dame de Toute Grâce at Assy, France) in 1947, I immediately had ideas about doing something similar related to my own religion. I had made sketches at that time which developed into *Our Tree of Life* (fig. 181), and I have been working on this idea ever since. It is so close to me that it has been one of the most difficult projects of my life. I cannot tell how many drawings and maquettes I have made between 1947 and the present time. Many of these perished in the 1952 fire. First I started it with a base having to do with the sacrifice of Isaac; then, in later sketches, it started with Noah. It is like an Indian totem having to do with the whole development of Judaism. I have still not completed the concept, but I hope to do so when I complete the monument for Philadelphia and I shall be free to work on it exclusively. In 1967 a group of ladies from the Hadassah

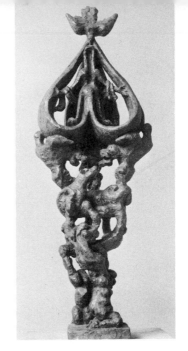

179. *Between Heaven and Earth*, 1958. Bronze, 46″ h.

180. *Between Heaven and Earth*, 1958. Bronze, 46″ h.

181. *Sketch for the Tree of Life*, 1962. Bronze, 34″ h.

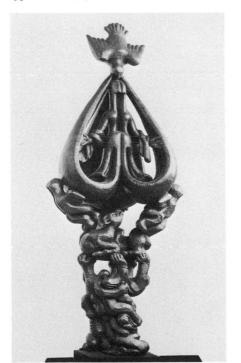

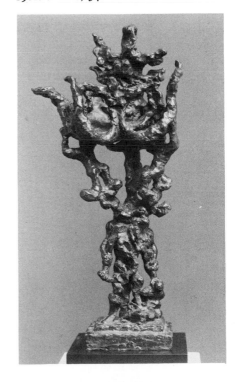

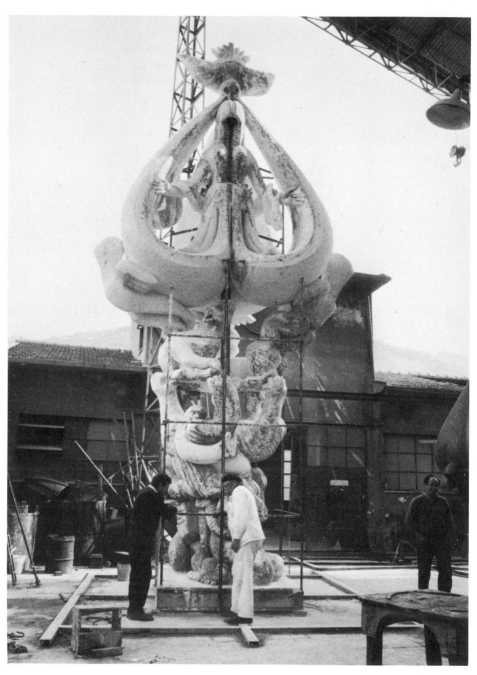

182. *Peace on Earth*, 1967–1969. Plaster, c. 29′ h. Photographed at Tommasi Foundry, Pietrasanta, Italy. Commissioned for Music Center, Los Angeles.

organization came to me and asked me to make a sculpture for Mount Scopus, and this is the location on which I hope *Our Tree of Life* will stand. It will be a huge piece, perhaps forty feet high with its base, on the edge of Mount Scopus overlooking the Judean hills and the Dead Sea in the distance. It is an absolutely extraordinary commission and if I am able to complete it it will be the climax of my life.

To return to *Between Heaven and Earth*, the cast of which was made at Pietrasanta in Italy: this underwent a series of disasters. We worked on it for seven months and then, the floods in Italy of 1966 came and destroyed the plaster, so we had to start all over again. I made a new version between 1967 and 1968 for Los Angeles which I entitled *Peace on Earth* (fig. 182), in which the figures were mounted on a large and complex base. There were changes made in the final version unveiled about May 5, 1969. During 1958, before my illness, I was working on the little pieces that I entitled *To the Limit of the Possible*. These, as I had indicated, grew out of the semi-automatics of 1955 and 1956. After my tentative experiment in 1956 or 1957 of introducing an actual dried-out flower into a semi-automatic, I had the idea of taking real objects which somehow impressed me and incorporating them into wax models for bronze sculpture. The question in my mind was whether it would be possible to cast this combination in bronze. In what I think is the first one I tried in the new series (*Carnival*, fig. 183), the combination of actual flowers and wax came out perfectly in the bronze cast, so this gave me courage to continue. I made twenty-six of these sketches but only fourteen came out as I wished them to. In this context, I think it is evident that whenever I am working on a large project such as the *Virgin*, the *Tree of Life*, or, earlier, the *Prometheus*, or, now, the *Bellerophon* and the *Government of the People* for Philadelphia, I always feel the need to work also on some small experimental pieces in which I am exploring new directions and new ideas.

The technique of these pieces in the series *To the Limit of the Possible* is interesting. In *Carnival*, for instance, I first designed it in wax, then added the flowers; then put it in a mold and placed it in the oven to burn out the wax and the other objects. Sometimes the technical problems became extremely difficult, as in the *Bone*, 1958, where I was using an actual cow bone which would not burn out. In pieces like these and some others I had to fill in the holes by welding.

In any event, all of these pieces were fascinating to me and from them I learned a great deal. They involved that combination of the conscious and the unconscious which has haunted me for so many years. For instance, in the *Bone*, I happened to be passing my butcher's one day when I saw a bone which looked to me like a head, so I asked the butcher to clean it and give it to me. I then made additions, the eye in wax and then the plants to emphasize the impressions I had had on seeing the original bone. This is a sort of montage, but one I think that historically goes far back of the twentieth century. In the sixteenth century the painter Arcimboldi used to make paintings of heads entirely out of plants and animals (although he was using the process for other aims), and even recently I learned of an old marble worker in Pietrasanta who was making sculpture of real bones and shells. In my collection I have examples from the Egyptian, eighteenth-century dynasty, in which a bone is slightly carved to make the heads of two lions. I also have pre-Columbian sculptures from Ecuador in which figures are carved out of human or animal bones.

This idea of combining materials, on which I have been working recently, is one, as I have said, that has intrigued me for many years. But I never simply wanted to make a collage, a combination or assemblage of different elements. I wanted to learn how to combine these elements into a unity in bronze so that they all became one; and it is the achievement of this idea, I think, which has been my great joy in recent years. Not only the solution of a complicated technical problem is involved, but the solution of the concept about which I have talked frequently, the creation of a work of sculpture in which I am able to move from the unconscious or the automatic gesture to the conscious sculptural structure and back to a final unconscious realization.

The other little bronzes in the series of *To the Limit of the Possible* incorporate every kind of found object, from driftwood to stuffed birds bought in novelty shops, sculptural mallets, baskets, flowers, and vegetables.

This has been a period of tremendous technical experiment and fulfillment resulting in highly poetic works that filled me with a beautiful sense of accomplishment.

# Chapter 15

At the end of 1958 (the exact date was November 20) I suddenly became ill. At first I thought it was nothing important, but then it developed that I had cancer of the stomach. I was operated on immediately and I was told by the doctor that if there was no recurrence within five years I would be completely cured. Fortunately, the five years have long since passed and I feel better all the time. This was obviously a major problem in my life, because I was facing death. I remember that before going to the operation I spoke to the doctor and said, "I want to ask you a great favor. If you see that this is fatal and that I will be an invalid and not be able to work, please do something to finish it." The doctor became very angry. So I told him about my doctor friend in Paris in 1940, whom I had asked when I was escaping the Nazis, to give me something in case I were caught. He also had been angry at the idea, but he more or less accidentally left me a small phial to take with me. I said, "Doctor, we are humans and if you will not do this, I will have to do it and that will be more difficult." After the operation the doctor came and brought me a bottle of wine and said, "Have a drink." I thought a great deal during this illness, and I felt that it would be a pity for me if I died because there were so many things that I still wanted to do; but I think I am honest in saying that I was not afraid. I had had a difficult but wonderful life. There were so many things that I wanted to do. I have to say here that my wife, Yulla, was marvelous throughout this entire period, and without her help I could not possibly have been

back at work as soon as I was. By 1959 I was working again and immediately began to feel better.

There were many things that happened in relation to my sickness which have affected me and my work since that time. My wife comes from a very religious orthodox family and she was bothered by the fact that I, although I think of myself as a faithful Jew, have not been as orthodox in the observation of the rites of Judaism. In this moment of crisis she went to see a rabbi, and it turned out that this rabbi had known my mother. He was a highly educated man, who had studied at the Sorbonne. He had known my mother in Lithuania and he knew about me. When Yulla spoke to him, he said, "Go home. Your husband will live." And he also asked her to have me come to see him when I came out of the hospital. This I did and we became good friends. His name is Menechem Mendel Schneerson. He is a fabulous man and a mystic. When he preaches in a snyagogue, I try to go, and it is always an extraordinary experience. When I talked to him he wanted to know whether I were a practicing Jew and I said, "No." He asked me only one thing: to take the phylacteries and to make my prayers every morning. He sent me the phylacteries, which are containers inside of which are prayers on some strips of parchment, and this I have continued to observe.

We stay in touch and I like him very much. I think we only disagree on the idea that for a Jew there should be no graven images. Thus, obviously, he does not approve of my vocation. I have tried to explain to him that graven image means an idol. And that this edict did not even come from Moses but from the time of the Romans. When the Romans were in Israel they placed statues of emperor gods everywhere, and it was from this that the Jewish hatred of the graven image emerged. From the Bible we know that Solomon's temple was ornate with sculptures. But the rabbi still will not agree with me. I agree with Moses in that I am against imitating nature in a literal sense.

I am now working on the Hadassah commission for the monumental sculpture on Mount Scopus in Israel. There have always been Jewish artists and, today, I think I may say that many of the leading painters and sculptors are Jewish. There were Jewish artists in Holland in the seventeenth century, in Sweden in the eighteenth century, and many thoughout Europe in the nineteenth century. In Russia in the nineteenth century one of the best sculptors was a Jew named

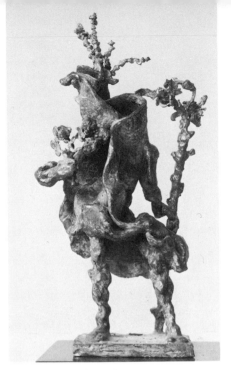

183. *Carnival*, 1958. Bronze,
17¾" h.

184. *Sketch of Sturgis Ingersoll*, 1960.
Clay, c. 17" h.

185. *Cup of Expiation* (*Images of
Italy*), 1962. Bronze, 15" h.

186. *The Tower and Its Shadow*, 1962.
Bronze, 11¾" h.

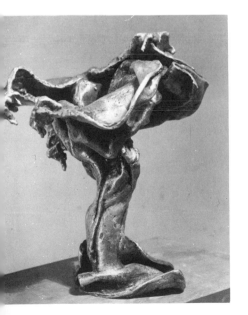

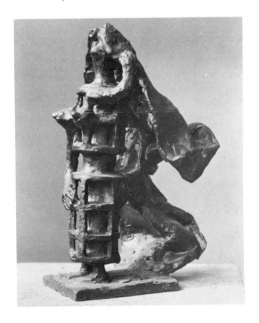

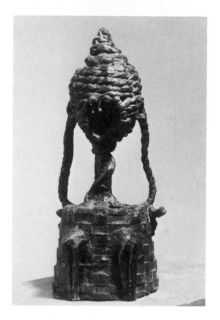

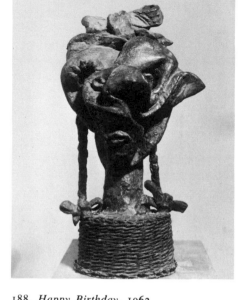

187. *The Beautiful One*, 1962.
Bronze, 12½″ h.

188. *Happy Birthday*, 1962.
Bronze, 16″ h.

189. *Giuliano (Sketch for Monument for Duluth)*, 1963–1964. Bronze, 26″ h.

190. *Sketch for Monument for Duluth*, 1964. 15¾″ h.

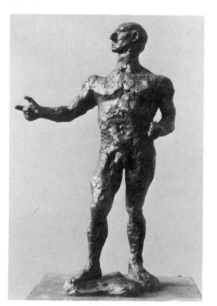

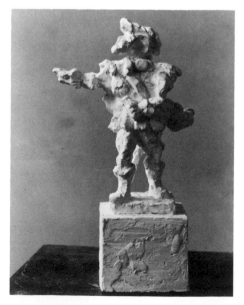

Antokolsky. Pissarro was a Jew, as was also Israels in Holland. Although I was brought up in a religious home, I have never had any reservations about creating images. When I was a child and was modeling sculptures, my father would bring friends to show them what I was doing, saying in a mocking but affectionate manner, "Here is my son. You see, he wants to become an Antokolsky." I never held this against him because I knew that he was such a gifted, intelligent man and that he was proud of what I was doing.

After my illness I began working again on the sculpture *Between Heaven and Earth*. About this time I also did a portrait head of Sturgis Ingersoll, President of the Board of Trustees of the Philadelphia Museum (sketch, fig. 184). I think this is a good portrait because I like the man very much. This feeling of empathy for a sitter does not necessarily lend itself to a good portrait. I certainly have a very special feeling for my wife, but my portrait of her did not turn out well.

In 1962 I was making sketches for *Our Tree of Life* and for the enlarged version of *Lesson of a Disaster*. Now I am making *Our Tree of Life* as a monument for Israel, and I have been rethinking the problem. I have decided to start not with Abraham but with Noah, who is the actual patriarch of the Jews, the father of the Jewish people. Everything builds on the figure of Noah. *Our Tree of Life* is still in process. I have not yet arrived at a satisfactory solution. There is a large sketch in my studio that I have been working on for six or seven years that is constantly changing. Even this year I made major changes. I hope that soon I can find the final image.

In the autumn of 1962 I was invited to visit Israel. Karl Katz was then director of the Museum and he took me around the entire country. Everyone was marvelous to me, particularly Teddy Kollek, who was then in the cabinet of Ben Gurion and is now the mayor of Jerusalem. The Israeli government wanted me to make a memorial to the Jews who had revolted against the Romans and had been besieged on a mountain by the Dead Sea over the Negeb. These Jews had fought off the Romans for something like two years until, finally, their cause became hopeless. At this point, when they had to surrender, they all committed suicide. Every tenth man killed the nine others and himself, so they all died except for two women who had been afraid and had hidden and thus lived to tell the story, which is documented by the Jewish historian of that time, Josephus Flavius.

The Israeli government gave me a helicopter to enable me to fly over the area. This in itself was a fantastic experience. The problem of placing a monument on this hill is extremely difficult, since it is not solid rock but earth. I gave various suggestions as to how such a monument could be handled, but nothing has come of this.

Visiting Israel was a very moving experience for me as a Jew. I was fascinated by the old Israel and the contemporary Israel. I remember that when I was in a hotel near Safet I stopped at a café where there were many young people. A girl recognized me and they crowded around me. They were all artists, and the next day I went to their studios. I feel very emotional about Israel, which has been in a nightmare for two thousand years. But now it is awake. When I went back to Israel a couple of years ago after the six-day war, I was able to go to visit the other side of Jerusalem.

In my first visit I had a most interesting conversation with Ben Gurion. He doesn't know much about art but he wanted to talk about it. He asked me if I liked Chagall and I replied that I liked him very much. He is a great artist, a beautiful jewel in the Jewish crown. So Ben Gurion said, "But where do you see Jews flying in the air?" I replied, "Mr. Prime Minister, you are a great expert on the Bible and the Bible is full of angels flying in the air; did you ever see any angels flying in the air?" I do not think he liked my answer. I wanted to tell him not to speak about art because he did not understand it, but I could not do this tactfully. At one moment Teddy Kollek, who was with us, started to talk politics, and I decided that this was my moment. I said, "In politics I don't understand anything," hoping that Ben Gurion would comprehend that I meant he understood nothing about art. But he was too quick for me in the sense that he understood exactly what I was implying and responded, "Oh, in politics I do not know anything either."

My impressions of Israel, both ancient and modern, are so full that it is almost impossible for me to describe them. What has been built between my first visit in 1963 and my second, in 1967, is incredible. The new museum is fantastic. In terms of my commission for Mount Scopus, the *Tree of Life*, the greatest problem that I am concerned with is the quality of the light in Israel. It is extraordinary in its intensity, and I have to find a method of controlling it, even subduing it. This is a new challenge for me that I love, but since my sculpture will be in bronze, the dark silhouette will help to give it presence; if I

were to make it in stone, especially a light stone, I would have a much more complicated problem.

I first went to Italy in 1962 at the invitation of a lady who was an acquaintance of ours, primarily because she told me that there was a very good foundry near where she lived; and thus I discovered the foundry in which I have been working ever since. The working conditions are so good that we bought a house, a Renaissance villa, even though it is much too big and too expensive for us, and we had to do an enormous amount of work to make it habitable. Working conditions here are perfect because everyone is willing to do anything that is necessary in terms of any crisis that arises. When I came to the foundry there were two men running it, Vignalis and Gigi Tommasi. Vignalis was the son of a famous foundryman of the nineteenth century, and he was a marvelous technician. I think that I helped them because my reputation attracted many other artists. Also, since I have been here I have accepted some very large commissions, so the foundry has grown larger, and Tommasi has helped me in the creation of these big works. This area, which is close to Carrara, the great marble quarries that have been worked since Roman times and from which Michelangelo drew his marbles, is known more for stone and marble; so this foundry is not very old. The father, Tommasi, was a very well-known academic sculptor who had four sons. One is a lawyer, one a sculptor, one a painter, and the fourth, Gigi, was studying architecture. Since the father had monumental commissions and needed a foundry, he persuaded Gigi to start one.

I arrived at Pietrasanta on a Saturday and on Monday I was at the foundry, working. The first group of things that I did here were my *Images of Italy*, some of which were inspired by Italy, others not. For instance, the *Cup of Expiation* (fig. 185), or the *Cup of Atonement*, was a personal prayer for forgiveness because I had been unpleasant in some context. This is an extremely *art nouveau* object, in some ways related to the Loie Fuller dancer with veils. It is a semi-automatic like the earlier ones in which I took a sheet of wax, softened it in hot water, and then twisted it to see what happened. This series is perhaps more deliberate than the earlier group, *To the Limit of the Possible*, because in most cases I had a specific idea in mind before I began.

*The Tower and Its Shadow* (fig. 186) is a curious mixture of the leaning Tower of Pisa and a tool designed to make macaroni. The en-

tire structure becomes a figure with breasts. In a number of the works, such as the *Fountain of the Dragon*, I used a basket as the base. The basket was beautiful; it intrigued me very much. *The Beautiful One* (fig. 187) is particularly interesting. It is a real version of the *To the Limit of the Possible*. I had seen a girl like this with braids at Forte dei Marmi on the beach; she had small breasts, was wearing a little chemise. The sculpture is made of two baskets and some rope. The neck is some kind of a tool, I do not remember exactly what.

I was very happy playing with these pieces, improvising and mixing techniques. The *Flame* was made on the day of my birthday with a candle. I did *Happy Birthday* on the same day, using the basket (fig. 188). This is a portrait of a little girl who came to wish me a happy birthday. This one I particularly love. Another has to do with my *Sacrifice*. It is the preparation for the ritual killing of the chicken, the "schechoth." So in six weeks I made all these pieces. I was in a lovely, euphoric mood that had something to do with Italy, which is why I called them *Images of Italy*. These pieces were a gay release from some of the monumental works I had been concerned with, including *Between Heaven and Earth* and *Our Tree of Life*.

When I returned to Italy in 1963 I did a few more of the semi-automatics, but I was no longer as interested in them. At this time I had become involved with a commission for the city of Duluth, Minnesota, for a sculpture of Daniel Greysolon, Sieur Duluth, one of the great French explorers of the American West. I think that I was asked to do this early in 1962, possibly at the end of 1961, but I was then reluctant because of all the problems of doing a large bronze piece in the United States. But once I was settled in Italy with all the help I had there, I could accept it. About the same time, in 1963, I received the commission for the Los Angeles Monument.

The Duluth monument was interesting because it was a portrait of a man of whom no portraits existed. Therefore, I had to create an idea of the explorer rather than a specific portrait. The result was that I made a great number of sketches, including a nude model (fig. 189) for which a man at the foundry posed one morning. The sculpture was designed to be placed on a high pedestal in a rather narrow courtyard between buildings. So I actually distorted the figure in order to correct the perspective from which it would normally be seen, with the upper part of the body larger than would be natural. The sculpture is about nine feet high and the base about ten feet or more,

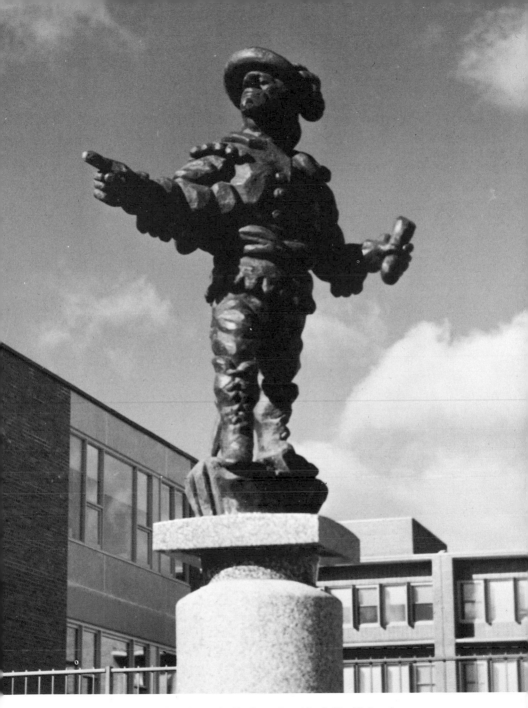

191. *Daniel Greysolon, Sieur du Luth*, 1965. 9′ h. (18′ with base).
University of Minnesota, Duluth.

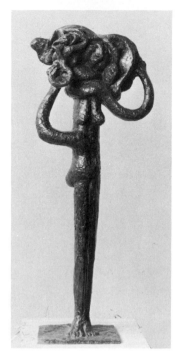

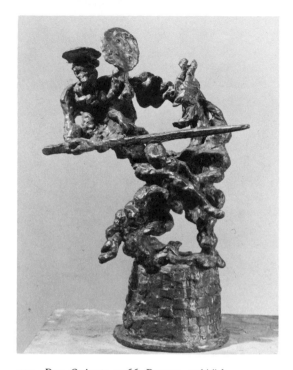

192. *The Sword of Duluth,*
1964. Bronze, 42½″ h.

193. *Don Quixote,* 1966. Bronze, 15½″ h.
Collection Jonathan E. Slater.

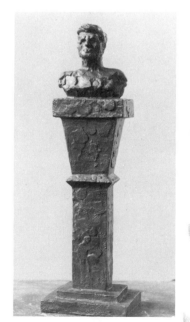

194. *Sketch for John F. Kennedy,* 1964.
Bronze, 18″ h.

eighteen feet in all. I worked on it in Italy during 1963 and it was installed in 1964 (sketch, fig. 190; sculpture, fig. 191). There is one curious by-product. The figure has a sword which was cast separately. When I was given the wax, I suddenly saw a figure in it, a familiar figure, so I made a separate sculpture based on the sword (fig. 192). There were then some more portraits and a little sketch of a *Don Quixote* (fig. 193) which I particularly like. I used the basket base and set the figure off balance, which gives it a dynamic sense of movement. This is just something I made very quickly in a week, but I had fun with it.

The Kennedy monument on which I worked in 1964 was a related but somewhat different problem. First of all a student organization in London asked me to make a sculpture of Kennedy after his death and, since I had great admiration for the President, I made it, even though it was a posthumous bust. Then I was asked to make a larger version for Newark, New Jersey. I had never seen the President, but I had a model who was supposed to look very much like him and Pierre Salinger sent me photographs. Members of the Kennedy family came and made suggestions about my sculpture. Nevertheless, I was never satisfied with it and I will never do such a posthumous sculpture again. I had made one earlier of Senator Taft in Cincinnati and had the same problem with that. The problem was entirely different from that of the Duluth sculpture, since for Duluth I was making an imaginary concept of a seventeenth-century explorer about whose appearance nothing was known. In the case of President Kennedy and Senator Taft I was trying to reconstruct the appearances of contemporary men who were enormously well known. This was the difficulty (sketch, fig. 194).

During 1964 I spent the summer in Pietrasanta working on the sketches for *Peace on Earth* for the Los Angeles Music Center and also for the *Bellerophon Taming Pegasus*, a large new commission from Columbia University. The Los Angeles piece I had, as indicated earlier, been working on for a number of years, and there was a large bronze model which I had loaned to Amsterdam. I brought this to Pietrasanta and made certain alterations which were then incorporated in the enlargement. The process of enlarging is mechanical. I usually make several sketches of different scales from a small maquette that may be only a few inches high to a finished sketch that may be six or nine feet high. Then, to enlarge this work further, I

work with a technician. The process of enlarging is, as I have said, based on the theory that if you know three points in the volume of a sculpture you can find the fourth. The armature is made mechanically, very accurately, of iron, steel, wire, plaster, all kinds of things, even wood. The armature takes the place of the sculptural core, so it is hollow, and the enlarger, working from this armature, adds jute fiber, cloths, and plaster.

Once the plaster enlargement is roughed out, I work over it completely. There is not a square inch which is not mine. But the helpers on large works such as these I have been doing recently must be competent sculptors who understand what you have in mind.

The process of enlargement in a monumental sculpture is very interesting; volumes that are enlarged can become too thin or too thick. In the small version you can completely overlook some relationship which in the large one becomes enormously distorted. So all the volumes have to be revised in the enlargement. The enlargement inevitably becomes a different sculpture.

It was in 1964 that I began to make sketches for the monumental piece for Columbia University (sketch for *Bellerophon*, figs. 195a, 195b, 195c, 195d). One day I received a letter or a telephone call from Dean Warren of the Columbia Law School, who invited me to a meeting with the architect Max Abramovitz. Abramovitz had designed a building for the Law School and they wanted a sculpture over the entrance. I immediately said, "Don't expect a blinded lady with a scale and all those things from me. I will try to think of something else." I received a model of the building and thought first of the possible relationships of a sculpture to the architecture. Obviously, something horizontal was needed over the entrance. There is a canopy there and provision is made for a column to go down through the canopy to support the weight of a large sculpture. I had thought first in terms of the form of the sculpture, something horizontal in relation to the space of the architecture. This led me to the idea of a horse, such as I had done many years earlier with the *Pegasus* relief. Then I thought about Bellerophon because Bellerophon is a symbol of man dominating nature. In the myth, Bellerophon was a human being who fell in love with the daughter of Zeus. When he asked for her hand, Zeus was not happy about it and gave him terrible deeds to do, hoping that he would perish, but Bellerophon, an intelligent man, tamed Pegasus, the winged horse who represents the wild forces of

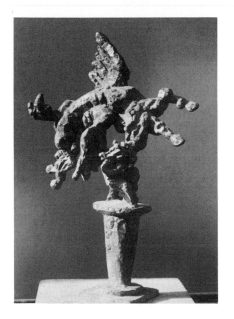

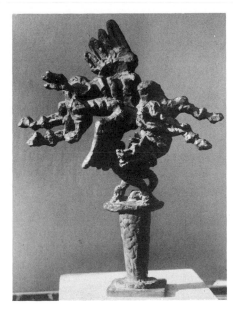

195a. *Sketch for Bellerophon Taming Pegasus*, 1964. Bronze, 20″ h.

195b. *Sketch for Bellerophon Taming Pegasus*, 1964. Bronze, 11¾″ h.

195c. *Sketch for Bellerophon Taming Pegasus*, 1964. Bronze, 11¾″ h.

195d. *Sketch for Bellerophon Taming Pegasus*, 1964. Bronze, 19½″ h.

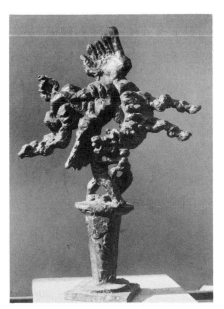

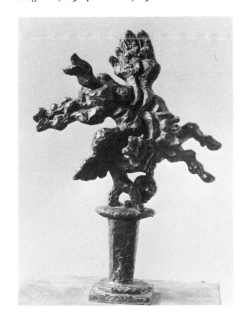

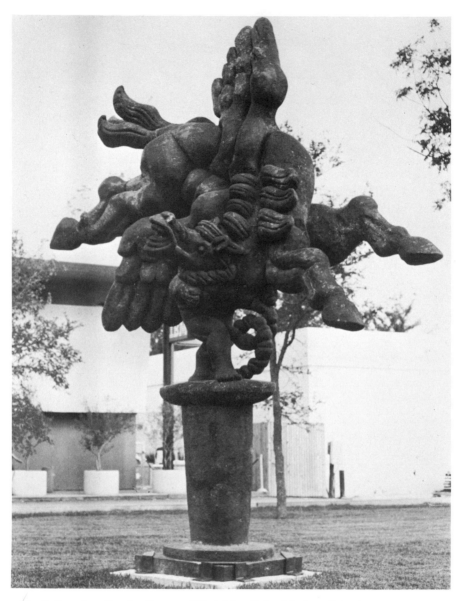

196. *Bellerophon Taming Pegasus* (Model for Columbia Law School Commission), 1966. 12′ h. On loan to Smithsonian Institution, Washington, D.C.

nature, and with the help of Pegasus he was able to accomplish all the tasks that were required of him. This myth seemed to me to have a definite relationship to the rules of law. You observe nature, make conclusions, and from these you make rules, and these rules help you to behave, to live, and law is born from that. This is a lovely theme and I thought about it for a long time. President Kirk of Columbia University, Dean Warren of the Law School, and Abramovitz were very happy with it and accepted it immediately. The *Bellerophon Taming Pegasus* is a very large sculpture, but is light in its proportions because the building is also light. As I said, it is to be placed on a canopy over the entrance, and I decided to cover the canopy with bronze in order that it should be integrated with the sculpture. From the base of the bronze column that supports it, the sculpture will be at least sixty feet high, perhaps the largest in the area of New York, second only to the Statue of Liberty (fig. 196).

I have made many sketches of the *Bellerophon*, and the completed plaster is now in process at the foundry in Pietrasanta. As is my habit, I started from maquettes, then made sketches three times larger and then models three times larger than those. From this the final version will again be enlarged by three times. I worked like this because, when I am making accurate enlargements, elements change until I come to the final dimension. When you have enlarged a sketch twenty-seven times, a small inconspicuous detail can become monstrous and out of proportion; so you have to watch and correct constantly what you are doing until you come to the final expression before you start casting the piece. When one works from maquettes a few inches high to immense sculptures, there are always difficulties in terms of the different dimensions and my mood at the time of the particular enlargements. I remember that I did not like the second enlargement, although I worked on it closely. I did not like it because I was disturbed at the time it was being made. I could not work well; there was someone who was bothering me and I was not able to concentrate.

The first sketches for *Bellerophon* were made in 1964, later ones in New York in the winter of 1964 and 1965; then the one-third enlargement was made in Italy in 1966. I worked a long time on this. The final enlargement was started about the winter of 1967 (fig. 197). The plaster was actually finished last year, in 1969, but when I first saw it, I was horrified because it was all wrong and I had to have my enlarger start all over again. I have perhaps another year of work

on the plaster, another two years before the bronze is cast. The bronze will have to be cast and put together, then cut for transportation, and then put together again in New York.

In 1966 I made some more portraits. The one that I think I like the best is that of the publisher Albert Skira, who had a bold, rough face that I sought to catch in the quality of the clay transposed into bronze.

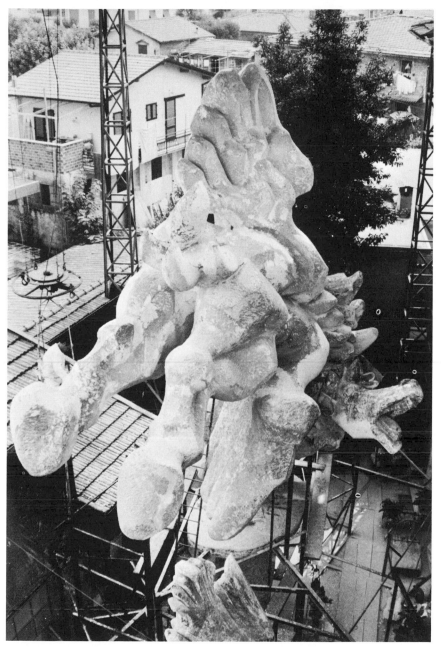

197. *Bellerophon Taming Pegasus*, 1969. Plaster for bronze, 38′ h.
Photographed at Tommasi Foundry, Pietrasanta, Italy.

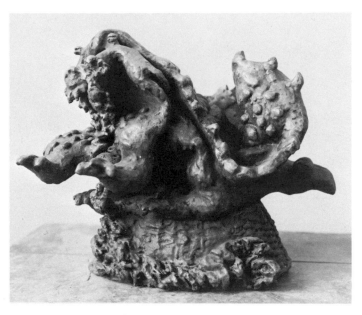

198. *Furious Arno*, 1967. Bronze, 11" h.

199. *Sketch for Government of the People*, 1967. Bronze, 49" h.

200. *Government of the People*, 1967–1968. Plaster, 51" h.

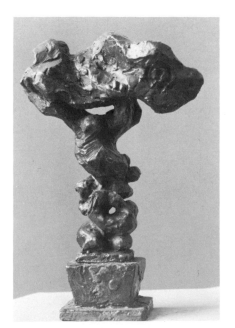

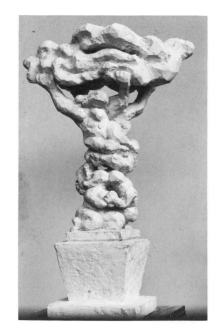

# Chapter 16

The spring of 1966 was the time of the terrible floods in Florence. I saw the horrible damage and it made an enormous impact. I tried to make some small things to record my reactions: a piece I called *Flowers for Florence*, then another, *L'Arno Furioso* (the *Furious Arno*) (fig. 198). This is an animal who is spitting or foaming at the mouth like a dog with rabies. It is very ugly. Then I made a *Lamentation*, which was a lamentation for the Christ of Cimabue, so damaged that it could not be restored; and, finally, a *Ponte Vecchio*, in which I translated the bridge into an old woman with a cap and crutches, but still standing erect. None of these things are beautiful but I think they represent my feelings about this disaster.

I have, of course, been to Florence a number of times, although, curiously, I only visited the Uffizi for the first time last year. The Accademia I had seen earlier for the Michelangelos. My reaction to Michelangelo is ambivalent. He is overwhelming, divine, superhuman, but there is something in him that repels me, perhaps a lack of humility. To me Donatello is a greater master. These are personal reactions of a sculptor which cannot be explained.

When I saw Florence it had been cleaned up, but the watermarks on the sides of the buildings were still everywhere visible. For example, I had been making lithographs at a studio, Il Bisonte, a beautiful house that was filled with water. All these things are over now, I hope never to happen again, and I am in Florence frequently, working in the lithography studio.

There was a new commission for a monumental sculpture in 1967 to be placed in the Municipal Plaza in Philadelphia. The Plaza involves in addition to the City Hall, a modern building and a number of heterogeneous nineteenth-century buildings; the original City Hall, nineteenth-century Victorian, is very interesting with the sculptural decorations done by Alexander Milne Calder, the grandfather of the sculptor Alexander Calder. So it has been quite a job to create a work that would unite these different buildings. I was not given a specific commission or theme but simply asked to make a monumental work. I did a sketch which was sort of a totem pole. At the base there is a couple, and then another couple, and this develops in groups to a climax of the Philadelphia city flag. So those concerned entitled it *Government of the People*. There have been many changes since the original design (figs. 199, 200). In my studio I have several photographic montages which show the site with the sketch superimposed, a technique I had never used before, but which has helped me a great deal. It is on this that I am working with my assistants, the two young sculptors.

In 1971 on the occasion of the five-hundredth anniversary of the birth of Albrecht Dürer, there was a large exhibition in Germany. I was invited to contribute a piece, and for this I designed a bronze that I entitled *Melancholia* in honor of Dürer's wonderful engraving of that name. This was a bronze of the lost-wax process, very free in execution, embodying many of my ideas about automatism and the relations of the unconscious to the conscious in sculpture. It inspired me to make a series in wax on themes from the Commedia dell'Arte, which I call *The Seven Madrigals* or *The Invisible Hand*. The last of these is *The Death of Pierrot*, a theme that has a very personal significance for me (fig. 202). These small bronzes have excited me very much as my most daring step in the incorporation of found objects—in the move from the unconscious or automatic gesture to the conscious sculptural structure and back to a final unconscious realization.

Since I am in the vicinity of the great marble quarries of Carrara, I have been inspired recently to try my hand once more at stone carving. From this have resulted a new, monumental interpretation of *Hagar* (fig. 201) and a smaller *Rape of Europa*. I am now completing another version of the embrace theme, which I call *The Last Embrace*. These three works are first made in plaster and then translated into a wonderful mottled red stone called "red of the Pyrenees." I am also

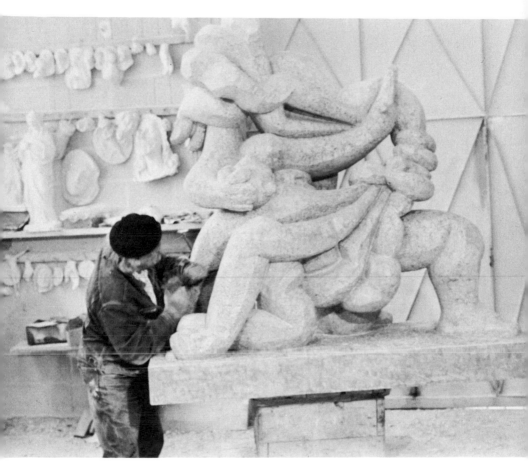

201. Lipchitz carving *Hagar*, 1971. Stone, c. 6′ h.

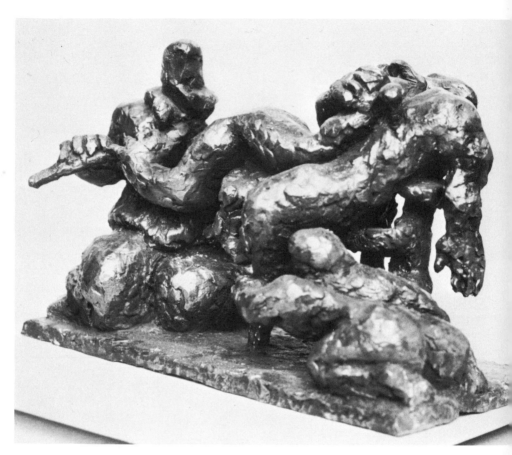

202. *The Death of Pierrot*, 1971. Bronze, c. 18″ l.

making bronzes of them. In these stones I continue to explore the problem of light on sculpture, something which has intrigued me since my visits to Israel and my Mount Scopus commission.

There are several sketches for the Israel monument but none of them is final. I am still trying to develop my ideas. I am still, like my father, putting one brick after another in the building of a house, attempting to make a final statement. I would like to be able to make this at the end of my life, or, as my father always said, "to come to the roof."

# Chronology and Bibliography

# Chronology

| | |
|---|---|
| 1891 | Chaim Jacob Lipchitz born August 22 at Druskieniki, Lithuania. |
| 1902–1906 | Commercial school in Bialystok. |
| 1906–1909 | High school in Vilna. |
| 1909–1910 | Arrived in Paris, October 1909. Became "free pupil" of Jean-Antoine Ingalbert at Ecole des Beaux-Arts. Attended sculpture classes of Raoul Verlet at Académie Julian. Also studied drawing, art history, and anatomy. |
| 1911 | Established studio in Montparnasse. |
| 1913 | Met Picasso and other cubists through Diego Rivera. |
| 1914 | Visited Spain and Majorca with Rivera and other friends. Returned to Paris at end of year. *Sailor with Guitar. Girl with Braid.* |
| 1915 | *Head,* and other major cubist sculptures. |
| 1916 | Met Juan Gris. Several major stone cubist sculptures, including *Figure, Standing Figure,* and *Man with a Guitar.* |
| 1920 | First one-man exhibition at Léonce Rosenberg Gallery. Maurice Raynal published first monograph of Lipchitz. *Portrait of Gertrude Stein.* |
| 1922 | Commission for five bas reliefs for Barnes Foundation, Merion, Pennsylvania. |
| 1925 | Moved to Boulogne-sur-Seine, house designed by Le Corbusier. *Bather.* Began to work on a series of "transparents" through experimentation with lost-wax process. |

1927      *Joy of Life* for garden of the Vicomtesse de Noailles at Hyères.

1928      *Reclining Nude with Guitar.*

1929      *The Couple (The Cry).*

1930      First large retrospective exhibition, Galérie de la Renaissance (Jeanne Bucher), Paris. *Figure.* First appearance of *Mother and Child* and *Prodigal Son* motifs.

1931–1932    *Return of the Prodigal Son. Song of the Vowels. The Harpists.*

1932      *Jacob and the Angel. Head.*

1933      *Portrait of Géricault. Woman Leaning on Elbows.* Sketches for *David and Goliath.*

1934      Exhibition of plaster of *David and Goliath* at Salon des Surindépendants.

1935      First large exhibition in United States, Brummer Gallery, New York.

1936–1937    *Prometheus* executed for Paris World's Fair; awarded gold medal. Room devoted to his sculpture at exhibition held during Fair, "Les Maîtres de l'art indépendant," Petit Palais.

1938      *Rape of Europa.*

1940      Moved to Toulouse. *Flight.*

1941      Moved to New York City. *Arrival. Return of the Child.*

1942      Began to exhibit regularly at Buchholz Gallery (later the Curt Valentin Gallery), New York. *The Pilgrim. Spring. The Promise.*

1943–1944    Worked on *Prometheus Strangling the Vulture*, commission for Ministry of Health and Education, Rio de Janeiro, and on *Mother and Child.*

1945      *The Rescue.*

1946      Visited Paris, where he exhibited at Galérie Maeght. Was made a Chevalier de la Légion d'Honneur. *Song of Songs.*

1947–1948    Settled in Hastings-on-Hudson, New York. Began series of studies for commission for the church of Notre-Dame-de-Toute-Grâce, at Assy. *Miracle II. Dancer. Pastorale. Hagar.*

1949      *Mother and Child.*

| | |
|---|---|
| 1950–1951 | Relief *Birth of the Muses.* Large model of *Notre Dame de Liesse* for Assy. |
| 1952 | Fire in New York studio destroyed many sketches and major works. Several commissioned portraits. |
| 1953 | Moved into new studio at Hastings-on-Hudson. *Virgin in Flames.* |
| 1954 | Retrospective, The Museum of Modern Art, New York; Walker Art Center, Minneapolis; The Cleveland Museum of Art. |
| 1955–1956 | *Hagar in the Desert.* |
| 1958 | Received Honorary Doctorate, Brandeis University. Completed *Spirit of the Enterprise* for Fairmount Park Association, Philadelphia. Worked on gateway for Roofless Church in New Harmony, Indiana, with architect Philip Johnson, to house second cast of *Notre Dame de Liesse.* Exhibition, Stedelijk Museum, Amsterdam; Rijksmuseum Kröller-Müller, Otterloo; Basel; Dortmund; Paris; Brussels; London. |
| 1959 | Series of fantastic bronzes from small objects, which were shown in exhibition "A la limite du possible" at Fine Arts Associates, New York. |
| 1963 | Work on the *Tree of Life.* Large retrospective exhibition at University of California at Los Angeles; San Francisco Museum of Art; Denver Art Museum; Forth Worth Art Center; Walker Art Center; Des Moines Art Center; Philadelphia Museum of Art. |
| 1963–1965 | Exhibition "157 Bronze Sketches, 1912–1962," Otto Gerson Gallery, New York; Currier Gallery; Albright Knox Art Gallery; Atlanta Art Association; Joslyn Art Museum; Tweed Gallery of the University of Minnesota; The Arts Club of Chicago; Detroit Institute of Arts; also circulated internationally to Buenos Aires; Santiago; Caracas; Lima; Melbourne; Auckland and Wellington. |
| 1964 | Exhibition of *Between Heaven and Earth* at Documenta International, Carnegie International. Exhibition of cubist sculpture and reliefs at Phillips Collection. |
| 1965 | Award for cultural achievement from Boston University and one-man exhibition there. Exhibition at opening of |

Jerusalem Museum. Installation of *John F. Kennedy* in London and Newark. Exhibition at Newark Museum. Installation of *Daniel Greysolon, Sieur Duluth* in Duluth, Minnesota.

1966    Gold medal from Academy of Arts and Letters and exhibition of works there. Exhibition Makler Gallery, Philadelphia. Exhibitions annually 1964, 1965, 1966 at Marlborough-Gerson Gallery, New York.

1967    Presentation by the artist of bronze *Between Heaven and Earth* to village of Hastings-on-Hudson.

1968–1969    Continued work of casting major sculptures in Pietrasanta, Italy. Lipchitz has been working there during the summers since 1963. He continues casting and finishing bronze sculptures during the rest of the year at the Modern Art Foundry, and Avnet & Shaw Foundry, New York. At present he is working on large and small bronze versions of *Lesson of a Disaster.*

1969    Dedication of monumental sculpture, *Peace on Earth*, Los Angeles County Music Center. Award of Merit from Einstein University. Medal of achievement from American Institute of Architects.

1970–1972    Retrospective exhibition at the Tel Aviv Museum and the National Gallery, Berlin. Small lost-wax bronze *Melancholia* in honor of 500th anniversary of birth of Albrecht Dürer. Series of seven lost-wax bronze semiautomatics on themes from Commedia dell'Arte, *The Seven Madrigals* or *The Invisible Hand.* Stone carvings, new monumental version of *Hagar, The Rape of Europa, The Last Embrace.* Currently working on monumental sculptures for Municipal Plaza in Philadelphia, *Government of the People*, and for Columbia University, *Bellerophon Taming Pegasus*, and *Our Tree of Life* for Mount Scopus, Israel.

# Lipchitz: A Documentary Review

*by Bernard Karpel*
*Chief Librarian, Museum of Modern Art, New York*

Citations are grouped according to *Bibliographies* (nos. 1–8), *Selected Texts by Lipchitz* (nos. 9–24), *Special Editions & Documents* (nos. 25–32), *Monographs* (nos. 33–43), Selected Catalogues (nos. 44–62), *General Books & References* (nos. 63–110), and *Articles* (nos. 111–159). The word *bibl.* below refers to that number in the bibliography.

## Bibliographies

Bibliographies are listed separately to assist the determined researcher who needs to go beyond the appended information, extensive yet hardly exhaustive.

1. Schwartzberg, Miriam B. *The Sculpture of Jacques Lipchitz.* [Typescript dissertation]. New York University, 1941.

     See bibl. 41. Bibliographies, pp. 105–32 (Lipchitz, pp. 105–107).

2. Muller, Hannah B. Selected bibliography. *In* Portland Art Museum. *Jacques Lipchitz Exhibition.* 1950.

     See bibl. 59. Includes 66 references incorporated into Hope monograph (bibl. 3).

3. Muller, Hannah B. Bibliography. *In* Hope, Henry R. *The Sculpture of Jacques Lipchitz.* 1954.

     Monograph-catalogue with 84 references. See bibl. 37. Also pp. 88–89: chonology, exhibitions, catalogs, reviews. Miss Muller, formerly Assistant Librarian of the Museum of Modern Art, pro-

vided the data which forms the basis for most subsequent statements, e.g., Patai (not mentioned), Hammacher (mentioned and enlarged), and others.

4. Vollmer, Hans. *Allgemeines Lexikon der bildenden Künstler.* Leipzig, Seeman, 1956.

   "Jakoff Lipschitz," v. 3, pp. 243–44.

5. Hammacher, A. M. Bibliography. *In* his *Jacques Lipchitz.* [1961.] See bibl. 36. Expands Muller to 98 references. Exhibitions list.

6. [Steinman, Anna, compiler]. Bibliography. *In* Patai. *Encounters.* 1961 (bibl. 38).

   "Sources," pp. 426–32, covers Lipchitz writings, selected books and articles, exhibitions list. Largely an alphabetical reorganization of Muller (bibl. 3).

7. Solomon R. Guggenheim Museum. *Sculpture from Twenty Nations.* 1967 (bibl. 105).

   Lipchitz, p. 143. Extensive general bibliography, pp. 127–36.

8. Clapp, Jane. *Sculpture Index, v. 2.* Metuchen, N.J., Scarecrow Press, 1970.

   An index to illustrations in books and catalogues v. 2, pt. II, pp. 701–704.

Also note frequent bibliographies in references following, both general and specific.

*Selected Texts and Editions by Lipchitz*

9. Answer to a questionnaire. *Little Review* (New York), May 1929, pp. 47–48.

   Reprinted in Hammacher (bibl. 36), pp. 70–71.

10. [Reflections on art], 1929. See bibl. 36, p. 70.

    From the Vitrac booklet (bibl. 43). Also reprinted in Goldwater (bibl. 35).

11. The Story of My Prometheus. *Art in Australia* (Sydney), June–Aug. 1942, pp. 28–35.

    Extract in Goldwater (bibl. 35).

12. Interview with Jacques Lipchitz. *Partisan Review,* Winter 1945.

    By J. J. Sweeney. Extract in Goldwater (bibl. 35). Also note Museum of Modern Art interview (bibl. 152).

13. [Forewords]. *In* [Exhibition Catalogues]. New York, Curt Valentin Gallery, 1943, 1944, 1954.
> For: "Bronzes by Degas, Matisse, Renoir" (1943).—"Juan Gris" (1944).—"Auguste Rodin" (1954), reprinted in bibl. 36.

14. [Guernica]. *In* Symposium on "Guernica." New York, Museum of Modern Art, Nov. 25, 1947.
> Unpublished typescript of auditorium conference; several participants included Lipchitz.

15. I remember Modigliani. *Art News* (New York), Feb. 1951, pp. 26–29, 64–65.
> "As told to Dorothy Seckler."

15a. Amedeo Modigliani. New York, Abrams, 1952.
> Brochure (22 pp.) in Portfolio "Library of Great Painters," no. 4. Also "Pocket Library of Great Art," no. A16, 1954.

16. Statement. *In* Fourteen eyes in a museum storeroom. *University Museum Bulletin* (Philadelphia), Feb. 1952, pp. 12–17.
> Also issued as separate brochure. Similar observations in *Archaeology* (Cambridge), Mar. 1953, pp. 18–23: "What in the world? Identifications of archaeological objects—a television broadcast."

17. On Rodin. 1954. See bibl. 13, 36 (p. 72).

18. [Forewords]. *In* [Exhibition Catalogues]. New York, Fine Arts Associates, 1957–1958.
> "Sculpture 1880–1957," Dec. 1957–Jan. 1958 (Letter to Otto Gerson, Nov. 1957.)—"Lipchitz: 33 Semi-Automatics," Mar. 1957. Texts also published in Hammacher (bibl. 36), pp. 73–74.—"A la limite du possible," Nov.–Dec. 1959. Similarly successor gallery: Otto Gerson (bibl. 51, 52).

19. Conversation with Lipchitz, Nov. 1957. *In* Wisdom. NBC, 1958 (bibl. 91).
> Excerpts of conversation with art critic Cranston Jones reprinted in Hammacher (bibl. 24), pp. 74–75.

20. Introduction. *In* The Lipchitz Collection. New York, Museum of Primitive Art, 1960. Pp. 6–7.

21. Foreword [on my maquettes]. *In* Arnason, H. H. *Jacques Lipchitz.* 1969 (bibl. 33), p. 4.
> Actually reprint of 1963 text to Gerson Gallery show (bibl. 52).

22. "A Talk with Lipchitz" by F. A. Wight. *In* Jacques Lipchitz Retrospective. Los Angeles, 1963 (bibl. 54).

23. Introduction. *In* Louis G. Redstone. *Art in Architecture.* New York, McGraw-Hill, 1968.

24. Statement. *In* Hammacher, A. M. *Jacques Lipchitz.* 1961. Pp. 9–10.

   Also translated texts, pp. 70–75: "Reflections on art" (from Vitrac, 1929).—"Questionnaire" (from *The Little Review*, 1929).—Foreword to "Jacques Lipchitz: Studies . . . 1912–1919." New Gallery, New York, Sept.–Oct. 1955.—"On Rodin" from Rodin catalogue, Curt Valentin Gallery, New York, May 1954.—Letter to Otto Gerson, Nov. 1957, from "Sculpture 1880–1957," Fine Arts Associates, New York, Dec. 1957—Jan. 1958.—Semi-automatics from "Lipchitz: 33 Semi-Automatics," Fine Arts Associates, New York, Mar. 1957.—"Conversation with Lipchitz" and Cranston Jones, Nov. 1957, NBC-TV, Mar. 9, 1958, published in *Wisdom* (bibl. 91).

Also note quotations, e.g. bibl. 42.

*Special Editions and Documents*

25. *34 Dessins pour Promethée terrassant le Vautour,* 1933–37. Paris, Jeanne Bucher (projected?), 1939.

   Announcement states "planned for May 1939." Edition advertised as 488 copies *sur vélin,* 12 *sur arches* signed (with drypoint). Possibly, owing to the war, replaced by 1940 edition. Not seen by compiler.

26. *12 Dessins pour Promethée, 1940.* Paris, Jeanne Bucher [1941?]. Folio of twelve plates in tint and color.

27. *Twelve Bronzes by Jacques Lipchitz.* 16 Collotype Plates with Introductory Note. New York, Curt Valentin, 1943.

   "Published by the Buchholz Gallery (Curt Valentin) in March 1943 in an edition of 435 copies. . . . Thirty-five copies, numbered and signed, each contains one original etching by the artist."

28. *The Drawings of Jacques Lipchitz.* New York, Curt Valentin, 1944.

   765 copies (3 pp., 20 plates) published by the Gallery, including limited signed edition (65 copies) with original signed etching.

29. *The Lipchitz Collection.* New York, Museum of Primitive Art, 1960.

The Jacques, Yulla, and Lolya Lipchitz collections. For commentary see bibl. 20, 55, 111, 133.

30. [*Conversations with Jacques Lipchitz.*] Taped interviews with Deborah Scott. New York, Jacques Lipchitz Art Foundation, 1968–1970.

31. [A Film on Jacques Lipchitz.] Directed and produced by Bruce Bassett. New York, Jacques Lipchitz Art Foundation, 1971.
Shot around Pietrasanta (Italy), in the artist's studio, a foundry, etc. Begun on his eightieth birthday, filmed "for some six weeks." Not yet released.

32. National Broadcasting Company. TV Series. *Wisdom: Lipchitz.* May 9, 1958.
For text and commentary, see bibl. 91.

Also note bibl. 35, 42, 49, 55, 70, 138, 152, 153.

*Monographs and Major Catalogues*

33. Arnason, H. Harvard. *Jacques Lipchitz: Sketches in Bronze.* New York, Praeger; London, Pall Mall, 1969.
"Foreword" by Lipchitz from Gerson 1963 catalogue on maquettes. 161 photos of maquettes by James Moore. Text, 15 pp., on these works, 1912–48. Chronology, 1891–1969. Selected bibliography in chronological sequence.

34. George, Waldemar. *Jacques Lipchitz.* Paris, Le Triangle, n.d. [1928?].
"Yidn-kinstler-monografies," i.e., Yiddish text. See also bibl. 50a, 124.

35. Goldwater, Robert. *Lipchitz.* Amsterdam, Allert de Lange; London, Zwemmer; New York, Universe Books, 1958.
"Modern Sculptors" series edited by A. M. Hammacher in Dutch (1954), German, French, and English versions. Includes excerpts by the artist; brief bibliography.

36. Hammacher, A. M. *Jacques Lipchitz: His Sculpture.* New York, Abrams, 1961; London, Thames & Hudson, n.d.
"With an introductory statement by Jacques Lipchitz." Translations of texts by the artist, pp. 70–75. Excerpts from reactions to his work, 1917–1958. Biography. Bibliography based on Muller

(bibl. 3). Exhibitions. One hundred fine plates. Reviewed by Alfred Werner, *Arts* (New York) Apr. 1961, p. 15.

37. Hope, Henry R. *The Sculpture of Jacques Lipchitz*. New York, Museum of Modern Art, 1954.

Monograph-catalogue in collaboration with the Walker Art Center (Minneapolis), the Cleveland Museum of Art. Catalogue of the exhibition. Chronology, exhibitions, catalogues, and reviews. Bibliography by Hannah B. Muller, extended from bibl. 2, reprinted by or incorporated into subsequent publications. Also bibl. 50, 78, 129–131.

37a. Jerusalem. Israel Museum. *Jacques Lipchitz at Eighty*. Sculptures and Drawings 1911–1971. Cat. no. 83. Jerusalem, Aug.-Sept. 1971.

English and Hebrew text. Essay by Ziva Amishai; extracts from Lipchitz texts. Chronology, bibliography. 109 exhibits (all illustrated).

37b. Jerusalem. Israel Museum. *Jacques Lipchitz Bronze Sketches*. Text and catalogue by Martin Weyl; preface by Willem Sandberg. Cat. no. 84. Jerusalem, 1971.

"The Reuven Lipchitz collection donated in memory of Abram and Rachel Lipchitz inaugurated August 3rd 1971." English and Hebrew text. Chronology, bibliography. 131 exhibits and illustrations.

38. Patai, Irene. *Encounters: The Life of Jacques Lipchitz*. Foreword by Andrew C. Ritchie. New York, Funk & Wagnalls, 1964.

"Sources," compiled by Anna Steinman, includes bibliography, an alphabetical rearrangement of data in Muller supra. Reviewed by Henry R. Hope, *Art Journal*, no. 1, pp. 56 ff., Fall 1962.

39. Raynal, Maurice. *Lipchitz*. Paris, Action, 1920.

Collection "L'Art d'Aujourd'hui," 1. Text, 13 pp. Works from 1911–1919 in 21 plates. Edition: 518 copies, including 53 *sur Hollande*. Second edition, 1927.

40. Raynal, Maurice. *Jacques Lipchitz*. Paris, Jeanne Bucher, 1947.

Text, 14 pp. Works from 1911–1945 in 71 plates. Frontis: "Lipchitz et sa femme" by Modigliani (Chicago). Edition: 950 copies. Also nos. 1–50, A-E (*hors commerce*) with original etching (apparently numbered and signed).

41. Schwartzberg, Miriam B. *The Sculpture of Jacques Lipchitz*. [Typescript dissertation]. New York, New York University, 1941.

Master of Arts thesis; degree Oct. 1941; "factual data checked

with the artist on arrival in U.S." Carbon copy deposited with
Museum of Modern Art Library. Includes notes, appendices,
chronology. Extensive bibliography: Jacques Lipchitz, pp. 105–
107.—Modern Art, General, pp. 108–16.—Modern Art, Painting.
pp. 117–23.—Cubism, pp. 124–28.—Modern Art, Sculpture, pp.
129–32.

42. Van Bork, Bert. *Jacques Lipchitz: the Artist at Work.* With a
critical evaluation by Dr. Alfred Werner. New York, Crown, 1966.
Includes quotations from the artist and verbatim transcripts. Many
studio shots. Foreword by Karl Katz. Werner text, pp. 204–20.
Review: A. A. Davidson, *Art Quarterly* (Detroit), nos. 3–4, pp.
296 ff., 1967.

43. Vitrac, Roger. *Jacques Lipchitz.* Paris, Gallimard, 1929.
"Les sculpteurs français nouveaux, 7." Extracts from critics. Brief
quote from Lipchitz also in Hammacher (bibl. 24).

*Catalogues: a Selection*

For longer listings see chronology in Hope (bibl. 37), 1911–1959,
the inventory in Hammacher (bibl. 36) and the up-dated record in
Arnason (bibl. 33).

44. Amsterdam. Stedelijk Museum. *Jacques Lipchitz.* 1958–1959.
Retrospective of 116 works (1911–1957) chosen by Lipchitz.
Circulated to Otterloo, Basel, Munich, Dortmund, Brussels, Paris,
London (bibl. 61).

45. Berlin. National Gallery. *Jacques Lipchitz, 1911–1969.* Sept. 18–
Nov. 9, 1970.
Includes sculpture and drawings.

46. Buchholz Gallery (Curt Valentin, New York). [*Jacques Lipchitz
Exhibitions*]. New York, 1942–1951.
Catalogues issued 1942, 1943, 1946, 1948, 1951, with lists, illus-
trations, and occasional texts. For reviews see H. B. Muller
(bibl. 3).

47. Brummer Gallery. *Jacques Lipchitz.* New York, Dec. 2–Jan. 31,
1935.
Largely text by Elie Faure (6 pp.). Lists 42 works.

48. Caracas. Museo de Bellas Artes. *Jacques Lipchitz: Bocetos en
Bronce, 1912–1962.* Feb. 1965.
Checklist of 158 works. Prefatory note by Miguel G. Arroyo C.

Organized by the International Council of the Museum of Modern Art, New York.

49. Corcoran Gallery of Art. *Jacques Lipchitz.* A retrospective exhibition of sculpture and drawings. Washington, D.C., Corcoran Gallery, Mar. 12–Apr. 10, 1960; Baltimore, Baltimore Museum of Art, Apr. 26–May 29, 1960.

Texts by A. D. Breeskin, H. W. Williams, and the artist.

50. Fine Arts Associates. *Jacques Lipchitz.* Thirty-three semi-automatics, 1955–1956, and earlier works, 1915–1928. New York, Mar. 5–30, 1957.

Introduction by Lipchitz. "I call them semi-automatics. . . . Hastings-on-Hudson, 1957" (2 pp.). Preface reprinted in Hammacher (bibl. 36). Rear illustration: installation, Galerie Renaissance, Paris, May 1930. Lists 45 works, 20 illus. Reviewed by Hilton Kramer, *Arts* (New York) Mar. 1957, pp. 46–47.

50a. Fine Arts Associates. *Jacques Lipchitz.* Fourteen recent works, 1958–1959 and earlier works, 1949–1959. New York, Nov. 10–Dec. 5, 1959.

Lists 22 works. Text by Lipchitz: "A la limite du possible." (Dec. 1958).—Insert: "Sculpture and sorcery" by Waldemar George (Paris, Oct. 1959).

51. Gerson, Otto, Gallery. *Fifty Years of Lipchitz Sculpture.* New York, Gerson Gallery, Nov. 7–Dec. 9, 1961; Ithaca, Cornell University, Jan. 8–Feb. 11, 1962.

Lists 71 works. Reproduces letter by Lipchitz, declaration by Sandberg. Reviews: *Apollo* (London), Nov. 1961, p. 150; *Progressive Architecture* (New York), Dec. 1961, p. 71. Also A. M. Kingsbury: Lipchitz sculpture at Cornell. *Art Journal* (New York), no. 2, 1963–64, p. 140.

52. Gerson, Otto, Gallery. *Jacques Lipchitz.* 157 small bronze sketches, 1914–1962. New York, Apr. 16–May 11, 1963.

Foreword by Lipchitz, on casts from his maquettes, dated Feb. 26, 1963. Catalogue of works, 6 illus., port. Reviewed by V. Raynor, *Arts* (New York), Sept. 1963, p. 55; also *Art News* (New York), Summer, 1963, p. 15. Lipchitz text reprinted in Arnason (bibl. 33).

53. Herron Museum of Art. *The Sculpture of Jacques Lipchitz.* Indianapolis, Ind., June 8–29, 1969.

Organized by Jack Wasserman, Department of Art History, for exhibit at the Art History Galleries, University of Wisconsin-Milwaukee, Apr. 1969. Introduction by Henry R. Hope. Brief bibliography. 46 works (all illustrated).

53a. Littérature. Palais des Fêtes. *Premier Vendredi de Littérature.* Paris, Jan. 23, 1920.

Paintings by Gris, Ribemont-Dessaignes, de Chirico, Léger, Picabia. Sculptures by Lipchitz.

54. Los Angeles. University of California Art Galleries. *Jacques Lipchitz. A retrospective selected by the artist.* Los Angeles, U.C.L.A. Art Council, 1963.

Catalogue of exhibit, 1963–64. Includes "A talk with Lipchitz" by Frederick S. Wight. Reviewed by J. Langsner, *Art News* (New York), May 1963, p. 48.

55. Los Angeles. University of California Galleries. *Jacques Lipchitz, Sculptor and Collector.* A photographic study by John Swope. UCLA Council in cooperation with the UCLA Art Galleries. 1967–68.

Part I: Objects from the personal collection of Jacques Lipchitz (quotations by Lipchitz).—II: Sculpture by Jacques Lipchitz.—III: The Sculptor's Environment (photos). 103 exhibits.

56. Maeght Galerie. *Jacques Lipchitz.* Paris, 1946. 8 pp.

84 works (5 illus.). Text by Jean Cassou, Camille Soula, Jacques Kober.

57. Marlborough-Gerson Gallery. *Lipchitz: the Cubist Period, 1913–1930.* New York, Mar.–Apr. 1968.

Catalogue: 65 works, all illustrated. Introduction by Alfred Werner: "Lipchitz-cubist" (3 pp.). Chronology (up to 1930). Reviewed by Lanes (bibl. 136). Previously exhibited: *Images of Italy: Lipchitz.* Apr.–May, 1966.

58. New York. Museum of Modern Art. *The Sculpture of Jacques Lipchitz.* May 18–Aug. 1, 1954.

Same as Hope (bibl. 37). Includes catalogue of the exhibition, pp. 90–92, and H. B. Muller documentation. For reviews see: *Art Digest* (D. Ashton), June 1954, p. 16; *New Yorker* (R. M. Coates), May 29, 1954, pp. 74–76; *Interiors*, June 1954, p. 10; T. B. Hess (bibl. 128).

59. Portland Art Museum. *Jacques Lipchitz.* An exhibition of his

sculpture and drawings, 1914–1950. Portland Art Museum, San Francisco Museum of Art, Cincinnati Art Museum, fall 1950– spring 1951.

Preface by Andrew C. Ritchie (4 pp.). Catalogue (28 works); chronology; bibliography by Hannah B. Muller.

60. Renaissance Galerie. *Cent Sculptures par Jacques Lipchitz*. Paris, June 13–28, 1930.

Catalogue lists 100 works (frontis.). Exhibit organized by Jeanne Bucher. (Installation view published in Gerson Gallery catalogue, Mar. 1957).

61. Tate Gallery. *Sculpture by Jacques Lipchitz*. London, Arts Council of Great Britain, Nov. 14–Dec. 16, 1959.

Introduction by Bernard Dorival. Chronology. 105 works.

62. Tel Aviv. Museum. *Jacques Lipchitz: Scultpure and Drawings, 1911–1970*. Tel Aviv (opened), Apr. 19, 1971.

See also group show catalogues below (bibl. 63, etc.).

*GENERAL: Books and Catalogues*

63. Amsterdam. Stedelijk Museum. *13 Beeldhouwers uit Paris*. Cat. no. 50, 1948.

Preface and biographical notes. Lipchitz: [5]pp., illus., nos. 132– 160.

64. Arnason, H. Harvard. *History of Modern Art*. New York, Abrams, 1968. pp. 653 (index).

General bibliography; brief Lipchitz bibliography.

65. Arnason, H. Harvard. *Modern Sculpture from the Joseph H. Hirshhorn Collection*. New York, Solomon R. Guggenheim Museum, 1961, pp. 58–59, 97, 220.

Also note bibl. 75.

66. Auerbach, Arnold. *Sculpture: a History in Brief*. London, Elek, 1952. pp. 85–87, 101.

67. Bazin, Germain. *The History of World Sculpture*. Greenwich, Conn., New York Graphic Society, 1968. p. 455 (index).

68. Bowness, Alan. *Modern Sculpture*. London, Studio Vista; New York, Dutton, 1965. p. 159 (index).

69. Burnham, Jack. *Beyond Modern Sculpture*. New York, Braziller, 1968. p. 399 (index).

70. Cassou, Jean. *Panorama des arts plastiques contemporains*. Paris. Gallimard, 1960. p. 776 (index).
Chap. XVIII: La sculpture cubiste, pp. 256 ff.—Chronology, p. 298–99.—"Notes de Lipchitz sur lui même," pp. 299–300.

71. Cooper, Douglas. *The Cubist Epoch*. London, Phaidon, 1971. pp. 249–55, 315–16 (index).
Includes catalogue of exhibition and publication done in association with Los Angeles County Museum of Art and the Metropolitan Museum of Art, New York. General bibliography.

72. Craven, Wayne. *Sculpture in America*. New York, Crowell, 1968. p. 706 (index).
Brief bibliography.

73. Cummings, Paul. *A Dictionary of Contemporary American Artists*. New York, St. Martin's Press, 1966. pp. 188–89.

74. *Current Biography*. New York, H. W. Wilson, 1949 and 1962–1963.
Yearbook 1948, pp. 378–80.—Yearbook 1962, pp. 262–64. Originally issued monthly under different editors and revised cumulatively, e.g., Nov. 1968, pp. 32–34. References mention general biography, e.g., Who's Who in America.

75. Detroit. Institute of Arts. *Sculpture in Our Time Collected by Joseph H. Hirshhorn*. Detroit, May 5–Aug. 23, 1959. pp. 54, 57–58.
Lipchitz, nos. 121–26.

76. *Dictionnaire de la sculpture moderne*. Paris, Hazan, 1960.
For English edition, see bibl. 88.

77. Elsen, Albert E. *The Partial Figure in Modern Sculpture from Rodin to 1969*. Baltimore, Baltimore Museum of Art, 1969. pp. 58–59, 111.
Includes catalogue of exhibition held Dec. 2, 1969—Feb. 1, 1970. Additional Elsen text, bibl. 89.

78. *Encyclopedia of World Art*. New York, Toronto, London, McGraw-Hill, 1960. v. 15, p. 322 (index).
Main entry, v. 9, pp. 258–59, by Henry R. Hope. Also note "Dictionary" (bibl. 89), McGraw-Hill, 1969.

79. Giedion-Welcker, Carola. *Contemporary Sculpture: an Evolution in Volume and Space*. Rev. and enl. ed. New York, Wittenborn, 1960. p. 395 (index).
First concise edition: *Modern Plastic Art* (Zurich, 1937); first

revised edition (New York, 1955); second enlarged edition (1960). No change in 1955 bibliography by Bernard Karpel, pp. 355–94.

80. Goldwater, Robert. *What Is Modern Sculpture?* New York, Museum of Modern Art, 1969. p. 144 (index).

81. Gómez de la Serna, Ramón. *Ismos.* Buenos Aires, Poseidon, 1943. pp. 231–36.

82. Greenberg, Clement. *Art and Culture: Critical Essays.* Boston, Beacon Press, 1961. pp. 105–10.

83. Hammacher, A. M. *The Evolution of Modern Sculpture: Tradition and Innovation.* New York, Abrams, 1969. p. 378 (index). Concise bibliography by Bernard Karpel.

84. Hartley, Marsden. *The Spangle of Existence.* [Unpublished Essays]. 1942. pp. 194–97. Includes "Letter to Jacques Lipchitz." Restricted typescript (unpublished carbon copy). Copyright Hartley Estate.

85. Kuh, Katherine. *The Artist's Voice: Talks with Seventeen Artists.* New York, Harper & Row, 1962. pp. 155–70. Originally published as bibl. 135).

86. Licht, Fred. *Sculpture: 19th & 20th Centuries.* Greenwich, Conn., New York Graphic Society, 1967. p. 350 (index).

87. Los Angeles. Museum of Art. *The Cubist Epoch.* 1971. Los Angeles and New York show. See Cooper (bibl. 71).

88. Maillard, Robert, ed. *Dictionary of Modern Sculpture.* New York, Tudor [1960?]. pp. 174–76. Article by Raymond Cogniat. Translated from the French (bibl. 76).

89. *McGraw-Hill Dictionary of Art.* Edited by Bernard S. Myers. New York, etc., McGraw-Hill, 1969. v. 3, pp. 441–43. Article by Albert Elsen.

90. Marchiori, Guiseppe. *Modern French Sculpture.* New York, Abrams, 1963. pp. 29–30.

91. Nelson, James, ed. *Wisdom: Conversations with the Elder Wise Men of Our Day.* New York, Norton, 1958. pp. 263–73. Lipchitz and Cranston Jones on NBC-TV, May 9, 1958. Portion reprinted in Hammacher (bibl. 36), pp. 74–75.

92. Otterloo. Rijksmuseum Kröller-Müller. *Sculptures of the Rijksmuseum Kröller-Müller.* [3d ed.] Otterlo, 1966. pp. 75–77. Biography, Chaim Jacob Lipchitz, bibliography, pp. 75–76. With

preface to first Dutch edition (1952), first English edition (1963), second English edition (1966).

93. Ozenfant, Amedée. *Art.* Paris, Budry, 1928. pp. 112–13.
Other continental editions. Translation: *Foundations of Modern Art.* New York, Dover, 1952. Also paperback editions.

94. Paris. Musée National d'Art Moderne, *Le Cubisme (1907–1914).* Paris, Jan. 30–Apr. 9, 1953. p. 63 (index).
Essay (Jean Cassou); chronologies (Bernard Dorival); catalogue (G. Vienne).

95. Paris. Petit Palais. *Les Maîtres de l'Art Indépendant, 1895–1937.* Paris, Art et Métiers Graphiques, 1937, pp. 118–19.
Lipchitz: salle 45, 36 works.

96. Read, Herbert. *The Art of Sculpture.* 2nd ed. New York, Bollingen Foundation and Pantheon Books, 1961 (c1956). p. 140 (index).

97. Redstone, Louis G. *Art in Architecture.* New York, McGraw-Hill, 1968.
Introduction by Jacques Lipchitz.

98. Rhode Island. School of Design. Museum of Art. *Herbert and Nanette Rothschild Collection.* Providence, R.I., Oct. 7–Nov. 6, 1966.
Joint exhibition with Brown University. Catalogue by George Downing. Lipchitz, nos. 92–95, includes commentary.

99. Ritchie, Andrew C. *Sculpture of the Twentieth Century.* New York, Museum of Modern Art, 1953. pp. 32, 42–43, 178–81.

100. Rodman, Selden. *Conversations with Artists.* New York, Devin-Adair, 1957. pp. 130–36, 164–69.

101. Rogers, L. R. *Sculpture: the Appreciation of the Arts.* London, New York, Oxford University Press, 1969. p. 241 (index).

102. Selz, Jean. *Modern Sculpture: Origins and Evolution.* New York, Braziller, 1963. pp. 264, 290 (index).
Biography and bibliography.

103. Seuphor, Michel. *La sculpture de ce siècle. Dictionnaire de la sculpture moderne.* Neuchâtel, Éditions du Griffon, 1959. pp. 31–33, 185, 294–95, 362.
Chronology and bibliography. Also English edition, 1960.

104. Seuphor, Michel. *The Sculpture of This Century.* New York, Braziller, 1960.
Translated from the French.

105. Solomon R. Guggenheim Museum. *Guggenheim International Exhibition 1967: Sculpture from Twenty Nations.* New York, Oct. 1967—Feb. 1968. pp. 49, 143.

Biography; bibliography (general and specific).

106. Solomon R. Guggenheim Museum. *A Handbook to the Solomon R. Guggenheim Museum Collection.* New York, 1958. pp. 208–09.

Similarly: *Selected Sculpture and Works on Paper.* 1969. pp. 134–35.

107. Trier, Eduard. *Figur und Raum. Die Skulptur des XX. Jahrhunderts.* Berlin, Mann, 1960. p. 75 (index).

Also English edition: *Form and Space.* New York, Praeger, 1962.

108. Valentiner, W. R. *Origins of Modern Sculpture.* New York, Wittenborn, 1946. pp. 79, 140, 176.

109. Yale University. Art Gallery. *Collection of the Société Anonyme: Museum of Modern Art 1920.* New Haven, Conn., Associates in Fine Arts, 1950. p. 132.

Biographical note; statement by Marcel Duchamp (1945); text by Gertrude Stein (*Ray*, no. 2, 1927); exhibitions.

110. Walker Art Center. *Twentieth Century Sculpture . . . Selections from the Collections.* Minneapolis, 1969. pp. 38–39, 82.

Biography, bibliography. General bibliography, pp. 95–96.

*Articles*

111. African art in the collection of Jacques Lipchitz. *African Arts* (Los Angeles), Summer 1970, pp. 48–51.

112. Bario-Garay, J. L. La escultura de Jacques Lipchitz. *Goya* (Madrid), May 1970, pp. 350–57.

Bibliography.

113. Benson, Emanuel M. Seven sculptors. *American Magazine of Art* (Washington, D.C.), Aug. 1935, pp. 455–58.

114. Cassou, Jean. *Contemporary Sculptors: V—Lipchitz. Horizon* (London), Dec. 1946, pp. 377–80.

115. Cocteau, Jean. Jacques Lipchitz and my portrait bust. *Broom* (Rome), v. 2, pp. 207–09, 1922.

Followed, pp. 216–19, by unsigned article: The technique of Jacques Lipchitz.

116. Cogniat, Raymond. See bibl. 88.

117. Craig, Martin. Jacques Lipchitz. *Art Front* (New York), Jan. 1936, pp. 10–11.
   With comments on the Brummer gallery show (bibl. 47).

118. Dermée, Paul. Lipchitz. *L'Esprit Nouveau* (Paris), Nov. 1920, pp. 169–82.

119. Eisendrath, William N. "Bather" by Jacques Lipchitz. *St. Louis Museum Bulletin*, no. 4, 1957, pp. 45–46.

120. Elsen, Albert E. The humanism of Rodin and Lipchitz. *College Art Journal* (New York), Spring 1958, pp. 247–65.
   See also bibl. 77, 89.

121. Faure, Elie. Jacques Lipchitz et le cubisme. *Arts Plastiques* (Brussels), no. 2, 1950, pp. 117–22.
   Article written 1932–1933. See Brummer Gallery 1935 (bibl. 47).

122. Fire [in Lipchitz's studio]. *Art Digest* (New York), Feb. 1, 1952, p. 14.

123. Frost, Rosamund J. Lipchitz makes a sculpture. *Art News* (New York), Apr. 1950, pp. 36–39, 63–64.

124. George, Waldemar, Jacques Lipchitz. *Amour de l'Art* (Paris) v. 2, 1921, pp. 255–58.
   For additional references see Hammacher (bibl. 36): nos. 17, 18, 19, 23, 25, 26, 27, 31. Also Le Triangle brochure (bibl. 34), and insert (bibl. 50a).

125. Greenberg, Clement. Sculpture of Jacques Lipchitz. *Commentary* (New York), Sept. 1954, pp. 257–59.

126. Guéguen, Paul. Jacques Lipchitz, ou l'histoire naturelle magique. *Cahiers d'Art* (Paris), v. 7, 1932, pp. 252–58.

127. Guéguen, Pierre. Le nouveau colloque avec Lipchitz. *XXe Siècle* (Paris), no. 13, 1959, pp. 76–80.
   English translation, p. [119].

128. Hess, Thomas B. Lipchitz: space for modern sculpture. *Art News* (New York), June 1954, pp. 34–37, 61–62.
   Review of retrospective at Museum of Modern Art (bibl. 58).

129. Hope, Henry R. Drawing by Lipchitz: "The Arrival." *John Herron Institute Bulletin*, Apr. 1957, pp. 5–7.

130. Hope, Henry R. Un sculpteur d'hier et d'aujourd'hui. *L'Oeil* (Lausanne), May 1959, pp. 30–37.

131. Hope, Henry R. La scultura di Jacques Lipchitz. *La Biennale di Venezia.* Sept. 1952, pp. 8–11.

Hope, Henry R. See also bibl. 37, 50, 78.

132. Huidobro, Vincente. Jacques Lipchitz. *Cahiers d'Art* (Paris), v. 3, 1928, pp. 153–58.

133. Jacques Lipchitz montre sa collection. *L'Oeil* (Lausanne), June 1960, pp. 46–53.

Similarly: Jacques Lipchitz collection at Museum of Primitive Art. *Art News* (New York), May 1960, p. 15; *Arts* (New York), June 1960, p. 56. See bibl. 29.

134. Kelleher, P. J. "Sacrifice": bronze acquired by the museum. *Albright Gallery Notes* (Buffalo, N.Y.), May 1952, pp. 2–3.

Similarly: Another Phoenix. *Art Digest* (New York), Feb. 15, 1952, p. 14.

135. Kuh, Katherine. Conclusions from an old cubist. *Art News* (New York), Nov. 1961, pp. 48–49, 73–74.

An interview with Lipchitz. Excerpts, later published in bibl. 85.

136. Lanes, Jerrold. [Work from the cubist period at the Marlborough-Gerson Gallery]. *Burlington Magazine* (London), May 1968, pp. 295–96.

137. Larrea, Juan. An open letter to Jacques Lipchitz. *College Art Journal* (New York), Summer 1954, pp. 251–88.

138. A little song. *Time* (New York), Feb. 18, 1946, p. 63.

With text by the artist on his sculpture *Benediction.*

139. Lozowick, Louis. Jacques Lipchitz. *Menorah Journal* (New York), v. 16, 1929, pp. 46–48.

140. Munro, E. C. Sculptor in the foundry: Lipchitz at work. *Art News* (New York), Mar. 1957, pp. 28–30, 61–62.

141. Nordland, Gerald. Lipchitz: lively legend. *Artforum* (San Francisco), June 1963, pp. 38–40.

142. Pach, Walter. Lipchitz and the modern movement. *Magazine of Art* (Washington, D.C.), Dec. 1946, pp. 354–59.

143. Parkes, Kineton. The constructional sculpture of Jacques Lipchitz. *Architect* (London), Sept. 18, 1925. pp. 202–204.

144. Raynal, Maurice. La sculpture de Jacques Lipchitz. *Arts de France* (Paris), no. 6, 1946, pp. 43–50.

145. Rewald, John. Jacques Lipchitz's struggle. *Museum of Modern Art Bulletin* (New York), Nov. 1944, pp. 7–9.

Ritchie, Andrew C. See bibl. 38.

146. Rouve, Pierre. The two faces of Lipchitz. *Arts Review* (London), Apr. 8–22, 1961, p. 16.
Review of Hammacher monograph (bibl. 36).

147. Sawin, Martica. Gonzalez and Lipchitz. *Arts* (New York), Feb. 1962, pp. 14–19.

148. Schneider, Pierre. Lipchitz: Cubism, the school for baroque. *Art News* (New York), Oct. 1959, p. 46.

149. Slusser, Jean P. Sculptures by Arp and Lipchitz. *Bulletin of the Museum of Art, University of Michigan* (Ann Arbor), May 1950, pp. 9–12.
Comment on Lipchitz's *Happiness*.

150. Stein, Gertrude. Lipchitz. *Ray* (London), no. 2, 1927, p. 1.
Reprinted in Société Anonyme catalogue (bibl. 109).

151. Sweeney, James Johnson. An interview with Jacques Lipchitz. *Partisan Review* (New York), Winter 1954, pp. 83–89.

152. Sweeney, James Johnson. Eleven Europeans in America. *Museum of Modern Art Bulletin* (New York), Sept. 1946, pp. 24–27, 38.
Includes Lipchitz interview and documentation.

153. Sweeney, James Johnson. Two sculptors: Lipchitz and Arp. *Theatre Arts* (New York), Apr. 1949, pp. 52–56.
Comments by Lipchitz in interview.

154. Talphir, Gabriel. Jacques Lipchitz. *Gazith* (Tel Aviv), no. 213–214, 1961, pp. 1–2.
English summary, pp. 1–2. Main Hebrew text and illustrations unpaged.

155. The Technique of Jacques Lipchitz. *Broom* (Paris), v. 2, 1922, pp. 216–19.
Complements Cocteau's article, pp. 207–209.

156. Weller, Paul. Jacques Lipchitz: a portfolio of photographs. *Interiors* (New York), May 1950, pp. 88–95.
Introductory note by A. D. [Arthur Drexler?].

157. Werner, Alfred. The dramatic world of Jacques Lipchitz. *The Progressive* (Madison, Wis.), Aug. 1954.

158. Werner, Alfred. Lipchitz: Thinking hand. *Midstream* (New York), Fall 1959.

159. Werner, Alfred. Protean Jacques Lipchitz. *Painter and Sculptor* (London), Winter 1959–1960, pp. 11–17.
Werner, Alfred. Also see bibl. 42.